Painting Flowers A to Z

Painting Flowers A to Z

with Sherry C. Nelson MDA

NORTH LIGHT BOOKS
CINCINNATI, OHIO
www.nlbooks.com

\mathcal{D}edication

*For my parents, Phil and Pearl Nickell,
whose unfailing love and support over a lifetime
have provided a secure footing and a springboard
from which I can pursue any goal.*

Painting Flowers A to Z with Sherry Nelson, MDA Copyright ©
2000 by Sherry C. Nelson, MDA. Manufactured in China. All rights
reserved. The patterns and drawings in this book are for the personal
use of the decorative painter. By permission of the author and pub-
lisher, they may be either hand-traced or photocopied to make single
copies, but under no circumstances may they be resold or repub-
lished. It is permissible for the purchaser to paint the designs con-
tained herein and sell them at fairs, bazaars and craft shows. No other
part of this book may be reproduced in any form or by any electronic
or mechanical means including information storage and retrieval sys-
tems without permission in writing from the publisher, except by a re-
viewer, who may quote brief passages in a review. Published by North
Light Books, an imprint of F&W Publications, Inc., 1507 Dana
Avenue, Cincinnati, Ohio 45207. (800) 289-0963. First edition.

Other fine North Light Books are available from your local bookstore,
art supply store or direct from the publisher.

04 03 02 01 00 5 4 3 2 1

Library of Congress Cataloging-in-Publication Data

Nelson, Sherry C.
 Painting Flowers A to Z with Sherry C. Nelson.
 p. cm.
 ISBN 0-89134-938-3 (pb. : alk. paper)
 ISBN 0-89134-957-X (pob. : alk. paper)
 1. Flowers in art. 2. Painting—Technique. I. Title.
ND1400.N45 2000
751.45'434—dc21

 99-055967
 CIP

Editor: Heather Dakota
Designer: Wendy Dunning
Cover Design: Amber Traven
Photographer: Deborah Galloway
Production Coordinator: Emily Gross

METRIC CONVERSION CHART		
TO CONVERT	TO	MULTIPLY BY
Inches	Centimeters	2.54
Centimeters	Inches	0.4
Feet	Centimeters	30.5
Centimeters	Feet	0.03
Yards	Meters	0.9
Meters	Yards	1.1
Sq. Inches	Sq. Centimeters	6.45
Sq. Centimeters	Sq. Inches	0.16
Sq. Feet	Sq. Meters	0.09
Sq. Meters	Sq. Feet	10.8
Sq. Yards	Sq. Meters	0.8
Sq. Meters	Sq. Yards	1.2
Pounds	Kilograms	0.45
Kilograms	Pounds	2.2
Ounces	Grams	28.4
Grams	Ounces	0.04

Acknowledgments

Much of the value of this book lies in the contributions of Deborah Galloway, my long-time business partner and friend. Deb spent nearly a year shooting the floral references, and took the hundreds of step-by-step photos necessary to illustrate the instructions. She handled all the film developing and labeling as well as offered valuable insight and advice over the long haul that such a production entails. Without Deb's expertise with the camera, this book would not be as useful for you. Thank you to Deb, for every aspect of your efforts.

Thanks must also go to Heather Dakota, my talented editor at North Light Books. Heather was a pleasure to work with and along the way we discovered common interests and a friendship that hopefully will continue long after the final edition of this book is printed.

A final thank you to Greg Albert and Kathy Kipp, who first came to me with the idea for this book. I appreciate your support, as well as your enthusiasm for my work. Thanks also to Wendy Dunning and Amber Traven for their work on the design for this book.

About the Artist

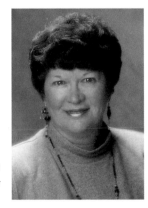

Sherry C. Nelson's career in painting has been shaped by her love of the natural world and its creatures. While birds and animals remain her favorite subjects, painting realistic florals with easy-to-master methods hold a special pleasure for her.

Sherry began teaching decorative painting around her kitchen table in 1971 and has, in the 29 years since, taught in 46 states and in countries around the world. She is a skilled and patient teacher, sharing with students her innovative and exciting techniques for florals, birds and animals. Her unique approach to teaching breaks down the process of painting into logical steps that anyone can learn quickly and easily. She now teaches almost entirely "on camera" demonstrating her methods step-by-step on closed circuit TV, making it possible for her students to master skills and techniques impossible with ordinary demonstrations.

Sherry has produced twenty publications for the decorative artist to date, including her immensely popular *Painting Garden Birds with Sherry C. Nelson MDA*, also available from North Light Books.

Sherry was born in Illinois, traveled extensively with her family in the military, and received her B.A. from Southern Illinois University. The lure of the mountains and desert prompted a move to New Mexico, where her children Neil and Berit were raised. Sherry lives and paints on her 37 acres of spectacular wilderness in the Chiricahua Mountains of Southeast Arizona. Eleven species of hummingbirds frequent the wildflowers of her property and animals abound, providing an unspoiled serenity and inspiration for her brush. Now, from her studio in wooded Cave Creek Canyon, Sherry invites you to join her in painting some of the most spectacular of America's garden flowers.

Contents

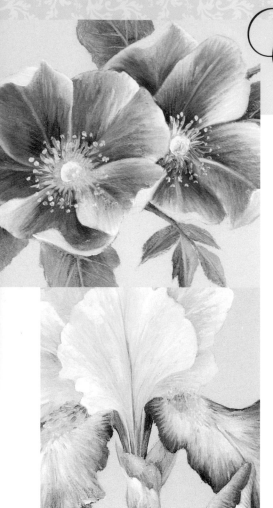

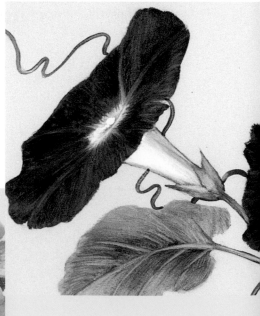

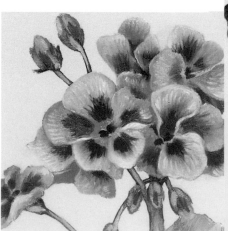

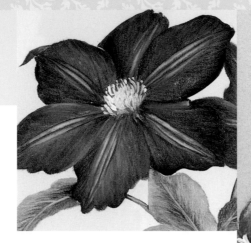

50 Flower Painting Projects...30

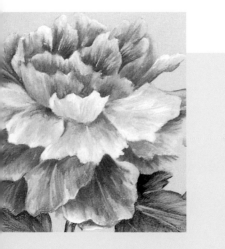

Put It All Together ...130

Materials

If you have painted in oils before, you no doubt have many of the supplies you need already. If you have not, just pick a few of your favorite projects from the book, and begin with those, to minimize your initial expense.

OIL PAINTS

Oil paints are a wonderfully easy medium to use and they last forever, since I use a very small amount of paint for any one painting. You can purchase inexpensive paints, but they have less pigment and more oil. You'll end up getting less for your money and they won't last as long, so it's a false savings.

BRUSHES

Always buy the best brushes you can afford, in the sizes and types you'll need. If you are a beginning painter and you attempt these projects with poor-quality brushes, your tendency will be to blame any problems you might encounter on your ability. In truth, with good brushes from the start, anyone can succeed.

Get your supplies together and let's get started!

WHAT SHERRY USES

Quality materials make my job easier and they last longer. This makes them well worth the additional expense.

- *Oil paints.* I use Winsor & Newton Artists' Oils because they have maximum pigmentation, minimum oil and the colors are brilliant.

- *Brushes.* I use Winsor & Newton Series 710 and Series 740.

- *Palette knife.* Sherry's Choice by Loew-Cornell.

- *Cobalt Siccative* by Grumbacher.

- *Acrylic paints for the backgrounds.* I prefer Accent.

- *Spray finishes.* I use Krylon Matte Finish #1311 and Krylon Spray Varnish #7002 for a final picture varnish.

- *Wood Sealer.* I use the Magic Brush Wood Sealer, a lacquer-based sealer that dries in five minutes and can be sanded immediately.

If you have difficulty locating what you need, you can write to The Magic Brush, Inc., P.O. Box 16530; Portal, AZ 85632 for a catalog.

The Basic Supplies

- *Palette pad.* A 9"x12" (23cm x 30cm) disposable strip palette for oils is best.

- *Palette knife.* A flat painting knife is best for mixing in drier and applying thinned oil paint on backgrounds for rouging.

- *Oil paints.* I used a total of 23 colors for all the projects in this book. They are listed on the color chart. You can actually get by with fewer if you want to mix colors; for example, you could mix Cadmium Scarlet plus Cadmium Yellow and get Cadmium Orange. You may also substitute similar colors from your own supply. Just check the color charts included with each project.

- *Cobalt Siccative (or Cobalt Drier).* This product is optional, but I would certainly encourage you to use it. When used in tiny amounts, your painting will dry overnight and you can do any final highlighting or other touch-ups.

- *Brushes.* Use red sable brights (short-bristled flat brushes) in sizes 0, 2, 4, 6, 8. Use a red sable round (a skinny, pointed brush) in size 0 for detailing.

- *Artist's odorless thinner* and a tiny capped jar to hold a little thinner while you're painting. The thinner will be used to extend the paint for some projects.

- *Tracing paper.* A pad in size 9"x12" (23cm x 30cm) will be perfect.

- *Stylus.* You can also use a worn-out ballpoint pen or the end of the brush handle for etching guidelines into wet paint.

- *Ballpoint pen*, not a pencil. Transfer designs with the pen.

- *Paper towels.* Buy towels that are soft and smooth, with minimum surface texture to save wear on brushes.

- *Spray varnish.* This is the final finish for the completed, dry paintings.

- *Artgel.* This is a cleaner and conditioner for your oil brushes.

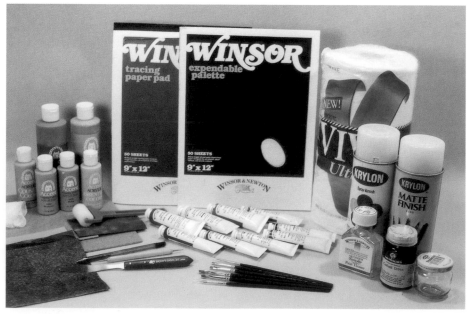

Materials and Supplies

	Titanium White		Winsor Red
	Ivory Black		Cadmium Red
	Raw Umber		Bright Red
	Raw Sienna		Alizarin Crimson
	Burnt Sienna		Permanent Rose
	Yellow Ochre		Magenta
	Jaune Brilliant		Purple Madder Alizarin
	Cadmium Lemon		Winsor Violet (Dioxazine)
	Cadmium Yellow Pale		French Ultramarine
	Cadmium Yellow		Sap Green
	Cadmium Orange		Oxide of Chromium
	Cadmium Scarlet		

WINSOR & NEWTON ARTISTS' OILS

These color samples will help determine the colors you'll need for each project. You can use these swatches to match to a specific brand of oil paint or even to match to an acrylic brand.

Prepare the Background

The background is an integral part of your painting. A background can make or break the look of the finished art, depending on how well it's prepared. Set up a worktable with perhaps a shelf or cabinet nearby with everything you need. It will make preparation easier and faster. Also, you'll do a better job if you don't have to hunt for something.

A background should stay "in the background" of the painting. It shouldn't be so complex or so colorful that it overwhelms your subject matter. A good starting point is simplicity and neutral colors that allow your design to be the focal point. Keep this in mind as you follow through the steps. If you find yourself getting too "gaudy," you probably won't like the finished product.

Background preparation begins with sanding. With Masonite panels, you don't have to sand the surface, just the edges, so it's aesthetically pleasing. If your panels have a fuzzy back, sand that too. I use an electric sander outside to keep the fuzzies from getting into the paint. You can also use #220 wet/dry black sandpaper. Wipe the sanding dust off with a damp cloth, and you are ready to paint.

A single acrylic color may be used for the background, as you see here. Choose a neutral color that won't conflict with your design. Drizzle some paint on the surface. If the paint gets bubbly when you roller it, you have put on too much. If it disappears into the surface right away, you've used too little.

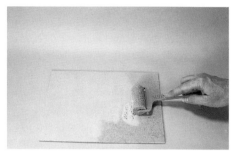

Roll through the paint and spread it around. Roller in one direction until the surface is covered, then go across in the opposite direction for a smoother finish. Lighten the pressure on the roller when you change direction.

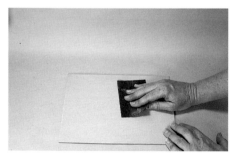

After the first coat dries, and is no longer cool to the touch, sand the surface well. This will remove all the impurities that may have gotten into the paint. Press lightly with all four fingers on the sandpaper, and move it around on the surface like you're polishing it.

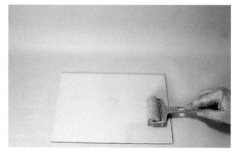

Now, apply the second coat. You'll need a little less paint this time, since the surface has been sealed with the first coat. Again, roller in one direction and then across the other way, until the surface is smooth and has a matte finish.

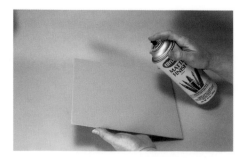

Let the surface dry completely before spraying with Krylon Matte Finish #1311. Absolutely *always* spray outside. I hold the can about a foot from the surface and begin spraying at the top, working from side to side, letting the spray go off the edge before starting back. This prevents a pileup on the edge. You'll soon learn how much is too little because your oil paints won't blend easily. When you have too much, your oil paints will slide.

❧Background Preparation Supplies❧

- *Hardboard or Masonite panels* cut to appropriate sizes, or other surface.

- *Sponge roller.* I apply all my backgrounds, whether on wood, Masonite, or paper, with 2-inch foam rollers.

- *Acrylic paints.* You may purchase a few neutral colors, such as the soft gray I used on all the flower samples, and add others for specific projects.

- *#220 or 330 wet/dry sandpaper.* It's black and comes from the hardware store.

- *Krylon Matte Finish #1311.* A must-have, this is an acrylic matte spray that you'll need to seal the acrylic-painted surface. This allows the oil paints to move easily for blending.

- *Newspaper* for your work surface.

- *Paper towels.* The inexpensive ones work fine.

- *Wood sealer* seals the wood prior to painting with water-based paints.

Transfer the Design

To make it easier for you to begin painting, there is a line drawing for each of the flower projects in this book. Accuracy is essential, so you may wish to work from a photocopy to make your transfer. Transfer the pattern precisely; every variation from the original will impact the painting's final appearance.

Lay the graphite (either dark or light, depending on the background color) on the prepared surface. Lay the line drawing on top of the graphite, and position it correctly on the background. Tape the line drawing to the painting surface. Lay a piece of tracing paper on the line drawing. Check to make sure the transfer paper is graphite side down by making a mark and checking. Using a ballpoint pen, carefully transfer all details in the line drawing. The tracing paper will help you know how accurate you are, and it will preserve the original copy. Adjust the pressure you are using if the transfer is too light or too dark.

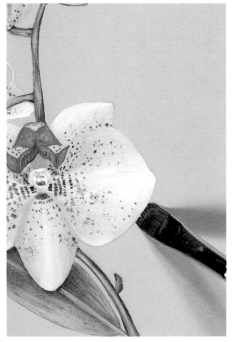

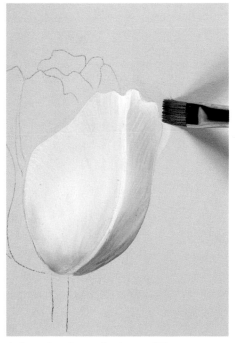

When using new graphite, the transfer is often too dark and shows through the oil paint. You can remove excess graphite by rubbing a folded paper towel firmly on the painting surface. Take care not to remove too much graphite.

When the design is completed and has dried, you can clean off the excess graphite around the edges. Dip the no. 8 bright into odorless thinner, and blot it on a paper towel. Pull the brush along to lift out any graphite lines.

A damp brush can also be used like an eraser as you paint. You can lift out areas, clean up along edges and remove mistakes entirely. Just remember to dip in thinner, then blot. Thinner left in the brush could bleed onto the painting surface when you start to clean up.

Palette and Brush Basics

For small projects such as the ones in this book, a 9"x12" (23cm x 30cm) palette is perfect. That size is easy to work with and takes up little space. Make sure your palette is resistant to oil paints. There will be a ring around each color if it is not. The paper will soak out all of the oil, making the paint difficult to work.

Do not tear off a sheet to paint on, but rather, work on the full palette to keep it from sliding around while you work. Fold your paper towel in fourths, and lay about three under the edge of the palette. The palette will hold them down so you don't have to handle them all the time, and they won't be in the way. Now, if you are right-handed, put the whole arrangement on your right. This will save a lot of time while you're painting.

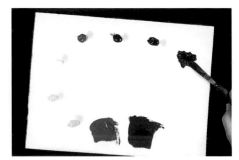

Put out ¼-inch (6mm) of paint of each color, spaced around the palette about 2-inch (5cm) apart to leave room for mixing in Cobalt Siccative, making loading zones and mixes.

To use the Siccative, dip the palette knife in the bottle, bleed off excess on the side of the bottle and immediately recap the bottle to keep it from drying out. Tap the knife point next to each paint patty, placing a little dot, the size of a freckle. That's all you need to have your palette workable for many hours, yet it will dry overnight. Mix the Siccative into the paint right away. After mixing, scrape the paint back into a tight pile, leaving less surface area exposed.

Your painting surface only has so much "tooth" and will hold just a small amount of paint, so it is essential to keep from applying an excess. Too much paint makes muddy colors and keeps you from getting good detail. Control the amount of paint you use by loading from the loading zone. That's an area of sparse paint, pulled into a dry and fuzzy strip. After making a loading zone, dry the brush between folds of paper towel. For example, when the instructions call for basecoating with Raw Sienna, use the Raw Sienna loading zone so you don't pick up too much paint.

Make a second loading zone, with another color, in preparation for making a mix. Work the color out into another loading zone. Then, work back and forth from one loading zone to the other until you have a mix of the two colors. The color charts will show you how dark or light the mix should be. If you need more of a particular color in a mix, load last in that color. Wipe the brush after creating a loading zone and before loading the brush to begin painting. This helps control how much paint you pick up. More problems are caused by too much paint, than too little.

WORKING WITH YOUR BRUSHES

After you have organized your work area, pour a very tiny amount of odorless thinner into a small container, no more than ¼-inch (6mm) deep. Put the cap on the container after each use. If you have new brushes, rinse them in thinner before using them to remove the glue sizing. Wet them and work the bristles with your fingers until the sizing is softened. Then, wipe the brushes dry on a paper towel.

When you have finished painting for the day, wash the brushes first in dirty thinner, then with clean thinner to get the last of the paint out. You may wish to use an optional brush cleaner. Winsor & Newton makes an Artgel that is an excellent cleaner and conditioner for oil brushes. There are other brands as well. A beautiful new brush with a perfect chisel edge deserves the best care.

🍂 Use a Dirty Brush 🍂

Sometimes in the instructions I refer to a "dirty brush". That means I've used a brush for one mix, wiped it dry and then gone straight into another mix with the same "dirty brush". If I'm going to pick up white, the dirty brush will make the mix a dirty white. In these techniques, you'll rarely wash the paint out of the brush. If it's necessary to wash the brush, the instructions will say so. Keep the lid on your thinner and your flat brushes out of it.

Create Form with Values

Form is created within a painted object through value gradations. When something is based with a single value, it appears flat. When it is shaded and then highlighted, it appears to take on dimension. However, dimension only becomes very real when the gradations between the values are so gradual that you can't see where one value ends and another begins.

Let's look at some basic concepts behind creating form and dimension with oil paints. Then we'll apply what we've learned to the fun of flower painting.

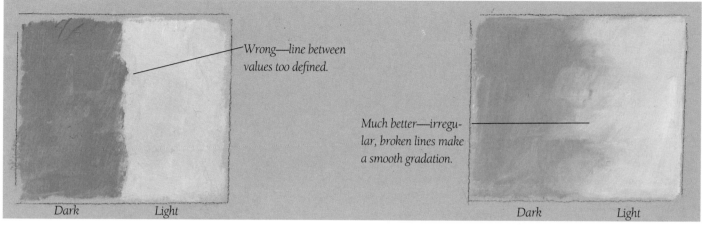

Wrong—line between values too defined.

Much better—irregular, broken lines make a smooth gradation.

Dark Light Dark Light

Placing values

When values meet in a hard line, that line "sets" into the surface and is nearly impossible to soften into a gradation. Practice right from the start: lay values side by side in an irregular, interlocking pattern, much like pieces of a jigsaw puzzle. This simple concept will be a wonderful help to you in your efforts to achieve good gradation and perfect form.

Blending on the line.

No matter how carefully you interlock the values as you basecoat, you still must blend between them to create a good gradation. One of the ways of doing this is shown here: blending on the line where the values meet and with the line, not against it, using a bright brush. By blending on the line, you create a third value, which forms a bridge or gradation between the original values.

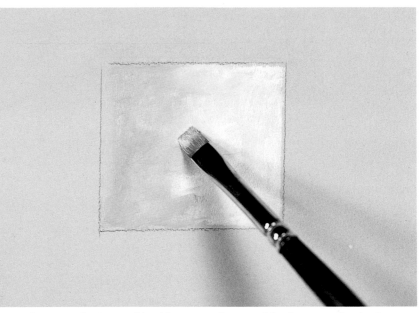

Crosshatch blending.

Another way of creating a bridge or a blend between values is to blend in a crosshatch, choppy motion with the bright brush, on the line where the values meet. This leaves the two original values and gives a third. The difference is in the surface texture. This technique is more appropriate for some objects than the smooth texture obtained with the first example.

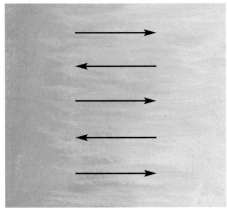

Chisel edge blending.

A third way of creating value gradations is by using the chisel of the brush instead of the flat. This time you'll blend the color across the line instead of with it. In order to keep the colors from becoming muddy, use the chisel edge to blend. The higher you hold the brush, the more texture you'll have. The lower to the surface you hold the chisel, the softer the lines.

Common blending error.

This is a common error. Pulling sideways across the line with the flat of the brush blends the colors totally. You will lose the dark and light value needed for contours. You can blend across the value line with a chisel but not with the flat of the brush.

The best way to create form in an object is to build depth through additions of darks and lights on top of the initial value. To accomplish depth, you'll see that there is a sparse basecoat of a middle value. And, like all single-value areas of color, it appears flat. When you add a dark value on approximately one-third of the area, blend where it meets the basecoat. Since you want a textured value gradation, blend with the crosshatch method. However, it's still not very dark, so you'll need to add a darker value. The trick is to place it on about half the area of the first dark value and repeat the choppy flat brushstroke across the line where the new value meets the old.

Now it's time to start adding the lights. The first highlight color is applied on approximately one-third of the light area. Then that junction is blended into the middle value. A smaller, lighter highlight is laid on within the previous highlight. Then, the final highlight is softened with the same choppy strokes giving the final gradation of value. Look at the difference in depth between the first example and the last. This shows that the addition of the two dark values and the two light values gives form, shape and depth to the objects you paint.

Learn to Paint Flowers

Painting realistically means studying the flower you wish to paint. For the first time, perhaps, you need to really involve yourself with the shape of the blossom, where the shadows form, and how the highlights lay on the petals, the bracts and even the leaves. If you don't have an actual blossom in hand, do the same with a good, detailed photo. Learn what the particular blossom really looks like. The trick is to paint what you see, not what you think is there. We get so used to seeing our common garden favorites that we tend to paint idealized versions of them, rather than how they truly appear in nature. Observe, then paint.

It is the shape of the blossom that determines how it must be handled and how the form must be created. Most flowers, no matter how complex, fall into a few basic categories that help us see how to render them in a more realistic way.

RAY SHAPE

A daisy is an example of a ray-like structure, in which the petals of varying lengths radiate from a visible center. In a ray, the shadows usually form at the base of the petals, under overlapping petals and in the deepest part of the center. The petal tips and edges carry the highlights.

BOWL SHAPE

Many flowers, such as anemones, camellias and roses, are characterized by their distinctive bowl shape. That shape creates the shadows on the underside of the bowl, where light is not able to reach, and inside the bowl, where the shape itself blocks the light and thus encourages shadows.

BELL SHAPE

Bell-shaped flowers, such as bluebells and lily of the valley, usually are dark inside the bell, particularly when it hangs down. The strong lights give form to the outer petals, which contrast against the dark interior.

TRUMPET SHAPE

There are also the trumpet-shaped flowers, such as the trumpet vine and morning glories. The flaring shape of the trumpet gives rise to various blending methods to create that curvature, and the darkest shadows are usually deep in the narrow trumpet shape. The light on this form often plays on the rolled and ruffled petal edges.

SIMPLE STAR SHAPE

Of all the flowers, the simple star shape, such as the geranium, is the easiest to paint. Shadows that form at the base of the petals and under overlapping petals are easy to understand. The lights are normally placed on petal tips and overlaps.

LIPPED SHAPE

Lipped shape flowers, such as the orchids and pansies, can be very complex. Light and shadow forms are interesting, and quite varied depending on the particular flower and species.

SPIKE SHAPE

The last category you need to be aware of is the spike, which would include the butterfly bush, lilac and astilbe. This form is usually characterized by numerous tiny blossoms clustered on a heavy stem. A few of the tiny blossoms must be treated in some detail to tell the story of their shape and form, and the way lights and shadows fall on the cluster as a whole needs to be considered.

Flowers are fascinating to study and even more enjoyable to paint. Now, let's take a few minutes to consider the variety of techniques that are specific to each flower and the tools you'll need to make them look more realistic.

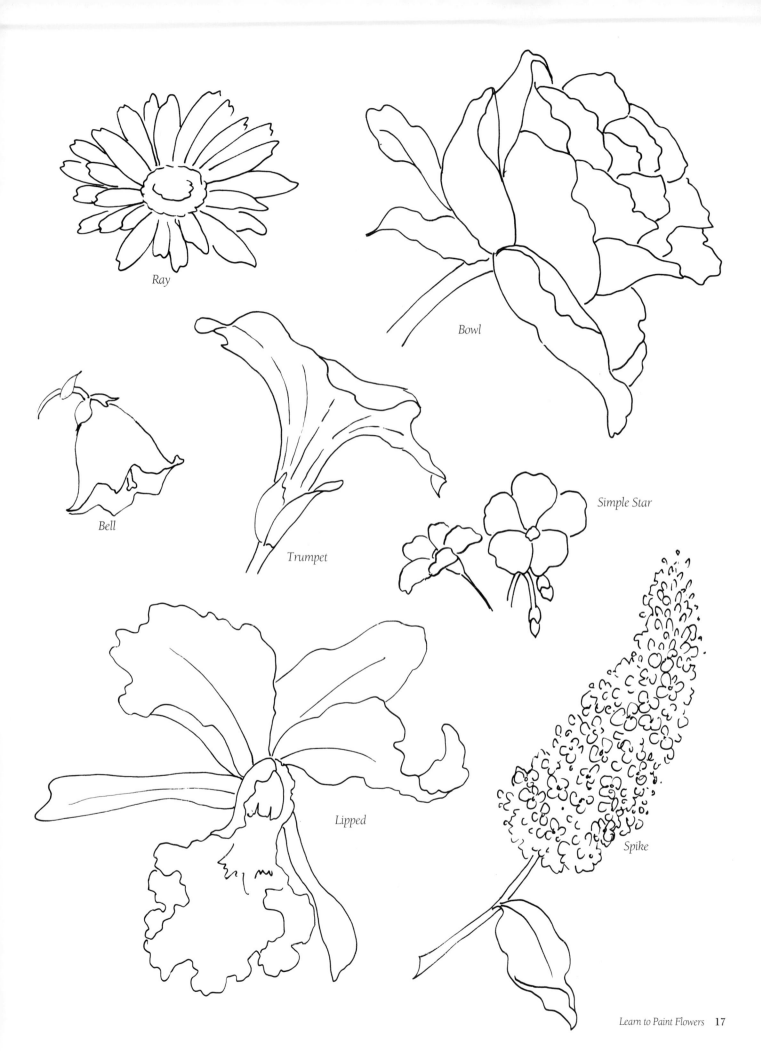

Ray

Bowl

Bell

Trumpet

Simple Star

Lipped

Spike

Create form on a petal by blending values with the brush held flat.

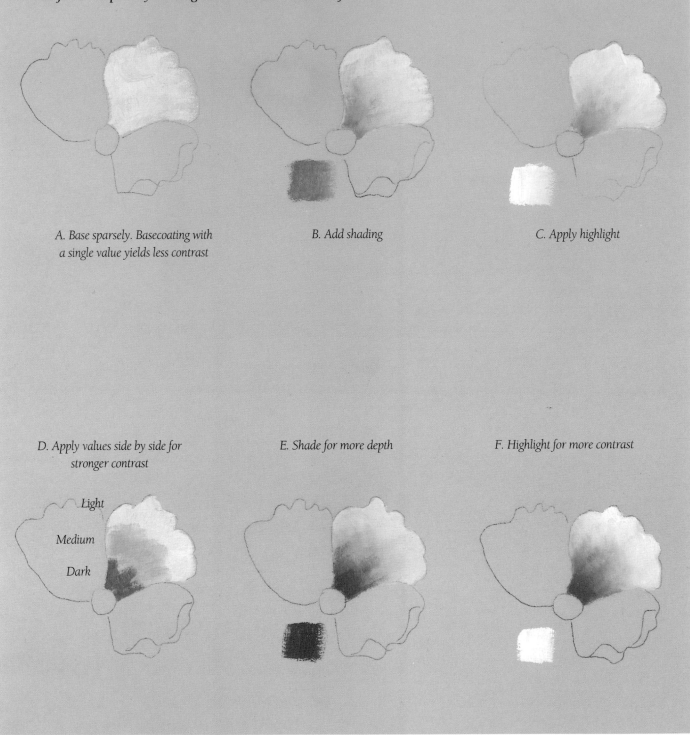

A. Base sparsely. Basecoating with
a single value yields less contrast

B. Add shading

C. Apply highlight

D. Apply values side by side for
stronger contrast

E. Shade for more depth

F. Highlight for more contrast

Light

Medium

Dark

Basic Petal Shapes with Form

Let's apply what you've learned about building values for form to some basic petal shapes. There are two ways to build contrast. You can start with a single-value basecoat or with a multiple value basecoat.

As shown in example A above, lay on a single-value basecoat, sparsely, with a choppy motion of the brush. Make a darker value, and lay it on the darkest part of the petal, usually at the base, as in example B. Blend on the line where those values meet. Now apply a highlight along the petal's edge from one side to the other. Blend where it meets the basecoat, as in C. With just those simple steps, you've created a petal with a soft value contrast.

Now, look at D. Start with three values laid side by side. Before going on to E, blend between them to create the initial gradation. In E, add the darkest dark, and blend where it meets the basecoat. Finally, in F, highlight for more contrast, blending where the white application meets the basecoat. Notice that applying values side by side, then shading and highlighting those with stronger values gives the maximum value contrast in your painting.

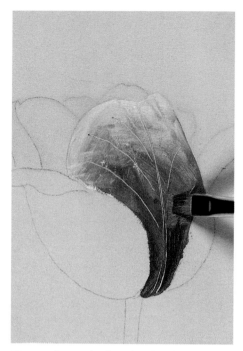

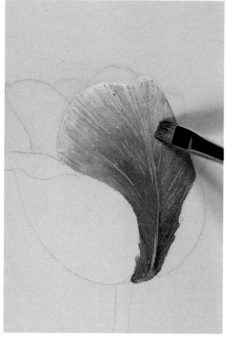

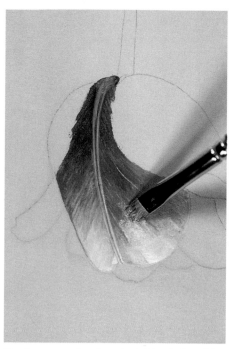

Here a tulip petal is based with a dark, medium and light value basecoat, letting the three values meet in the interlocking pattern. I'm using the chisel of a no. 6 bright, held parallel to the growth direction of the petal, to blend on the line where the values meet. Notice the fine surface texture that is being formed by the brush edge.

Here the values are blended in the dark area, and you can see the chisel blending on the area where the original light value met the medium. I'm working in the growth direction and still holding the brush parallel to the growth direction so the lines suggest the surface texture in that area.

The basecoat values have been blended, and the highlight colors have been added for a stronger contrast. Blend in the same manner as before where the highlight meets the basecoat. As the texture develops, the shape of the petal becomes more apparent and more realistic. Turn your work to make painting more comfortable.

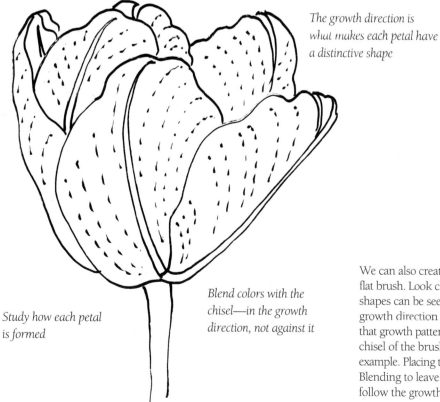

The growth direction is what makes each petal have a distinctive shape

Study how each petal is formed

Blend colors with the chisel—in the growth direction, not against it

We can also create form by blending values with the chisel edge of the flat brush. Look closely at most petals, and you'll see that their distinctive shapes can be seen in the vein structure, which indicates the petals' growth direction and usually gives a surface texture. We can simulate that growth pattern and texture by blending between the values with the chisel of the brush instead of the flat, as used in the previous example. Placing the curved lines on this diagram makes it look rounded. Blending to leave a similar texture in the paint on a petal and making it follow the growth direction will give it roundness in the same way.

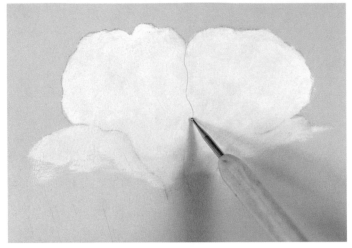

Now let's look at how we can use our color to separate adjoining petals which have been basecoated in a single value. As soon as I've covered the junction of the petals with paint, I'll quickly draw over the graphite line with a stylus that indicates the petal's edge, before I forget the location or lose it in the basecoat.

Lay the shadow in the form of a darker value, under the edge of the overlapping petal. Pressure the color on, applying it sparsely and irregularly, not in a hard line.

Blend where the shadows meet the basecoat. Now, place a strong highlight on the edge of the top petal. Apply sparse paint with firm pressure, and always break the edge so you don't develop hard lines in the surface.

Blend the edge of the light softly into the petal, and place a shadow under the adjacent petal. Look at the depth that forms with just such basic steps. Notice I'm blending with the flat of the brush. Had the flower been one with a distinctive and defined growth direction, you could achieve a similar effect with the chisel edge following the natural growth direction.

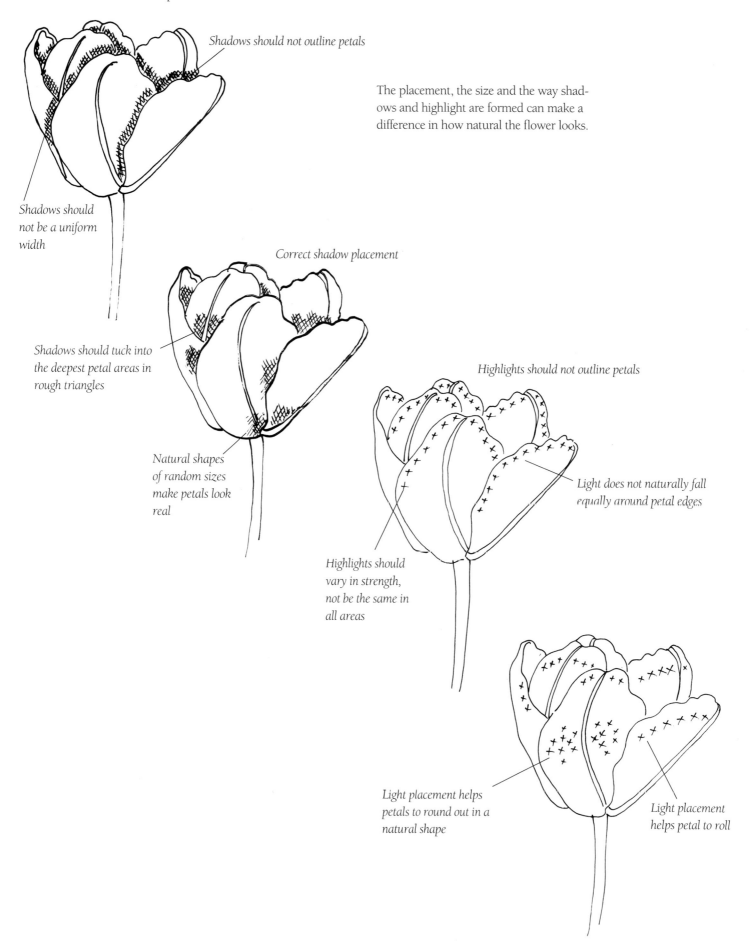

Unnatural shadow placement

Shadows should not outline petals

The placement, the size and the way shadows and highlight are formed can make a difference in how natural the flower looks.

Shadows should not be a uniform width

Correct shadow placement

Shadows should tuck into the deepest petal areas in rough triangles

Highlights should not outline petals

Natural shapes of random sizes make petals look real

Light does not naturally fall equally around petal edges

Highlights should vary in strength, not be the same in all areas

Light placement helps petals to round out in a natural shape

Light placement helps petal to roll

Flower Techniques

From the tiny bells of lily of the valley to the magnificent plate-sized amaryllis, the flowers with which we share this planet truly make our world come alive. So it's natural when we paint them that we want techniques that express our pleasure, that give life and personality to each blossom. In this chapter, we'll explore some easy tricks and concepts to make the flowers you paint more realistic.

Remember all the basic concepts we've been discussing so far. Most important perhaps is applying sparse paint at the basecoat stage. Keep your brushes dry-wiped when working on the flower surface, and be patient. Most times we try to rush the process, and that usually translates into overworking and muddy blending. Take time to smell the flowers while you're painting them.

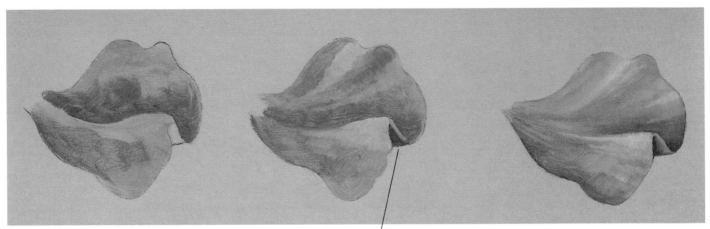

Base with a dark and medium value, blend between them.

Place several highlights and tuck in the tiny shadow under the fold

Soften the edges of the light values

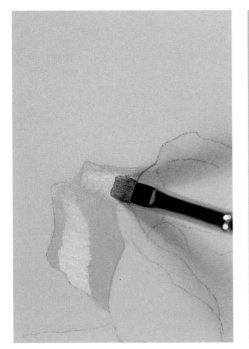

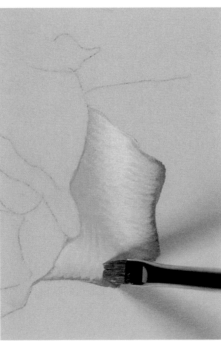

Begin rolling a rose petal by basecoating with a sparse amount of the petal color. Then study the way light hits the petal. Lay on the highlight value in areas of strongest light.

Look carefully at the growth direction of the petal. With the chisel, begin blending the inner edges of the light bands and then the outer edges, creating a value gradation going both ways. The growth direction will change from one side of the light to the other because the petal is rolling. A bit of color on the edge, blended properly, adds an extra special touch. Again turn your work to make painting more comfortable.

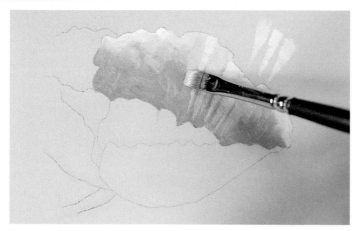

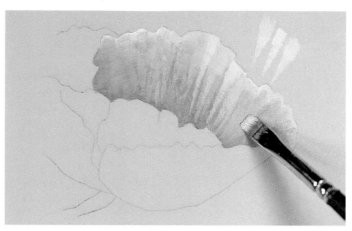

Some petals have more texture than others. To indicate this, lay "tornadoes" of light value on the loosely blended basecoat of this poppy petal. Look at the shapes outside the petal. They are done by pulling short strokes, starting at the top of the tornado, overlapping and getting smaller as you move inward, as you strengthen the lights to create a ruffled edge.

If it looks too rough, smooth it out with dry-brush tornadoes on the edges of the ones you did with the highlight color.

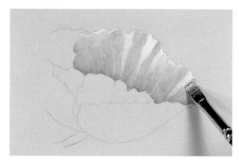

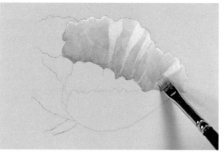

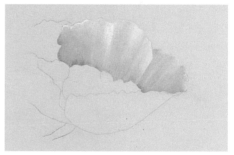

For a smoother, more softly rolled look, begin by placing some tornadoes for highlights, but not so many or so roughly applied.

Now, with a value slightly darker than the basecoat, lay shadows on either side of the light values you added. Pull shadows in the same tornado shapes.

With a larger brush, pat and soften the junctions between the dark and light values, working carefully toward a more refined blend. This look is appropriate for a more formal blossom, such as a rose.

It is called a flip turn when a petal edge rolls and you see the underside. Pick up the highlight value, and shape the little fold, making it fatter in the middle.

After the fold is partially based, lift the brush up on the chisel and slide the light value in a fine line to meet the petal edge.

Very precise connections can be made between colors using a good sharp chisel edge. Such connections are essential on pansy faces, where the colors should not blend, but meet on an edge that is ragged or spiky. Work around the edge of the purple, pulling little lines out over the light value but don't blend the colors at all. If you pick up any light value, wipe it off the brush before going back into the dark.

Here's another kind of connection. Lay the strong pink along the edge of the poppy petal, irregularly, using little paint. Use a small bright for better control. Move the brush back and forth just slightly on the junction of the values. For interest, or to stress the growth direction, a bit of pink can be pulled into the petal to suggest a fold or crease.

Stippling for texture can add dramatic color to some flowers, such as a daisy. Dab a little yellow onto the center with the tip of the round brush.

Squeeze the tip of the round brush between folds of paper towel to flatten the bristles. With the flat tip, stipple (bounce the brush) on the line between values. This creates a value gradation with texture.

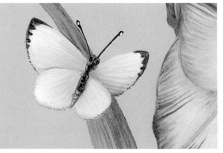

To create gorgeous, clear, clean highlights instantly, paint them on a dry surface. Here I have white on the brush and am laying the final highlights on a painting that was allowed to dry overnight.

Wet-on-dry highlights are dramatic, and that's reason enough to use them. But there's yet another good reason. Too much texture in the original blending can be softened by using the wet-on-dry highlight. On this butterfly you can see the underlying texture and how effectively the glaze of white distracts the eye.

Here I've blended—with the same dry-brush method—the edges of the wet paint into the dry basecoat. Stubborn edges can be softened with a paper towel. If you don't like the results, remove the highlight with odorless thinner and try again.

How To Fix Those Mistakes

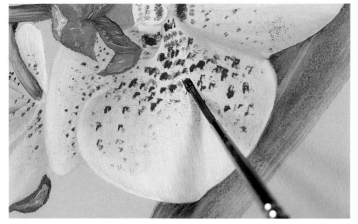

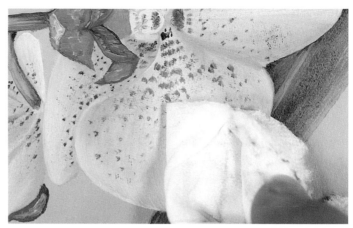

Sometimes we get heavy-handed, despite our best intentions. Here I've painted the dot pattern on the orchid petals too dark and some of them too large. You can't easily remove them from the wet surface.

You can blot mistakes or blend them into the surface. Just pat lightly with the paper towel and you are back in control.

Here is another example of overkill. There is too much paint on both sides of the brush and way too much basecoat. I can tell blending my dark and light values would be making mud.

Fold a very soft, textureless paper towel, and lay it gently on the flower. Press firmly, even hard, with the side of your hand, being careful not to slide the towel around. Look at how much paint came up. Now you can finish the flower without the risk of overblending.

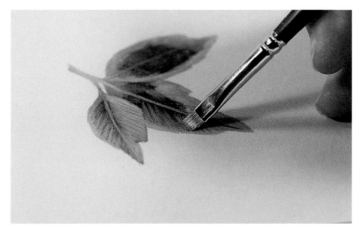

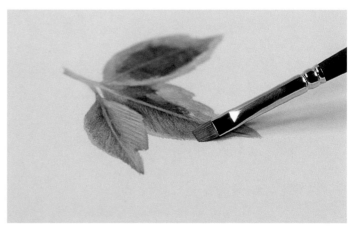

Many times I hear complaints that the chisel edge blending method lifts paint, scrapes it up or leaves too many ridges and lines. It's the high angle of the brush you see here that contributes to the problem.

Here I've dropped the angle of the brush to the surface, still blending with the chisel but coming in very flat. This approach keeps from disturbing the paint too much yet allows the needed texture for growth direction.

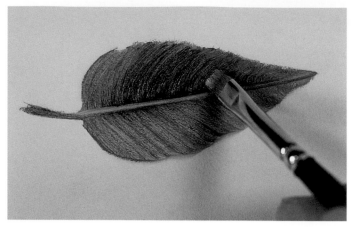

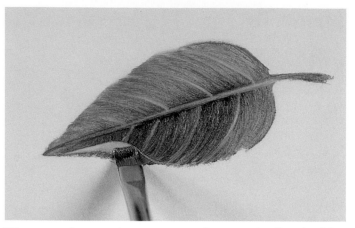

A common error is to pull the chisel so straight from the edge of the leaf to the center that the resulting texture looks like a fish skeleton. This is too stiff. Hold the brush inside the natural curve of the leaf, and at the same time pull the chisel in a slight curve to suggest a more natural shape. When you lay the vein structure on top, make sure it mimics the growth direction of the blend.

Flip turns on leaves are just as easy as on flowers. Pick a flat side of the leaf, and start the flip a bit away from the edge in the flip's fattest part. Then slide the chisel back to the leaf edge on both sides of the flip. Blend the light value softly into the basecoat within the flip, and you have a natural shadow.

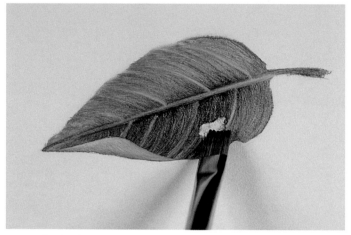

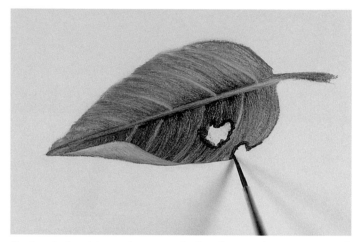

Now, take the damp brush and lift out a bug bite within the leaf and a notch on the edge. I use my cleanup brush for this.

Outline the bug bites with an irregular bit of rusty color, using a round brush.

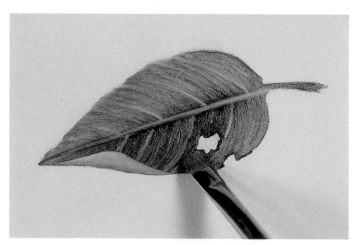

Pick up the brush you blended with, and connect the edges of the rusty outline into the leaf, pulling the edge a bit in the direction of growth.

Blend with the shape of the leaf or growth
direction to get a more natural look.

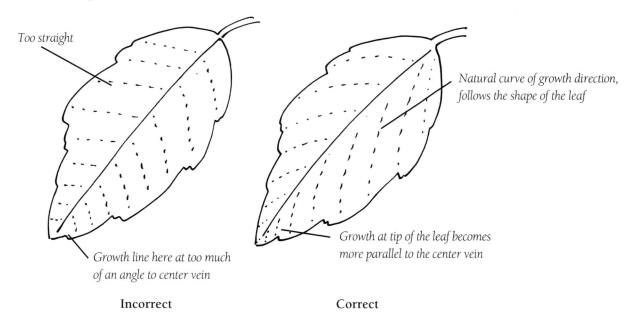

Too straight

*Natural curve of growth direction,
follows the shape of the leaf*

*Growth at tip of the leaf becomes
more parallel to the center vein*

*Growth line here at too much
of an angle to center vein*

Incorrect Correct

Leaf shapes and their growth directions vary.
Study the leaves of the flower you're painting.

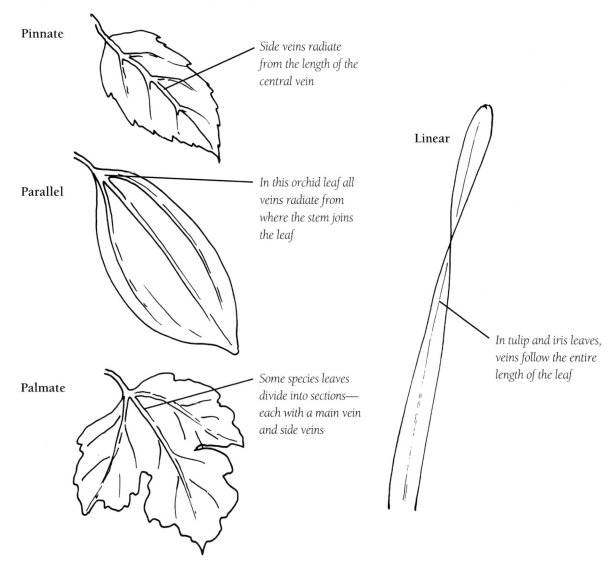

Pinnate

*Side veins radiate
from the length of the
central vein*

Linear

Parallel

*In this orchid leaf all
veins radiate from
where the stem joins
the leaf*

*In tulip and iris leaves,
veins follow the entire
length of the leaf*

Palmate

*Some species leaves
divide into sections—
each with a main vein
and side veins*

Rouging the Background

Rouging or antiquing the background around a finished painting allows you to add drama the easy way. You can start with a neutral background that doesn't distract from your work, but when you're finished you can add some wonderful finishing touches to the piece.

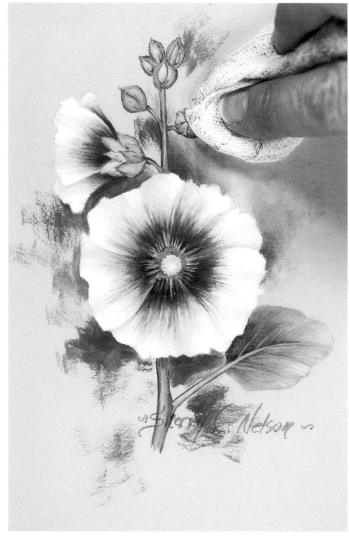

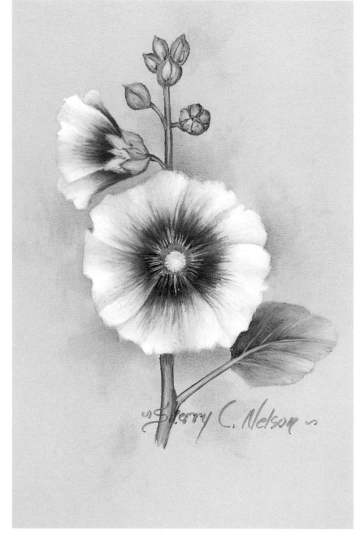

Here's a hollyhock painting. I've taken some of the Alizarin mix that I used on the flower and drybrushed it here and there next to various design elements, making the areas of color darker next to the design and less strong out away from it. Be sure to continue a little of the color on both sides of a stem, so the stem doesn't appear to "stop" the color. Then, fold a small pad of cheesecloth and begin softening the edges of the paint into the background.

The final result is much more interesting when the background has a little variation to help unify the design. If the design is thoroughly dry, the color will not adhere to it and can easily be removed if you get a bit on the flower. But if you're worried, you can spray the finished painting with Krylon Matte Finish #1311. Then any color additions you dislike can be removed without harm to the painting.

Antiquing the Background

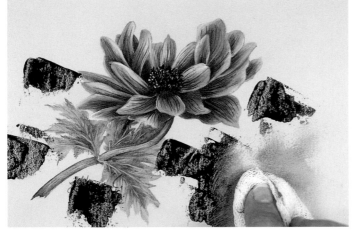

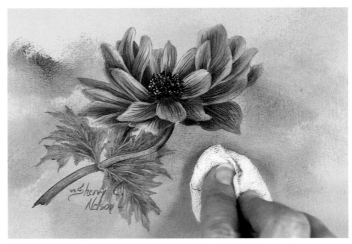

Here's another variation. Thin some of the dark green value used for the leaves with a little odorless thinner. Using the palette knife, apply some thin scrapes of this mix here and there around the design. With the pad of cheesecloth, begin blending.

Blend the edges of the green splotches to create a value gradation between the added color and the background.

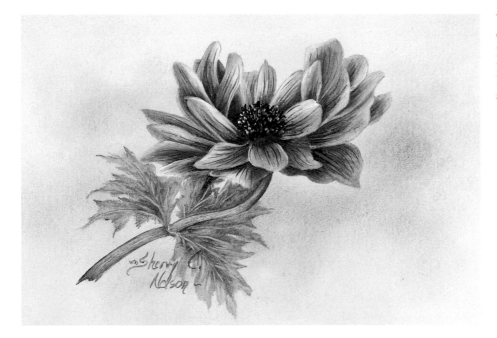

To me, this method suggests the interesting out-of-focus backgrounds you often see in photographs, where the interesting color and patterns aren't so harsh as to be distracting. Remember, you can spray the piece prior to antiquing to protect the painting.

PROJECT 1 *Amaryllis*

Amaryllis is a perfect bloom with which to begin these projects. The family Amaryllidaceae includes other much-loved garden favorites such as snowdrops and daffodils. The large snowy petals have intricate and beautiful details, a delight for any painter.

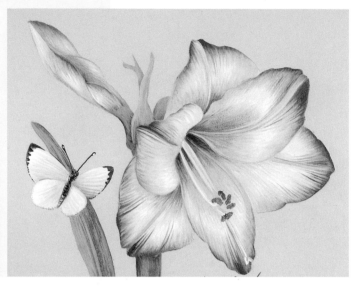

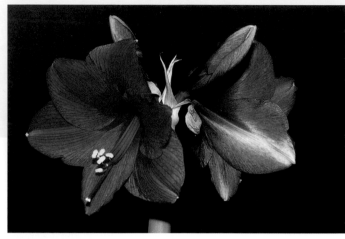

Amaryllis grows easily indoors allowing you an excellent source of reference photos. Taking a series of photos each day will help you to understand the structure, the growth direction and the bud's form. This kind of reference is invaluable when planning a painting.

⚜ Materials List ⚜

- **Brushes:**
 nos. 2, 4, 6 red sable brights no. 0 red sable round

- **Winsor & Newton Artists' Oils:**
 Ivory Black Titanium White Raw Sienna
 Burnt Sienna Raw Umber Sap Green
 Alizarin Crimson

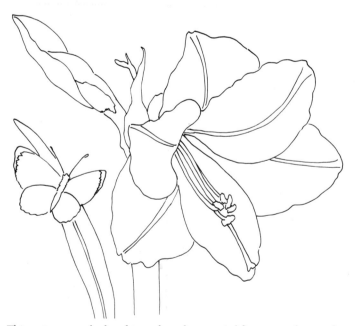

This pattern may be hand-traced or photocopied for personal use only. Enlarge at 167% to bring it up to full size.

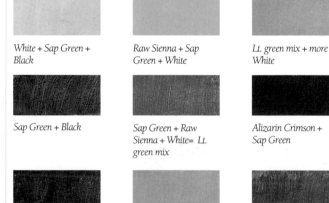

White + Sap Green + Black	Raw Sienna + Sap Green + White	Lt. green mix + more White
Sap Green + Black	Sap Green + Raw Sienna + White= Lt. green mix	Alizarin Crimson + Sap Green
Black + Raw Umber	Raw Sienna + White	Burnt Sienna + Raw Sienna

Color Key
Use these swatches for mixing or when using other paint mediums.

This diagram shows the form and structure of each petal. Refer to it often as you paint. Follow the dotted lines to ensure you are following the growth direction to create the correct contours.

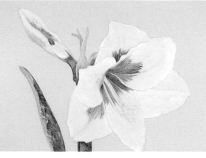

Flowers that are White have some green in them. Apply the dark green value, Sap Green plus black, pulling in the correct growth direction. Base the light areas with a dirty brush plus White. The small bracts are based with Raw Sienna plus Sap Green plus White. The dark area on the leaf and stem is Black plus Sap Green. The lighter value on the leaf and stem is Sap Green plus Raw Sienna plus White.

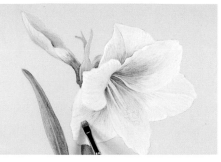

Blend the dark and light values with the chisel edge parallel to the diagram lines on the flower, bud, stems and leaves. If the brush makes hard lines or lifts paint, lower the brush angle and lighten your touch.

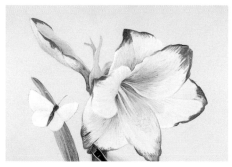

Add Alizarin Crimson plus a bit of Sap Green at the petal tips. Do not outline the petals. The wings of the Great Southern White butterfly are basecoated with the dirty brush plus white, and the body, with Black plus Raw Umber.

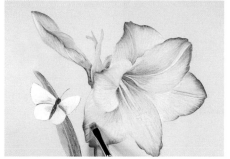

Edge the Alizarin mix into the petals using the chisel edge of a no. 6 bright. Allow some areas of strong color to remain at the edge. Add a bit of Raw Umber plus White to shade and separate the butterfly's wings. Highlight the leaf with the Lt. green mix plus White.

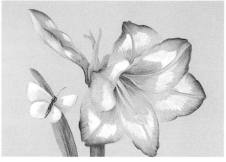

Add highlights of pure White on each petal and bud. Use a small amount of paint on the brush, and apply with pressure to set the paint into the basecoat. Blend the shading color on the butterfly wings. Add highlights on the wings with pure White. Base the stamens with Raw Sienna plus White. Blend to soften the highlights.

Notice how sparse the highlight color is and the pressure with which it is applied. You'll want to lift out some of the basecoat as you apply the highlight. Highlight the stamens with White. Using a no. 0 round, paint the anthers with Burnt Sienna plus Raw Sienna.

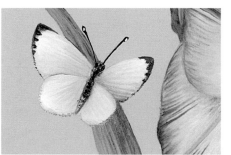

Blend the highlights on the wings. The forewing edge is detailed with Black plus Raw Umber, using a no. 0 round. Use the same mix thinned to paint the antennae. Use Raw Umber plus White to define the edges of the hind wings. Stipple the body with Black. The eyes are a dot of Black. Add a little white stipple on the body and a dot of White on each antenna.

Apply the final highlights that help the petals roll. When blending leave the middle of the application alone to form the strongest light, and blend the edges where it meets the basecoat. Your goal: a lovely gradation of color.

Anemone

The poppy anemone is a member of the family *Ranunculus*, which includes larkspurs, delphiniums and clematis. The anemone is noted for being one of the early spring bloomers, and easy to grow, with colors that are rich and varied. 🌿

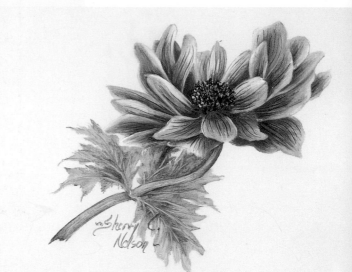

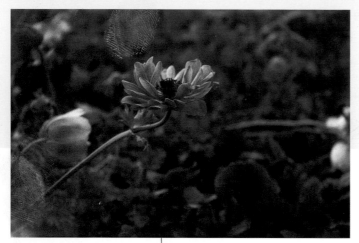

This photo reference slide was taken in Japan, where anemones are popular garden plants. This bloom was one of hundreds in a raised bed. Notice the fine purple lines on each petal.

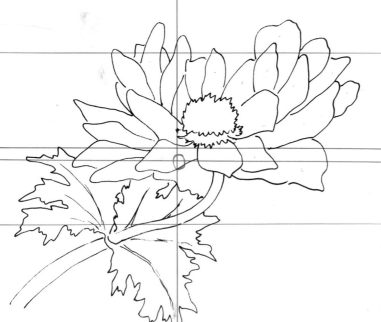

This pattern may be hand-traced or photocopied for personal use only. Enlarge at 125% to bring it up to full size.

🐞 Materials List 🐞

• **Brushes:**
 nos. 2, 4, 6 red sable brights no. 0 red sable round

• *Winsor & Newton Artists' Oils*
 Ivory Black Titanium White Raw Sienna
 Raw Sienna Cadmium Lemon Alizarin Crimson
 Winsor Violet

Winsor Violet + Raw Sienna + White

Black + Sap Green

Sap Green + Cadmium Lemon + Raw Sienna + White = Lt. green mix

Lt. green mix + White

Winsor Violet + Black

Alizarin Crimson + Cadmium Lemon + White

Dirty brush + White

Black + Winsor Violet

Color Key
Use these swatches for mixing or when using other paint mediums.

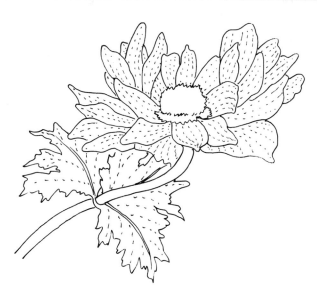

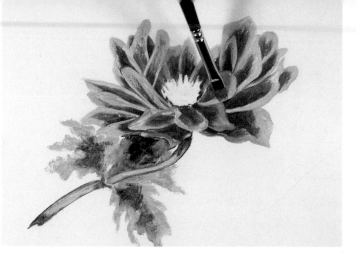

Use this diagram to help you determine growth direction. The leaf shape is quite distinctive, so paint one section at a time. Then blend to soften where the sections meet.

Base the dark shadows on the petals with Winsor Violet. Fill in the rest of each petal with a mix of Winsor Violet plus Raw Sienna plus White. Base the dark area of the leaves with a mix of Black plus Sap Green. Fill in the rest of the leaf and stem with a light green mix of Sap Green and Cadmium Lemon plus Raw Sienna and White. This mix is easy to vary: for a brighter green add more Sap Green; warmer and yellower, increase Raw Sienna; a mossy green, add White.

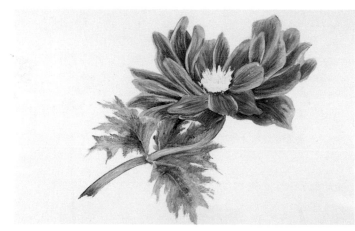

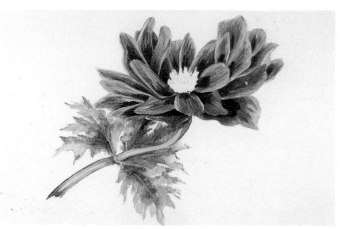

Using a no. 2 or 4 bright, begin blending each individual petal. Let the chisel edge marks show. Blend the leaf in the growth direction, one segment at a time. Soften the colors on the stem lengthwise.

Increase the shading at the petal's base with Winsor Violet plus Black. Lay highlight areas on the leaf with the light green leaf mix plus more White.

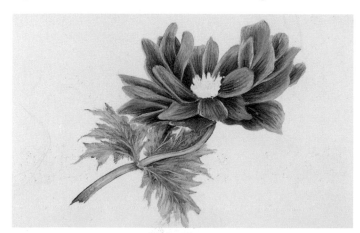

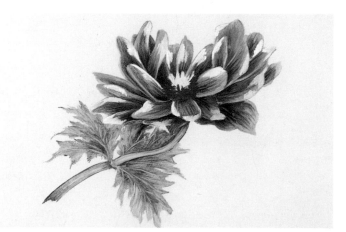

Make a mix of Alizarin Crimson plus Cadmium Lemon plus White. Use this to accent a few petal edges, softening the color into the petal. Softly blend the highlight color on the leaf segments into the basecoat. Add a vein structure with the light leaf mix.

Begin to add the highlight areas on the petals, using a no. 2 bright with light pressure. When you reload the brush, wipe it dry. Then, reload to keep the White clean.

Add Alizarin Crimson accents on a few petals, blend to soften. Fill in the base of the blossom's center with Alizarin Crimson, using a no. 2 bright. Accent the stem with Alizarin Crimson, brushing it on dry and blending into the greens. With a no. 0 round brush, add the stamens of Black plus Winsor Violet, pulling from the base. Dot the tips of some with the dirty brush plus White. Add the fine petal lines using thinned Winsor Violet and a no. 0 round brush held vertically, using light pressure.

PROJECT 3 *Angel's Trumpet*

There are ten species of plants in the genus Datura, of which Angel's Trumpet is one. The beautiful pendulous blooms may cover the small shrub making an impressive display. The species we'll paint is Datura cornigera. This spectacular peach-colored plant is from Peru, Colombia and Ecuador. 🐝

This photo of the species D. suaveolens, is characterized by pure White flowers. The shape is the same as that of the cream colored blossom. This reference gave me the design idea. Then I used a different photo for the color reference.

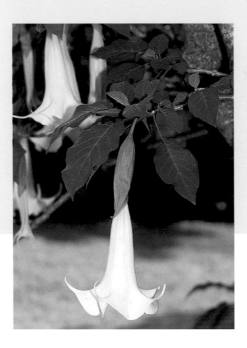

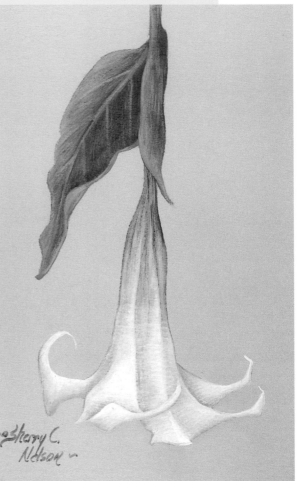

This pattern may be hand-traced or photocopied for personal use only. Enlarge at 167% to bring it up to full size.

🐝 Materials List 🐝

• *Brushes*
nos. 2, 4, 6 red sable brights no. 0 red sable round

• *Winsor & Newton Artists' Oils*
Ivory Black Titanium White Raw Sienna
Burnt Sienna Jaune Brilliant Sap Green

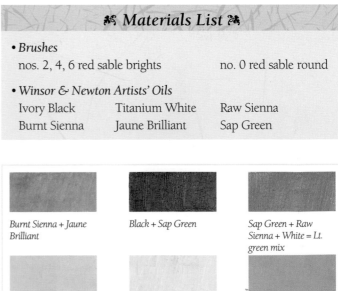

| Burnt Sienna + Jaune Brilliant | Black + Sap Green | Sap Green + Raw Sienna + White = Lt. green mix |
| Jaune Brilliant + White | Jaune Brilliant + more White | Lt. green mix + White |

Color Key
Use these swatches for mixing or when using other paint mediums.

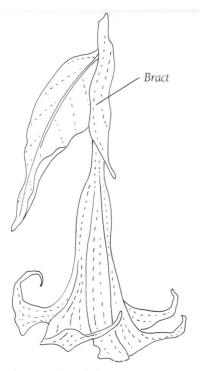

Bract

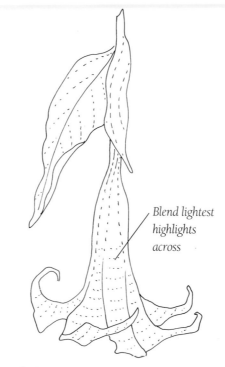

Blend lightest highlights across

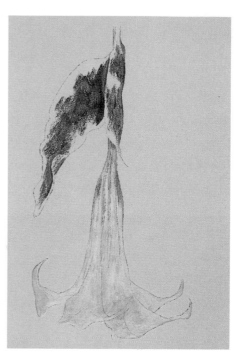

This blossom is blended in two stages. Brush the values together lengthwise first. Then, when highlighting, add texture to simulate the ribbing, in a cross direction.

Start by basing the blossom with Burnt Sienna plus Jaune Brilliant. Apply sparsely. Make a dark value mix of Black plus Sap Green, and base the areas as shown.

Using the chisel edge of the no. 6 bright, blend the green to connect with the Jaune Brilliant mix on the flower's trumpet. Make a mix of Sap Green plus Raw Sienna plus White, and base the remainder of the leaf areas. Place the first highlight on the flower with Jaune Brilliant plus White.

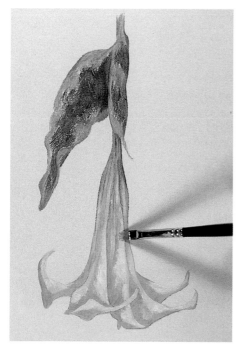

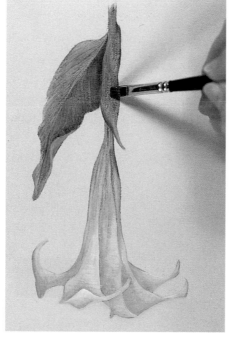

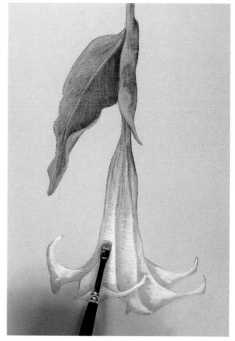

Blend the highlight on the flower lengthwise. When the values are connected, chop across the fattest part of each division to create ridges using a no. 4 bright. Blend the leaf and flower bract to connect the values.

Apply sparse White highlights on the flower. Begin blending with a no. 2 or 4 bright across the narrow sections to develop the faint ridges. Add White to the light green leaf value, and place highlights on the green areas.

Blend the highlights on the leaf and bract, using the light green value to set the vein structure. Finish blending the highlights on the flower.

After the painting has dried overnight, you may wish to add some pure White highlights in a few small areas. If you do this, reblend across the flower.

PROJECT 4 *Astilbe*

Astilbes are part of the larger family of Saxifrages, and to me are the most beautiful of all the related species. I love the graceful plumes and interesting shapes. They make wonderful additions to an arrangement, whether painted or straight from the garden.

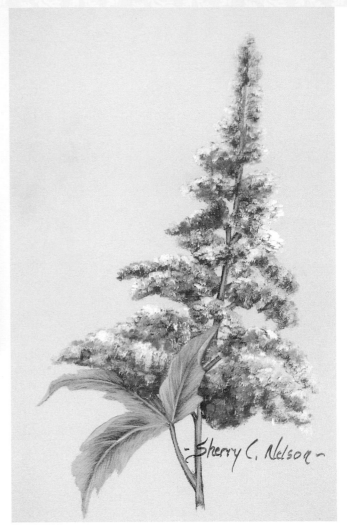

This reference shot was taken at a nursery, another often-overlooked place to obtain good photographs of some difficult-to-grow or otherwise unusual plant species. The colors are inspiring and the detail good. Both are essential when planning a painting of a particular species.

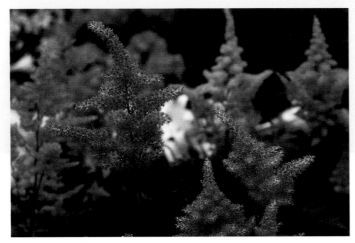

This pattern may be hand-traced or photocopied for personal use only. Enlarge at 143% to bring it up to full size.

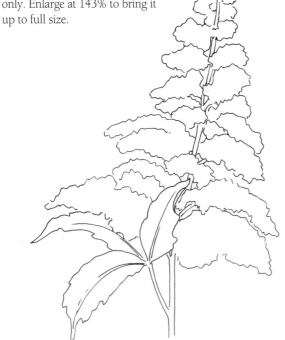

🐞 Materials List 🐞

• *Brushes*
nos. 2, 4, 6 red sable brights no. 0 red sable round

• *Winsor & Newton Artists' Oils*

Ivory Black	Titanium White	Raw Sienna
Sap Green	Cadmium Scarlet	Alizarin Crimson
Purple Madder Alizarin		Cadmium Lemon

Alizarin Crimson + Purple Madder Alizarin + Cad. Scarlet

Black + Sap Green

Sap Green + Cadmium Lemon + Raw Sienna + White = Lt. green mix

Alizarin Crimson + Cadmium Scarlet + White

Lt. green mix + White

Color Key
Use these swatches for mixing or when using other paint mediums.

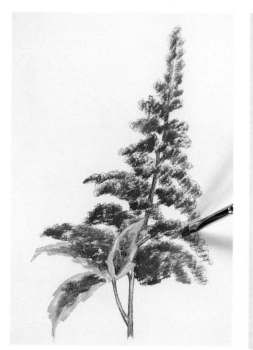

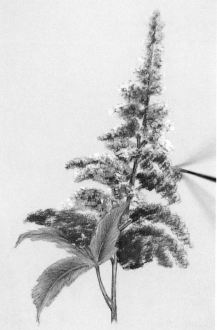

Use the corner of a dry no. 4 bright to pounce on a mixture of Alizarin Crimson plus Purple Madder Alizarin plus Cadmium Scarlet in the middle to bottom of each flower section. Use a dark value mix of Black plus Sap Green to lay in the dark stem and leaf areas. Fill in the remainder of green areas with a mix of Sap Green plus Cadmium Lemon (1:1) plus Raw Sienna plus White to lighten. Place the stems into the edges of the reddish basecolor. Additional layers of color will set them back.

Make a mix of Alizarin Crimson plus Cadmium Scarlet plus White. Load a bit onto the flattened tip of a round brush, and begin to pounce it on the top edges of each spike of the astilbe. Gradually, blend it over the dark base mix as the brush begins to run out of paint. Reload, start at the upper edges of an area and gradually work down as you lose paint off the brush. Repeat this process until you build sufficient light on each section. Change the amount of Cadmium Scarlet so the mix becomes rosier in places. Blend the leaves and stems with the growth direction.

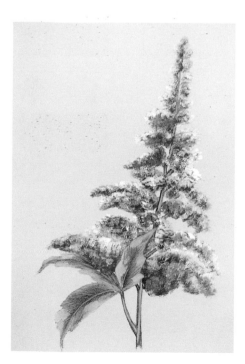

Continue to apply the light mix until all portions of the astilbe are covered. Then, load once again with additional White and add some stronger White highlights in the same manner. Mix the Lt. green mix with more White, and paint the leaf and stem highlights. Blend the leaf and stem highlights to soften. Add a vein structure in the leaves with the Lt. green mix. Retouch highlights on the astilbe if needed.

PROJECT 5 *Azalea*

Few shrubs rival those of the spectacular Rhododendron family, with their clusters of rainbow-hued blooms. The genus includes the azalea, which is closely related and produces brilliant flowers of flame, orange and scarlet, many of them rich with fragrance.

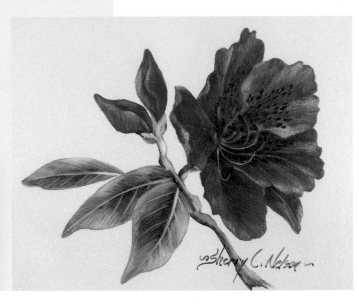

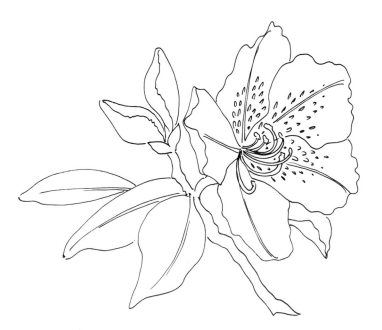

This lovely spray of azaleas was photographed in Japan, where they are extremely popular and thrive well. It's not unusual to see thousands of flowers massed on shrubs next to the busiest of city streets.

❧ Materials List ❧

- **Brushes:**
 nos. 2, 4, 6 red sable brights no. 0 red sable round

- **Winsor & Newton Artists' Oils:**

Ivory Black	Titanium White	Raw Sienna
Cadmium Lemon	Cadmium Scarlet	Alizarin Crimson
Sap Green	Cadmium Red	

Cadmium Red + Sap Green	Cadmium Red + Cadmium Lemon + White	Black + Sap Green
Sap Green + Raw Sienna + White = Lt. green mix	Cadmium Lemon + Sap Green + Raw Sienna	Alizarin Crimson + Black

Color Key
Use these swatches for mixing or when using other paint mediums.

This pattern may be hand-traced or photo-copied for personal use only. Enlarge at 143% to bring it up to full size.

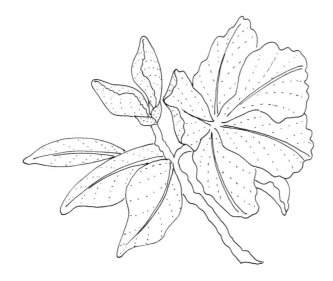

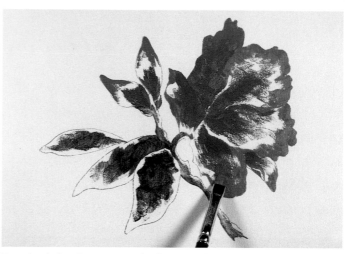

Note on the azalea's growth direction that the petals are fairly distinct though joined at the base. Each is blended to a central vein, much like a common pinnate leaf.

Base the dark value areas on the flower with a mixture of Cadmium Red plus a little Sap Green to dull the intensity. Lay in the light values around the petal edges and overlaps using Cadmium Scarlet. Now begin basing the remaining area with straight Cadmium Red. Lay in the dark value on the leaves and stems with a mixture of Black plus Sap Green.

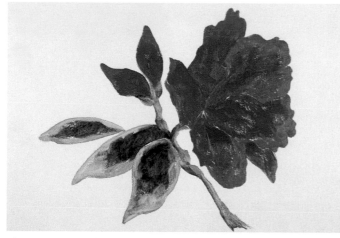

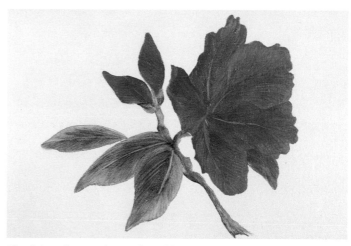

The remaining mid-value areas on the petals are based with Cadmium Red. The light value on the leaves and stems is based with a green mix of Sap Green plus Raw Sienna plus White.

Blend the colors on the petals and leaves with the growth direction. When the texture is established against the natural growth direction, it is difficult to obtain a realistic look.

Apply highlights on the petals with a mixture of Cadmium Red plus Cadmium Lemon plus White. Place the highlights on the leaves and stems with Cadmium Lemon plus Sap Green plus Raw Sienna. Blend the petal highlights using the chisel edge of the brush. Shade at the deepest part of the flower center with Alizarin Crimson plus Black. Add stamens with a light red value of Cadmium Red plus Cadmium Lemon plus a little White. Add dots on the ends of the stamens with Alizarin Crimson plus Black. Add a central vein to each petal with a little light value red mix. Blend the leaf highlights with the growth direction, and add a central vein structure with the Lt. green mix.

When the painting has dried, rehighlight with a mixture of Cadmium Red plus Cadmium Lemon plus White, if needed. Lay small amounts of the color in the areas with the strongest existing light, and blend softly into petals with a dry brush. Wet-on-dry highlights reduce surface texture and give a smoother glaze of light to the petals, increasing the impact.

PROJECT 6 *Begonia*

Begonias come from a large genus of more than 900 species, most of which grow in tropical and subtropical areas. They do well as houseplants, in pots and containers, and as lovely long-blooming bedding plants for the garden. Such lovely varieties as Kismet have color variations to tempt any painter. ❧

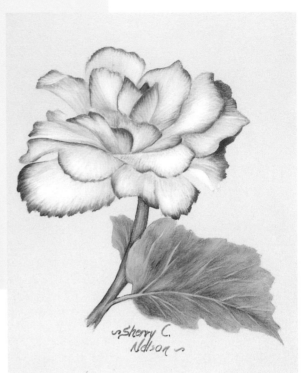

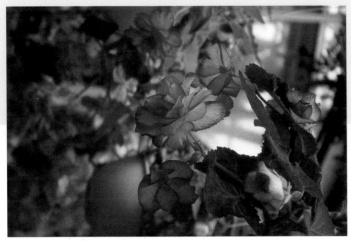

This photo reference was shot in a greenhouse, hence the low light. Wherever possible, use a tripod in situations such as this to ensure a good in-focus picture. Botanical gardens offer lots of flower photo opportunities for unusual species that might not be found in the backyard garden.

This pattern may be hand-traced or photocopied for personal use only. Enlarge at 118% to bring up to full size.

❧ Materials List ❧

- **Brushes:**
 nos. 2, 4, 6 red sable brights no. 0 red sable round

- **Winsor & Newton Artists' Oils**
 Ivory Black Titanium White Raw Sienna
 Cadmium Scarlet Cadmium Lemon Alizarin Crimson
 Sap Green

Raw Sienna + Cadmium Scarlet + more White

Raw Sienna + Cadmium Scarlet + a tad White

White + a little Cadmium Scarlet + Raw Sienna

Alizarin Crimson + White

Black + Sap Green

Sap Green + Raw Sienna + White = Lt. green mix

Lt. green mix + more White

Raw Sienna + Cadmium Lemon + White

Color Key
Use these swatches for mixing or when using other paint mediums.

This diagram shows the growth direction of each petal to help you as you blend.

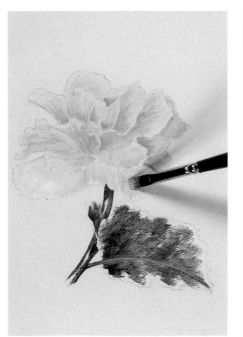

With Raw Sienna plus Cadmium Scarlet plus a bit of White, begin basing the dark value at the bottom of each petal. Lighten the mix with White and fill in the remaining petal. Base the dark areas of the leaf and stem with Black plus Sap Green.

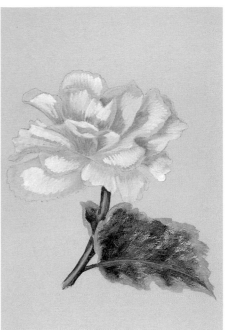

Blend the basecoat between values, following the growth direction indicated on the diagram. Then begin adding the highlight mix, which is the light value mix plus more White. Fill in the rest of the stem and leaf areas with a light value of Sap Green plus Raw Sienna plus White.

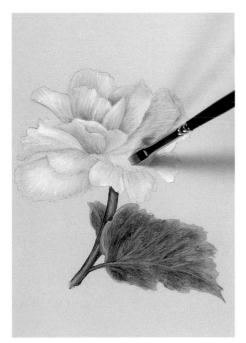

Blend between values on the green areas, as well as on the flower petals. When in doubt, check the direction on the diagram. Make the surface as smooth as you like. For a rougher look, hold the chisel edge more vertically; for a smooth surface, hold the brush flatter to the surface.

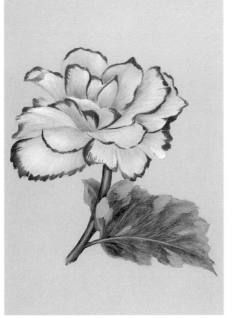

Apply the red edge with a no. 2 bright using Alizarin Crimson plus White. Add highlights to stems and leaf with the Lt. green mix plus White.

With a dry, clean no. 2 bright, begin connecting the edge of the dark pink to the petal basecoat. Don't pull into the petal too far; let most of the pink stay along the edges. As you blend, vary the width of the pink edge. Pay careful attention to the growth direction of

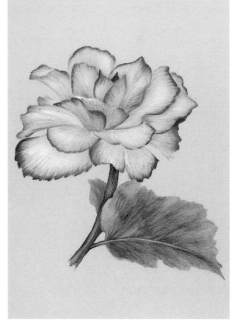

each petal. Soften the highlights on the leaf and stem, leaving a bit of texture if desired.

Finish the petal blending. Apply the vein structure in the leaf with the Lt. green mix. While still wet, add a little yellow accent with Raw Sienna plus Cadmium Lemon plus White to give additional spark to the blossom. You can rehighlight a few petals with White, or wait until the flower is dry and add additional light then.

PROJECT 7 *Bleeding Heart*

Bleeding hearts originally came from Japan and belong to a relatively small plant family that includes Dutchman's-breeches. *Dicentra spectabilis* grow in long arching sprays hung with rosy pink hearts and cut leaves. They are considered a beautiful part of an old-fashioned cottage garden and are a favorite of many gardeners. ❧

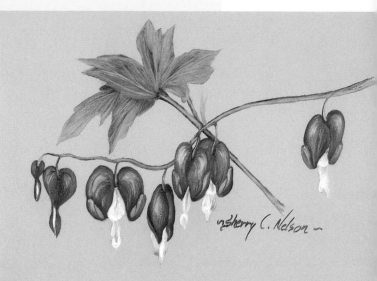

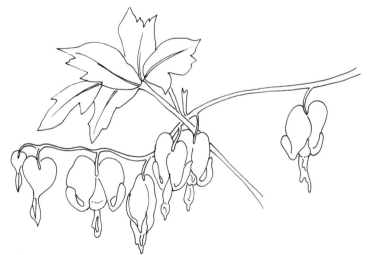

This reference shot was taken years ago with an inexpensive camera and even less expertise. Nonetheless, it is a helpful photo. You do not have to be a professional photographer to take pictures that will aid you in your painting efforts.

❧ Materials List ❧

- **Brushes:**
 nos. 0, 2, 4, 6 red sable brights no. 0 red sable round

- **Winsor & Newton Artists' Oils**
 Ivory Black Titanium White Raw Sienna
 Burnt Sienna Sap Green Alizarin Crimson
 Cadmium Red Cadmium Lemon
 Cadmium Yellow Pale

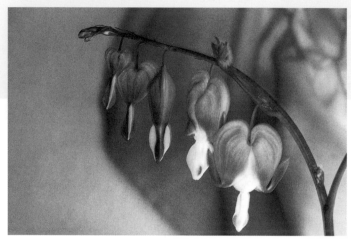

This pattern may be hand-traced or photocopied for personal use only. Enlarge at 167% to bring it up to full size.

Cadmium Red + Alizarin Crimson

Black + Sap Green

Sap Green + Cad. Lemon + Raw Sienna + White = Lt. green mix

Raw Sienna + White

Burnt Sienna + Sap Green

Cad. Yellow Pale + White

Lt. green mix + White

Color Key
Use these swatches for mixing or when using other paint mediums.

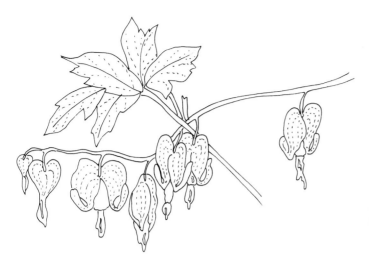

Use this diagram when blending, to understand the structure of both the flowers and the leaf.

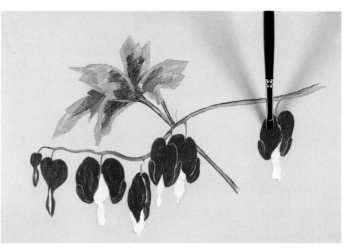

Base the red areas with Cadmium Red plus Alizarin Crimson. Base the White areas with a mix of Raw Sienna plus White plus a little Sap Green. Base the stem where flowers attach with Burnt Sienna and the rest of the stem and the dark value of the leaf with a mixture of Black plus Sap Green. Base the remaining leaf area with a light green mix of Sap Green plus Cadmium Lemon (1:1) plus a little Raw Sienna to control intensity and some White to lighten. It is helpful when basing adjacent areas with the same color to draw the design lines back into the wet paint with a stylus.

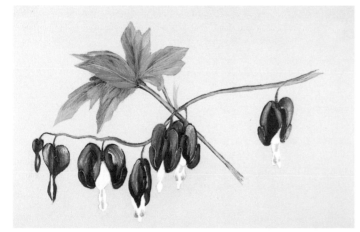

Lay on the flower highlights with a no. 2 bright and a mix of Cadmium Yellow Pale plus White. Deepen the stems into the flowers with Burnt Sienna plus Sap Green. Touch Cadmium Red and Cadmium Yellow Pale accents onto the White flower centers. Blend the leaf segments, following the growth direction. Soften between the values on the various stems as well. Add a little White to the Lt. green mix, and place the leaf highlights, and a line of light down the center of the stems.

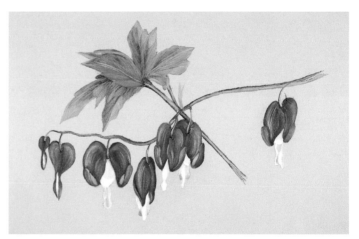

Blend the highlights on the flowers with a no. 2 bright, working carefully to keep the heart shape. Blend the pink accent on the flower centers, and highlight them with White. Add Lt. green mix or dirty-brush-plus-White highlights on the flower stems.

Add additional White highlights on the flower centers. Soften the highlights on the flower centers. Stipple a little additional White onto the flower centers with a no. 0 round brush to add texture. Blend the leaf highlights and refine blending so that the segments feel connected. Soften the last highlights on the flowers and add Burnt Sienna accents on the leaf. Give the leaf segments a more finished central vein structure with the light value leaf mix.

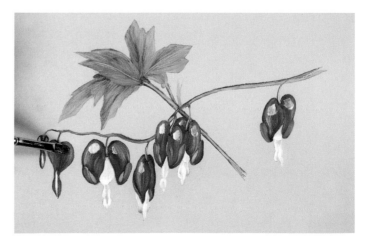

PROJECT 8 *Butterfly Bush*

The Buddleias are a small family of shrubs, originally from China, of which our butterfly bush is the best known. As the name suggests, many species of butterflies have a strong attraction for this flower. The colors vary from purple and lilacs to rich reds and pink, with the White variety being the most popular with the lovely winged creatures. ⚘

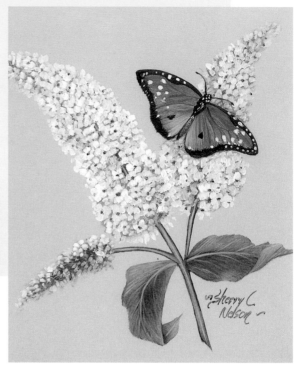

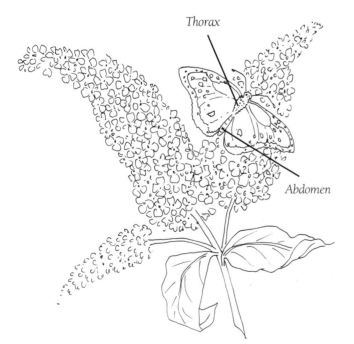

Here's the shot of the queen butterfly I used in the painting. The right hind wing is a bit tattered, but the great benefit of being a painter is you can fix it. Notice the wonderful detail. This sort of picture makes it easy to paint realistically.

🦋 Materials List 🦋

- **Brushes:**
 nos. 0, 2, 4, 6 red sable brights no. 0 red sable round

- **Winsor & Newton Artists' Oils**
 Ivory Black Titanium White Raw Sienna
 Burnt Sienna Raw Umber Cadmium Lemon
 Sap Green

Thorax

Abdomen

Raw Sienna + Sap Green | Sap Green + Black | Sap Green + Cadmium Lemon + Raw Sienna + White = Lt. green mix

White + Raw Sienna + Sap Green | White with Burnt Sienna | Lt. green mix + White

Raw Sienna + Burnt Sienna + White | Black + Raw Umber

Color Key
Use these swatches for mixing or when using other paint mediums.

This pattern may be hand-traced or photocopied for personal use only. Enlarge at 167% to bring it up to full size.

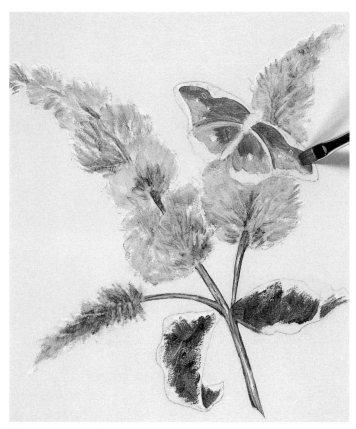

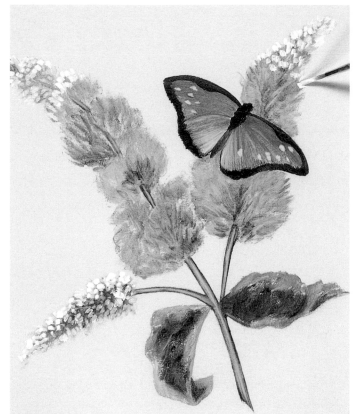

With a dark mix of Sap Green plus Black, base in the dark values on stems, leaves and at the base of the flower clusters. Base the remaining areas of flower clusters very sparsely with Raw Sienna plus Sap Green. Base the dark value on the butterfly with Burnt Sienna and the light value with Raw Sienna.

Begin to overlay the unopened buds on the cluster tips with White, using a no. 0 round brush. In the natural shadow areas, toward the bottoms of the tips, use White plus Raw Sienna plus Sap Green, a very pale mix. Fill in the remaining areas on the stems and leaves with a light value mix of Sap Green plus Cadmium Lemon (1:1) plus Raw Sienna to control intensity plus White to lighten. Blend between values on the butterfly, working with the natural pattern of the wings. Highlight the hind wings with Raw Sienna plus Burnt Sienna plus White. Base the wing edges with Black plus Raw Umber. Base the body with Burnt Sienna. Base the head with the Black and Raw Umber mix. If spots were entirely covered during blending, you can lift some out with a damp no. 0 bright or draw them back in with a stylus if you need a guide for placement.

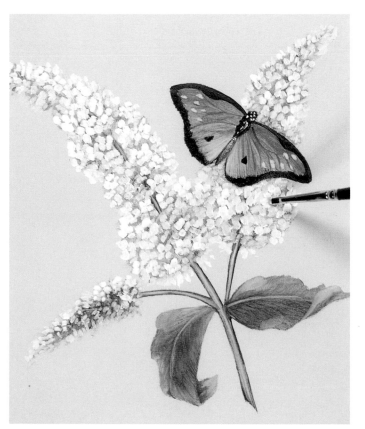

Now, using the White or the light green overstroke mix and a no. 0 bright, begin laying in the pattern of tiny opened blossoms on the clusters. Note that a good bit of background shows between blossoms. Do not cover it all. Make the blossoms a variety of shapes, and paint some at the bottom of the cluster with the darker values. Add additional White to the light value leaf mix, and lay on the leaves and stems highlights. Highlight on the butterfly's abdomen with Raw Sienna plus White with a no. 0 round. Add dark dots on the wing with Black, using a no. 0 round. Add light dots on thorax and head with White on a no. 0 round. Lay in faint section lines of Burnt Sienna on the wings using thinned paint on a no. 0 round.

Now add Burnt Sienna centers to connect sets of petals where appropriate. Blend the leaf values and central vein structures to smooth gradations with the Lt. green mix. And finally, add the White dots on the queen butterfly's wings, keeping in mind that the dots vary in size. Paint antennae with a round brush and slightly thinned Black.

PROJECT 9 *Calla Lily*

A member of the tropical family Araceae, the calla lily originated in Africa. In Cape Town, it grows in huge masses in wet pastures and along every ditch, so common as to be unappreciated. The trumpet shape has a graceful curvature that makes getting the strong lights and perfect value gradations an interesting painting challenge. 🖌️

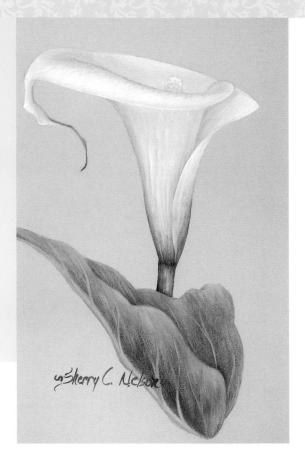

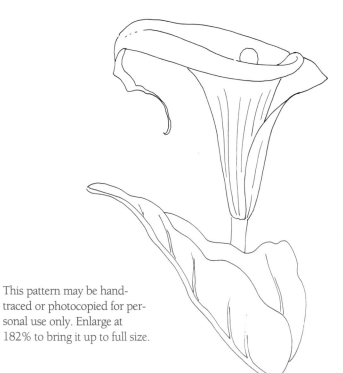

Good backup flower photos must be taken where you find these lilies. These perfect blooms were in a vase at a bed and breakfast at which I stayed. The shadows add an interesting painting dimension, and the beautiful vein structure is clearly illuminated by the light shining into the trumpet. The roll of the petal edge and the huge furled leaves give even more inspiration.

This pattern may be hand-traced or photocopied for personal use only. Enlarge at 182% to bring it up to full size.

🌿 Materials List 🌿

- **Brushes:**
 nos. 2, 4, 6, 8 red sable brights no. 0 red sable round

- **Winsor & Newton Artists' Oils**
 Ivory Black Titanium White Raw Sienna
 Raw Umber Burnt Sienna Sap Green
 Cadmium Yellow Cadmium Lemon
 Cadmium Yellow Pale

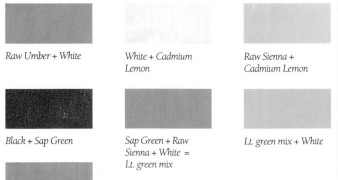

Raw Umber + White

White + Cadmium Lemon

Raw Sienna + Cadmium Lemon

Black + Sap Green

Sap Green + Raw Sienna + White = Lt. green mix

Lt. green mix + White

Cadmium Yellow + Cad. Yellow Pale

Color Key
Use these swatches for mixing or when using other paint mediums.

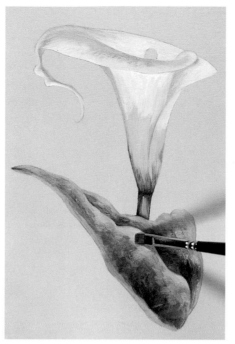

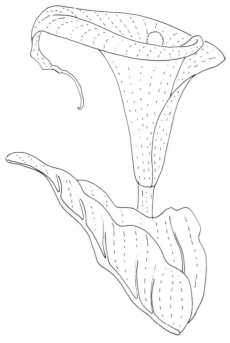

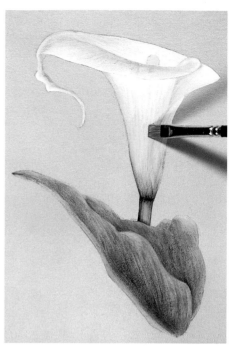

Here's a diagram of the growth direction to help you obtain the best form and contour as you paint.

Base the dark value in the flower with Raw Umber plus White. Lay in Black plus Sap Green on the trumpet. The yellowish mix on the trumpet is Raw Sienna plus Cadmium Lemon. Base the remainder of the flower with White plus Cadmium Lemon. The dark value on the leaf and stem is Black plus Sap Green. The light value green mix is Sap Green plus Raw Sienna plus White.

Blend almost entirely with the chisel of the brush, raising or lowering it to the surface to control texture and lines. I use the brush parallel to the growth direction indicated on the diagram, blending just where values meet. Work between the dark and light values in each area, following the veining and other growth indicators carefully.

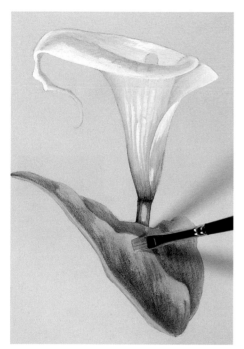

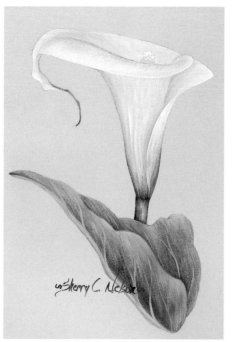

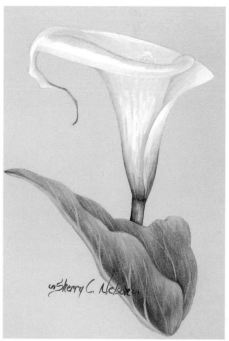

Now start adding highlights. Use White on the flower, and the Lt. green mix plus more White for the leaf and stem. Use small amounts of sparse paint on the brush, and apply with pressure.

Blend between values once again. Use the round brush to apply Burnt Sienna to the curled tip of the trumpet. Base the spadix with Cadmium Yellow plus Cadmium Yellow Pale by stippling on color with the tip of the round brush. Highlight the spadix tip with a bit of stippled White. Create veins on the large leaf with the light green value.

Allow the painting to dry overnight. Now place wet-on-dry White for the final highlights in various strong light locations on the flower. Use small amounts of paint. The flower has a real glow and a dimension that is not possible without those final lights.

PROJECT 10 *Camellia*

The camellias are beautiful ornamental shrubs, many originating in Japan and China. Camellia plants were introduced to Europe in the 1600s. The camellia blossoms are solid red, pink, white or variegated. ❧

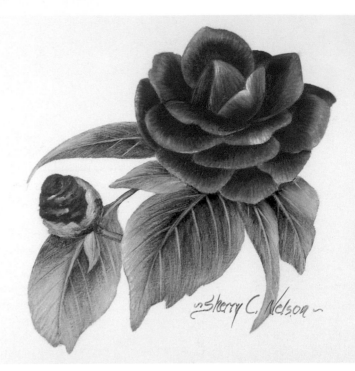

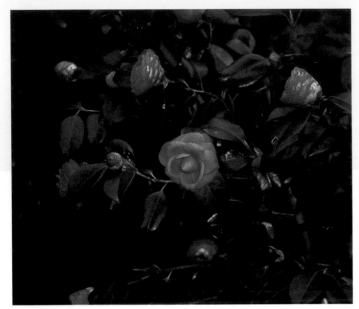

Camellias are unusual to find in many areas of this country, so the chance for good reference photos is not great. This shrub was photographed in Japan at a botanical garden.

❧ Materials List ❧

- **Brushes:**
 nos. 2, 4, 6 red sable brights no. 0 red sable round

- **Winsor & Newton Artists' Oils:**
 Ivory Black Titanium White Raw Sienna
 Sap Green Cadmium Red Alizarin Crimson
 Cadmium Lemon

 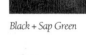 Alizarin Crimson + Cadmium Red

Cadmium Red + Raw Sienna + White

Black + Sap Green

 Sap Green + Cadmium Lemon + Raw Sienna + White

Alizarin Crimson + Sap Green

White + Alizarin Crimson + Raw Sienna = Flower highlight mix

 Sap Green + Raw Sienna + White

Flower highlight mix + White

Color Key
Use these swatches for mixing or when using other paint mediums.

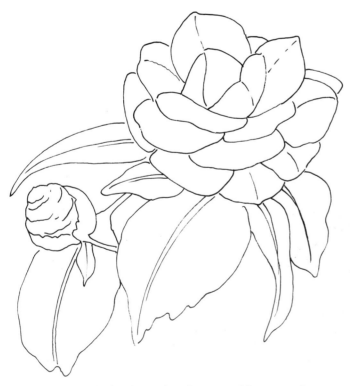

This pattern may be hand-traced or photocopied for personal use only. Enlarge at 125% to bring it up to full size.

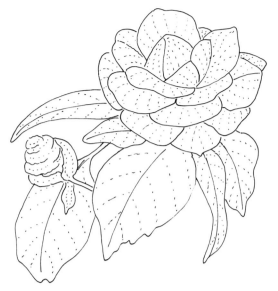

This diagram will help you with the interesting pattern of growth to be found in the camellia's petals. Both leaves and petals are quite firm and need to be blended smoothly and evenly.

Place the dark area value on the petals with a mix of Alizarin Crimson plus Cadmium Red. Use Cadmium Red plus Raw Sienna plus White for the light value. The dark value in the leaves, bracts and stem is Black plus Sap Green. The light leaf value is a mix of Sap Green plus Cadmium Lemon (1:1) with Raw Sienna added to cut the intensity and White to lighten.

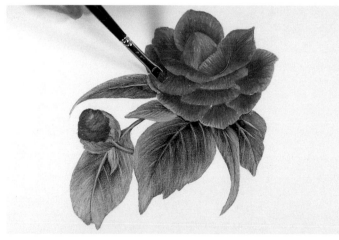

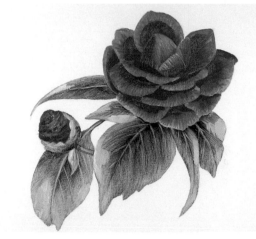

With a dry-wiped brush, begin blending. Check the diagram for growth direction. Use the no. 2 or 4 bright where petals are narrow. The direction of blend is across the petal, but blend the values in the leaves and stems with the growth.

Shade in the darkest petal areas with Alizarin Crimson. Add a little Sap Green to Alizarin Crimson to dull it, if needed. Lay some highlights on the green areas with Sap Green plus Raw Sienna plus White.

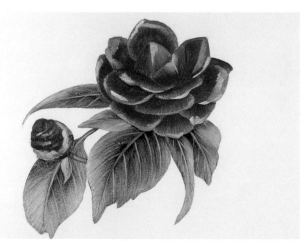

Blend the shading color with the growth direction in the same manner as you did the original values. Blend the highlight values into the green areas, and use the light green value for the vein structure. Add the final highlights on the flower petals with Alizarin Crimson plus Raw Sienna plus White. Use paint sparsely but apply with pressure to seat into petal and to lift out some of the underlying color.

You can see the highlights were carefully blended to retain nice shine, and in one or two petals additional light was added and then blended. As the flower dries, the reds may fade a bit. If you want more luster, accent with pure Cadmium Red and blend into petal. Usually such accent colors are best added into the middle value areas, so as not to disturb the strong lights or shadow areas.

PROJECT 11 *Canterbury Bells*

These little blossoms are part of the larger family of *Campanulaceae*, originating in Southern Europe. These blooms are from one of several species commonly called *Canterbury bells*, after the horse bells used by pilgrims visiting St. Thomas Becket's Canterbury Cathedral. 🌿

This wonderful scene of a thatched-roof cottage set in acres of bluebells was photographed at Kew Gardens in London. Below is a close-up of them for future bluebell paintings. Reference photos can be such wonderful memories.

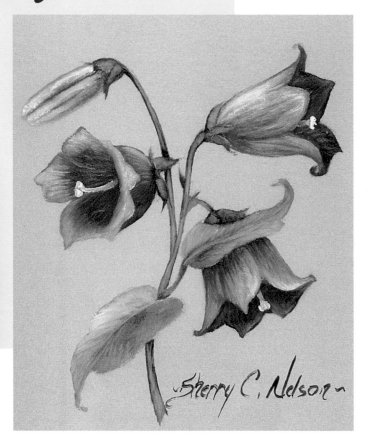

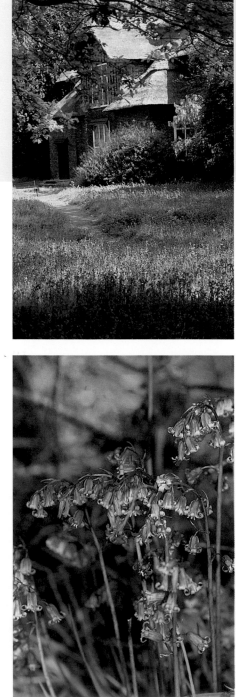

🌿 Materials List 🌿

- **Brushes**
 nos. 0, 2, 4 red sable brights no. 0 red sable round

- **Winsor & Newton Artists' Oils**
 Ivory Black Titanium White Raw Sienna
 Sap Green French Ultramarine
 Winsor Violet

Winsor Violet + French Ultramarine + Black = Purple mix

Purple mix + more French Ultramarine + White = Lt. purple mix

Black + Sap Green

Sap Green + Raw Sienna + White

White + Raw Sienna + tiny bit of Lt. purple mix

Color Key
Use these swatches for mixing or when using other paint mediums.

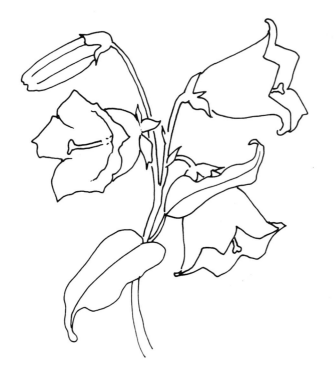

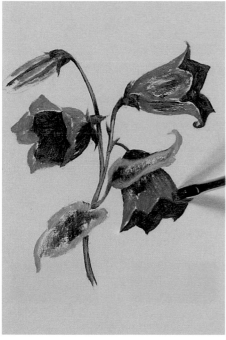

This pattern may be hand-traced or photocopied for personal use only. It is shown here full size.

Use this diagram to help you with the growth direction as you blend the blossoms and leaves.

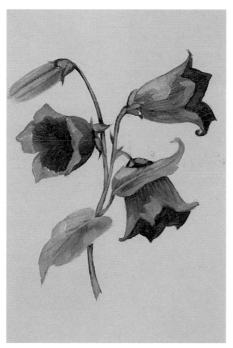

The dark value mix on the blossoms is Winsor Violet plus French Ultramarine plus just a bit of Black. The light value is the same mix plus a little more blue and some white to lighten the value. The dark value on the green leaves and stems is Black plus Sap Green. The light value green is made with Sap Green plus Raw Sienna plus White. Base all values sparsely. Let the values meet in irregular edges.

Blend the blossoms to connect the dark and light values. Follow the growth direction suggested on the diagram. Blend the leaves and stems, too, setting in a central vein line in the leaves with Lt. green mix. Add some more White to the Lt. green mix, and add highlights on leaves, stems and bracts. Place the highlights on blossoms with a no. 4 bright loaded with White with a little Raw Sienna added and a tiny bit of the Lt. purple mix.

Blend the highlights with the growth direction. On just a few petal tips, add White highlights with the no. 2 bright. Blend the leaf and stem highlights, and set in the final leaf vein with the Lt. green mix.

Blend the final highlight value, leaving some chisel edge brush streaks in the surface to mirror the growth direction and to create the petal divisions. Use a no. 0 round to place the center stamens. Shade at the stamens' base with a little Winsor Violet. Tip the stamens with just a bit of white.

PROJECT 12 *Carnation*

Carnations belong to the genus Dianthus and come in almost every color except blue and green. They are a wonderful addition to the garden and lovely as cut flowers in bouquets. In this painting, I used a White carnation as my model, but edged the petals with a delicate crimson. This color variation is called picotee. Adding the brilliant lacy edge is fun to do and gives the blossom real spark. 🌸

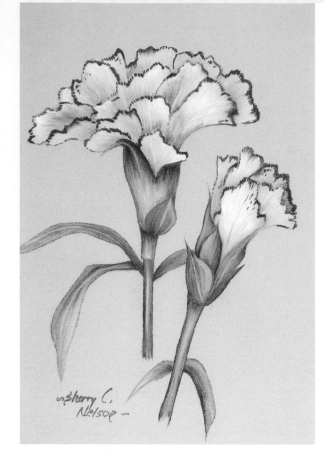

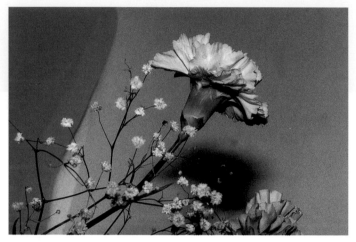

In this photo reference of a pink carnation, you can see the complex petal arrangement and the way the shadows form under the petal overlaps. We'll paint the flower as realistically as possible, but that still means simplifying to make the job manageable. We'll paint fewer petals and with less detail than on the real flower, but strive to keep the essence of the blossom.

❧ Materials List ❧

- **Brushes**
 nos. 2, 4 red sable brights no. 0 red sable round

- **Winsor & Newton Artists' Oils**
 Ivory Black Titanium White Raw Sienna
 Yellow Ochre Alizarin Crimson
 Raw Umber Oxide of Chromium
 Cadmium Yellow Pale

Yellow Ochre + White	Oxide of Chromium + Black + Aliz.Crimson	Raw Umber + Raw Sienna
Oxide of Chromium + Raw Sienna + Cad. Yellow Pale =Lt. green mix	Oxide of Chromium + Raw Sienna + Cad. Yellow Pale + White	Alizarin Crimson detail

Color Key
Use these swatches for mixing or when using other paint mediums.

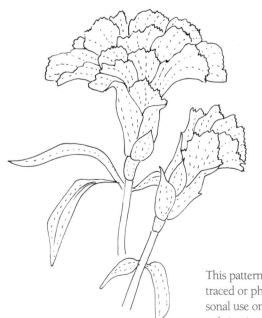

This pattern may be hand-traced or photocopied for personal use only. Enlarge at 154% to bring it up to full size.

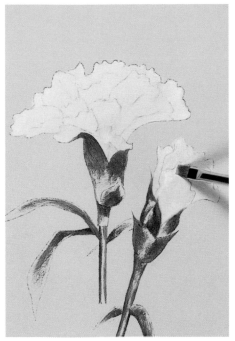

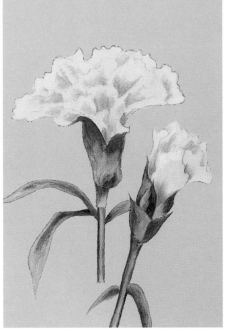

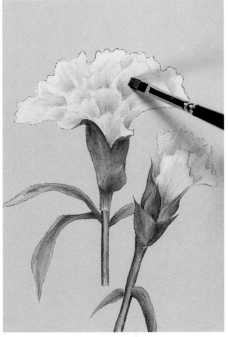

Basecoat the petals with a creamy mix of Yellow Ochre plus White. Leave a bit of graphite, so you don't lose the petal shapes. Apply the darks on the leaves, stems and calyx with Oxide of Chromium plus Black plus a little Alizarin Crimson to dull the mix.

Define the petal separations with shading color of Raw Umber plus Raw Sienna. Place in the triangle shapes, but not all along the overlapping petal's edge. Fill in the green areas with Oxide of Chromium plus Raw Sienna, plus Cadmium Yellow Pale.

Establish the growth direction on the petals using the chisel of the no. 2 or 4 bright, blending parallel to the growth direction. Blend between the dark and light values on leaves, stems and calyx with the chisel held parallel to the vein structure in each area.

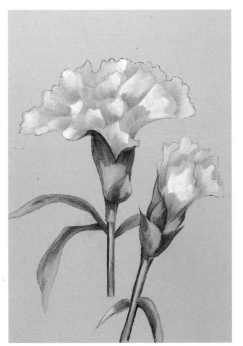

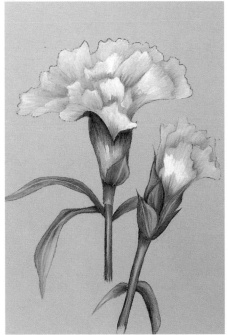

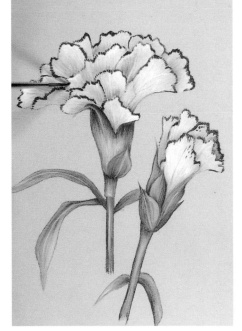

Add the highlights at the petal edges, on overlaps and in central areas of larger petals with the no. 2 bright, using sparse White. Apply with pressure to seat the color into the wet basecoat. Place the highlight in the green areas using the Lt. green mix plus White.

Blend the highlights with the brush held parallel to the growth direction of the petals and leaves.

The highlights readily show brush marks. This provides the best opportunity to create the life-like veining that makes your flower petals and leaves look realistic. Highlight again with White to define a few of the front petals.

Blend the strong highlights a little. Tip the round brush in Alizarin Crimson, and bring it to a fine point.

Apply the delicate edge along each petal. The Alizarin Crimson should vary in width and strength, fading along some of the zig-zaggy edges. Work with the growth direction of the petal, not outlining, using the point to make short fine lines.

When the painting is dry, add highlights in a few areas. On the frontmost petals, place a bit of sparse White on the inside edge of crimson and blend with the growth direction.

PROJECT 13 *Clematis*

The genus Clematis belongs to the larger family called Ranunculaceae, which includes delphiniums, columbine and anemones. The clematis are wonderful climbers and will become beautifully established over trellises and arbors. The beautiful purple variety is just one of 250 species of clematis to be found in gardens in the United States and Europe. 🌣

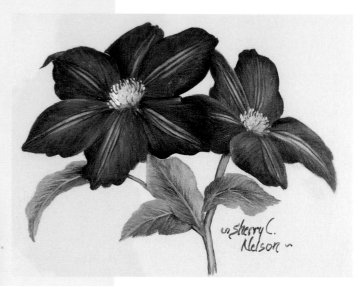

This photograph shows several purple clematis blossoms and centers, and gives a lot of information about the way the petals are formed. The interesting seed pod that remains after the petals have fallen would also be fun to use in a painting. When I am low on inspiration, all I have to do is start looking through my files of reference material to find many fresh ideas.

🌺 Materials List 🌺

- **Brushes:**
 nos. 2, 4, 6 red sable brights no. 0 red sable round

- **Winsor & Newton Artists' Oils:**
 Ivory Black Titanium White Raw Sienna
 Sap Green Alizarin Crimson Purple Madder Alizarin
 Winsor Violet Cadmium Yellow Pale

Winsor Violet + Purple Madder Alizarin

Black + Sap Green

Sap Green + Raw Sienna + White = Lt. green mix

Alizarin Crimson + Purple Madder Alizarin + White

Lt. green mix + White

Cad. Yellow Pale + White

Color Key
Use these swatches for mixing or when using other paint mediums.

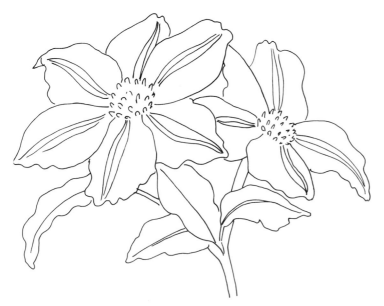

This pattern may be hand-traced or photocopied for personal use only. Enlarge at 133% to bring it up to full size.

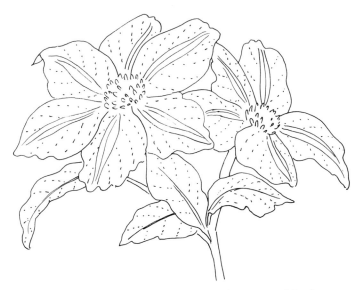

This diagram details the growth direction and structure of the flower and leaf. When blending the petals, watch the angle at which you hold the brush. The right direction is essential for the form and shape to be realistic.

Base the dark values in the top flower using a mix of Winsor Violet plus Purple Madder Alizarin. Base the dark areas in the underneath blossom with Purple Madder Alizarin. Lay in the dark values in leaves and stems with Black plus Sap Green. Keep the paint sparse for more control over colors.

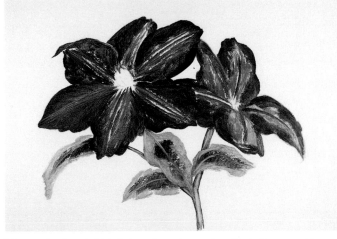

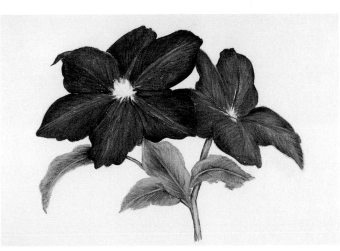

Now make the pinkish light value mix used on both flowers with Alizarin Crimson plus Purple Madder Alizarin plus a little White. Fill in the remaining areas of leaves and stems with Sap Green plus Raw Sienna plus White.

Begin blending the basecoat values. Here's where moving the brush in the same direction as the growth becomes essential. You should use the chisel edge rather than the flat to control the colors and prevent overblending. Notice how the central veins are placed in the star shape typical of the clematis, while the sides of each petal blend inward to the main vein much like the vein structure on many leaves. Blend leaves and stems where the values meet, establishing form.

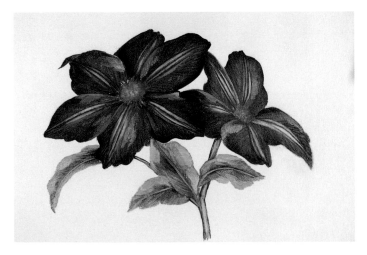

Dampen a no. 6 bright with odorless thinner, and blot on a paper towel. Then use it to lift out a little paint to form the central veins in each petal. Add highlights with the petals' light value base mix plus White. Fill in the flower center with Raw Sienna. Place highlights on leaves and stems with Sap Green plus Raw Sienna plus White.

Finally, pull a few lines of Raw Sienna from the flower's center. Then do a few more with Cadmium Yellow Pale plus White. Dot in some pollen detail with the round brush using Cadmium Yellow Pale. Soften the leaf and stem highlights into the basecoat and add a center vein structure on the leaves with the Lt. green mix. Soften the highlights on the flower petals, giving enough division between petals to show separation.

PROJECT 14 *Columbine*

Aquilegias have been cultivated for centuries in England; Shakespeare and Chaucer included them in their writings. The columbine is the state flower of Colorado, and the genus is part of the larger family Ranunculaceae, making them a relataive to the anemones, larkspurs and delphiniums. ❧

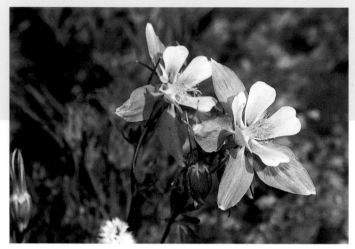

This photo has a workable arrangement of the two blossoms and shows nice detail. Once you've tried your hand at the single flower, you could use this shot to create other pleasing studies.

This pattern may be hand-traced or photocopied for personal use only. Enlarge at 167% to bring it up to full size.

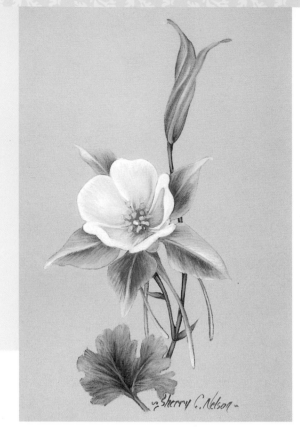

🐝 Materials List 🐝

- **Brushes**
 nos. 2, 4, 6 red sable brights no. 0 red sable round

- **Winsor & Newton Artists' Oils**
Ivory Black	Titanium White	Raw Sienna
Sap Green	Cadmium Lemon	Cadmium Yellow
Purple Madder Alizarin		French Ultramarine

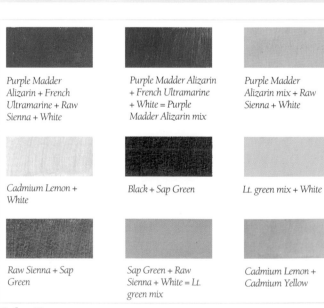

Purple Madder Alizarin + French Ultramarine + Raw Sienna + White

Purple Madder Alizarin + French Ultramarine + White = Purple Madder Alizarin mix

Purple Madder Alizarin mix + Raw Sienna + White

Cadmium Lemon + White

Black + Sap Green

Lt. green mix + White

Raw Sienna + Sap Green

Sap Green + Raw Sienna + White = Lt. green mix

Cadmium Lemon + Cadmium Yellow

Color Key

Use these swatches for mixing or when using other paint mediums.

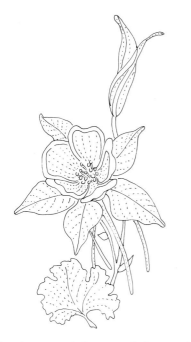

Use this diagram to help you with the growth direction on both flowers and leaf.

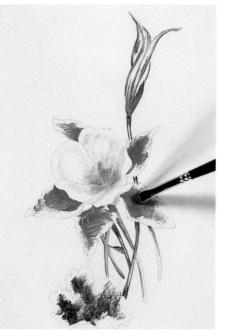

Base the dark value of the sepals with Purple Madder Alizarin plus French Ultramarine plus Raw Sienna plus White to lighten. Fuzz in the same mix to the base of the petals. The dark value on the leaf, bud and stem is Black plus Sap Green.

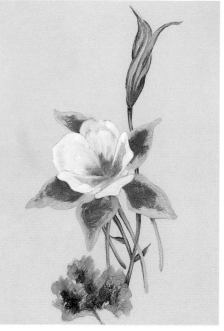

Add a little more White and Raw Sienna to the Purple Madder Alizarin mix, and base in the light value on the sepals. Base the remaining petal areas with Cadmium Lemon plus White. Block in the light value on the leaves with Sap Green plus Raw Sienna plus White.

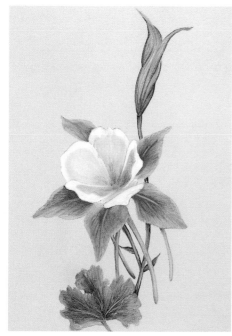

Blend to connect values on the sepals, following the growth direction. Blend the values on the petals, but keep the dark confined to the "hollow" of the petal, leaving the edge of the petal the light value base mix. Blend between dark and light values on the leaves, bud and stems.

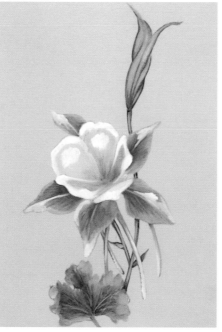

Highlight with White on the sepals and spurs, and with White plus a bit of Cadmium Lemon on the edges of the petals. Add White to the light value leaf mix, and use it to highlight the leaf, bud and stem.

Soften the highlights. Add White veining on the sepals. Add veining on the leaf with the Lt. green mix, and add a Purple Madder Alizarin mix accent or two. Soften the highlights on the bud, and then accent with the Purple Madder Alizarin mix.

If the growth direction lines seem too harsh, lower the brush angle.

Use a mix of Purple Madder Alizarin plus French Ultramarine plus White for accent on either side of the sepal center veins. Pull a few lines from the flower center with Sap Green plus Cadmium Yellow. Then add detail dots with Cadmium Lemon plus Cadmium Yellow.

PROJECT 15 *Dahlia*

Dahlias are members of the wide-ranging and varied family of Compositae. Their size and many colors are rivaled only by the chrysanthemums in that family. Dahlias are not difficult to paint, since their basic structure is still that of a simple ray, with a petal growth direction that follows the petal shape. 🌿

This lovely pure yellow dahlia was the inspiration for this painting, but then I saw a photo in a garden book showing a tipped variety that seemed more interesting. The wonderful thing about a good photo is you can use what you want and pull ideas from other sources.

This pattern may be hand-traced or photocopied for personal use only. Enlarge at 143% to bring it up to full size.

🌿 Materials List 🌿

- **Brushes**
 nos. 2, 4 red sable brights

- **Winsor & Newton Artists' Oils**

Ivory Black	Burnt Sienna	Cadmium Yellow
Titanium White	Sap Green	Cadmium Scarlet
Raw Sienna	Cadmium Lemon	

Raw Sienna + Cadmium Yellow

Cadmium Lemon + Cadmium Yellow

Burnt Sienna + Cadmium Scarlet

Sap Green + Black

Sap Green + Raw Sienna + White = Lt. green mix

Cadmium Lemon + White

Dirty brush + White

Color Key
Use these swatches for mixing or when using other paint mediums.

The growth direction for the dahlia is very easy to follow. Just remember to blend each petal along the outer edge and a bit straighter down the middle for the perfect form.

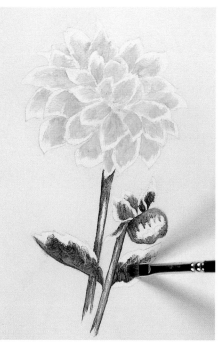

Lay in the dark value on all petals with a mixture of Raw Sienna plus Cadmium Yellow. Lay in the dark values on leaves, stem and bud with Sap Green plus Black to create a deep forest green.

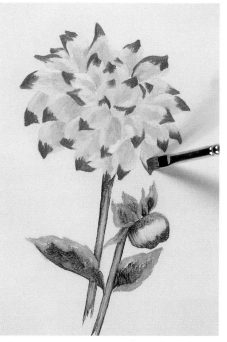

Fill in the remaining petal area with a light value mix of Cadmium Lemon plus Cadmium Yellow. Add tips on each petal with Burnt Sienna plus Cadmium Scarlet. Base in the light values on the leaves and stem with Sap Green plus Raw Sienna plus White. Shade the bud's bottom with a little Burnt Sienna to brown the green base color. Fill in the central area of the bud with the light value yellow.

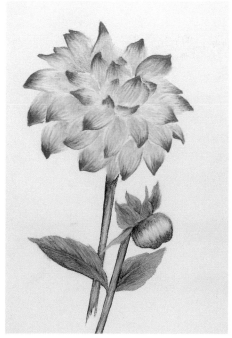

Blend the yellows together with the growth direction on each petal using a no. 2 or 4 bright. Then connect the rusty tip color by blending where it meets the yellow, using a small bright brush. Blend the bud connecting the bottom color and the greens with the yellow central area. Leave some surface lines to help indicate form. Blend the leaf and stem values with the growth direction.

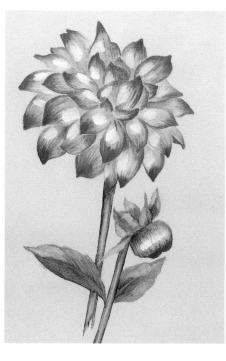

With initial blending complete, you can tell if the petal tips need stronger color. If so, add more of the rusty mix. Highlight the bud with Cadmium Lemon plus White, and add a bit more Burnt Sienna to the bottom. The central petals are highlighted with Cadmium Lemon plus White. Use the Lt. green mix plus more White for highlighting the leaves and stems.

Notice how the yellow highlights on the petals provide a spark. Add more Cadmium Lemon plus White on a few petals if needed. Add stamens of Cadmium Lemon in between the centermost petals. Blend the bud colors with the growth direction. Add a few lines of the dark green mix to define the bud's shape.

PROJECT 16 *Daisies*

Daisies belong to the wonderful world of Compositae, one of the largest flower families. More than a tenth of the world's flowers belong to this collection of ray-like flowers. They are structurally very easy to understand and paint. Daisies are such lighthearted blossoms, making them fun to paint in and on most anything. Chrysanthemums, dahlias, asters, sunflowers, gaillardia and gazanias are all members of this diverse and paintable family. 🌿

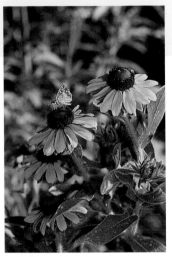

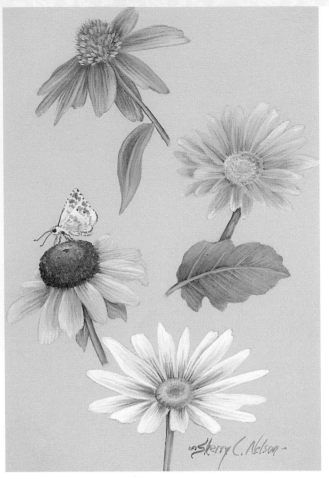

This picture of coneflowers was taken long ago in my grandmother's garden. Since the ray-like structure makes painting very quick and easy, be sure to get reference photographs that have lots of flowers, buds and even an occasional butterfly.

CONEFLOWER

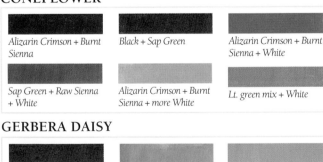

Alizarin Crimson + Burnt Sienna	Black + Sap Green	Alizarin Crimson + Burnt Sienna + White
Sap Green + Raw Sienna + White	Alizarin Crimson + Burnt Sienna + more White	Lt. green mix + White

GERBERA DAISY

Sap Green + Raw Sienna + White	Cad. Scarlet + Raw Sienna + White	Sap Green + Cad. Yellow Pale + White
Black +Sap Green	Lt. green mix + White	

CHECKERED SKIPPER BUTTERFLY

Raw Sienna + Raw Umber + White	Burnt Sienna + Raw Sienna + Raw Umber

🌿 Materials List 🌿

- **Brushes**
 nos. 2, 4, 6 red sable brights no. 0 red sable round

- **Winsor & Newton Artists' Oils :**

Ivory Black	Titanium White	Raw Sienna
Burnt Sienna	Raw Umber	Sap Green
Alizarin Crimson	Cadmium Scarlet	Cadmium Lemon
Cadmium Yellow Pale		Cadmium Yellow

BLACK-EYED SUSAN

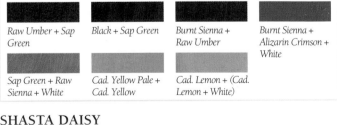

Raw Umber + Sap Green	Black + Sap Green	Burnt Sienna + Raw Umber	Burnt Sienna + Alizarin Crimson + White
Sap Green + Raw Sienna + White	Cad. Yellow Pale + Cad. Yellow	Cad. Lemon + (Cad. Lemon + White)	

SHASTA DAISY

Raw Umber + Sap Green	Black + Sap Green	Raw Sienna + Sap Green + Raw Umber
Sap Green + Raw Sienna + White	Lt. green mix + White	

Color Keys

Use these swatches for mixing or when using other paint mediums.

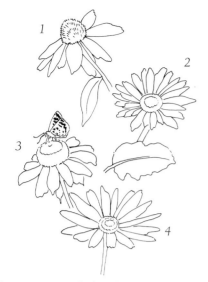

This pattern may be hand-traced or photocopied for personal use only. Enlarge at 270% to bring it up to full size.

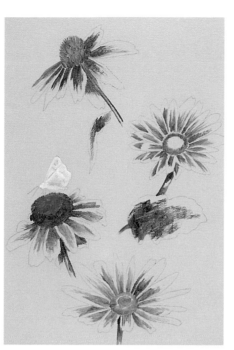

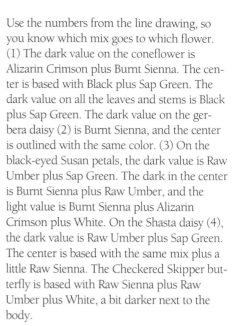

Use the numbers from the line drawing, so you know which mix goes to which flower. (1) The dark value on the coneflower is Alizarin Crimson plus Burnt Sienna. The center is based with Black plus Sap Green. The dark value on all the leaves and stems is Black plus Sap Green. The dark value on the gerbera daisy (2) is Burnt Sienna, and the center is outlined with the same color. (3) On the black-eyed Susan petals, the dark value is Raw Umber plus Sap Green. The dark in the center is Burnt Sienna plus Raw Umber, and the light value is Burnt Sienna plus Alizarin Crimson plus White. On the Shasta daisy (4), the dark value is Raw Umber plus Sap Green. The center is based with the same mix plus a little Raw Sienna. The Checkered Skipper butterfly is based with Raw Sienna plus Raw Umber plus White, a bit darker next to the body.

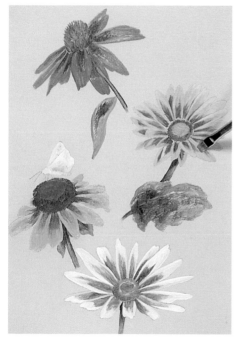

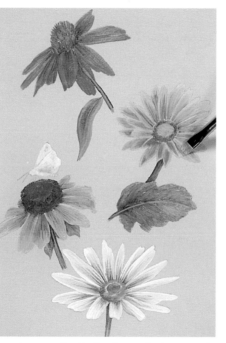

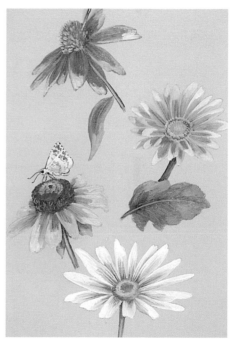

Lay in the light values: (1) Alizarin Crimson plus Burnt Sienna plus White. (2) Cadmium Scarlet plus Raw Sienna plus White, and Cadmium Yellow Pale plus Sap Green plus White to fill in the center. (3) Cadmium Yellow Pale plus Cadmium Yellow; (4) White for the Shasta's light value; and highlight the butterfly's forewing with White. The light value on all leaves and stems is a mixture of Sap Green plus Raw Sienna plus White.

Use the no. 4 bright for the petals, leaves and stems, begin blending with the chisel, where the values meet. Leave the dark stronger at the center of the petal for shading. Don't overwork. If an area gets ridged or streaky, lower the angle of the brush.

Lay on the highlights: (1) Use White on the petal tips, letting it get a little dirty as you pick up basecoat during the applications. Detail the Cadmium Yellow lines in the center with the no. 0 round. (2) Highlight with Cadmium Scarlet plus Raw Sienna plus White mix with more White added for a lighter value. Stipple Cadmium Yellow dots into the center with a round brush. (3) Highlight with Cadmium Lemon and Cadmium Lemon plus

White. Stipple a little Cadmium Yellow on the center edges and a bit of a pinkish mix on the center top. (4) Highlight with White. Stipple on Cadmium Yellow center dots with a round brush.

Detail the Checkered Skipper with a mix of Burnt Sienna plus Raw Sienna plus Raw Umber, extended with odorless thinner and applied with the no. 0 round. Use the Lt. green mix plus more White to highlight the leaves and stems.

Blend the highlights in the flower petals. For contrast, rehighlight with lighter value mixes. Finalize the blending in the leaves and stems. Use the Lt. green mix to add a central vein.

PROJECT 17 *Delphinium*

Dephiniums belong to the same family as clematis, anemones and larkspurs. This lovely garden flower produces huge spikes of blooms that come in the richest purples and blues to the palest of lavenders. Small amounts of paint, especially at the basecoat stage will help you stay in control of these flowers. You'll find they are quite simple and can be painted quickly.

Here's the reference photo used for this study. It was very helpful having the buds, two different flower colors and some flowers just beginning to open.

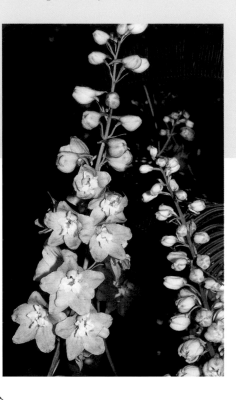

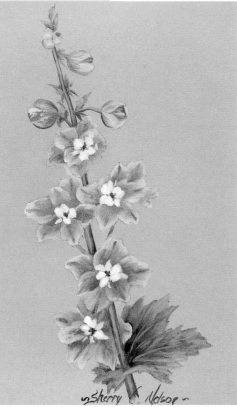

This pattern may be hand-traced or photocopied for personal use only. Enlarge at 167% to bring it up to full size.

✿ Materials List ✿

- **Brushes:**
 nos. 0, 2, 4 red sable brights no. 0 red sable round

- **Winsor & Newton Artists' Oils**
 Ivory Black Titanium White Raw Sienna
 Sap Green French Ultramarine
 Cadmium Lemon Winsor Violet

Winsor Violet + French Ultramarine + Raw Sienna + White	*Winsor Violet + French Ultramarine + Raw Sienna*	*Sap Green + Cadmium Lemon + Raw Sienna + White = Lt. green mix*
Raw Sienna + White	*Lt. green mix + White*	*Black + Sap Green*
Cadmium Lemon + White		

Color Key
Use these swatches for mixing or when using other paint mediums.

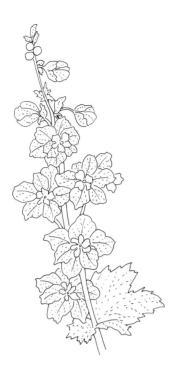

This diagram shows the growth direction of the blossoms as well as the stem and leaf. Be sure to check each section before blending.

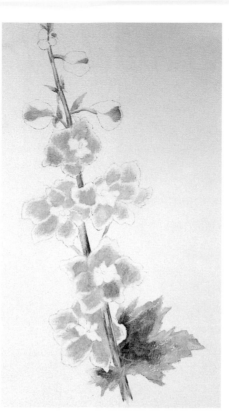

Base the dark value of the lavender petals with a mix of Winsor Violet plus French Ultramarine (1:1) plus Raw Sienna to decrease intensity and White to lighten. Keep the paint sparse and use small brushes to keep track of each little petal. Base the dark value of the leaf and stem with Black plus Sap Green. Base the remaining light green areas with Sap Green plus Cadmium Lemon (1:1) plus Raw Sienna to dull intensity and White to lighten.

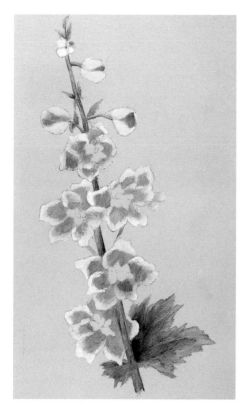

Add the light value around all petal edges with a bit of the dark value mix plus White plus Raw Sienna. Blend the leaf in the growth direction indicated, using the chisel edge to obtain a little texture. Too much? Lower the brush angle, but still use the chisel.

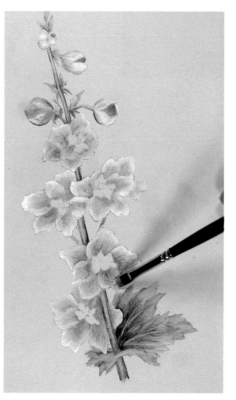

Using a dry, clean no. 4 bright, blend each petal following the natural shape. Shade around the buds with a little of the dark green mix. Then, add a little White to the Lt. green mix and use it to place highlights on leaf and stem. Base the tiny center petals with a no. 2 bright loaded with Cadmium Lemon plus White. Then, overlay smaller strokes of White. Add a dot of Sap Green plus Black to anchor the small strokes at the center. Make a mix of Winsor Violet plus French Ultramarine plus Raw Sienna for the accent color on the largest petals. Pull a line of this mix down the center vein of each petal, blending slightly to soften.

PROJECT 18 *Dogwood Blossoms*

Masses of flowering dogwood, which bloom to perfection in early spring in the eastern United States, make an unforgettable picture. *Cornus florida*, the species painted here, is the state flower of Virginia, and belongs to the larger family Cornaceae. Besides being beautiful, dogwoods are the favored nesting tree of the tufted titmouse, and I hardly ever think of one without the other.

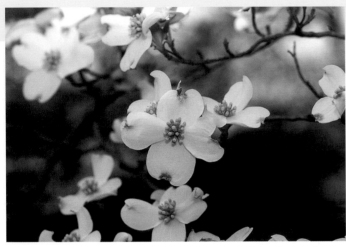

The detail needed to add realism to your painting of this flower shows up exceptionally well here. From the growth direction of the bracts to the detail of the center, it's all there to use as reference.

❧ Materials List ❧

- **Brushes**
 nos. 2, 4, 6 red sable brights no. 0 red sable round

- **Winsor & Newton Artists' Oils**
 Ivory Black Titanium White Raw Sienna
 Raw Umber Alizarin Crimson Sap Green

White + Raw Sienna + Sap Green | Dirty brush + White | Raw Sienna + Raw Umber

Black + Sap Green | Sap Green + Raw Sienna + White | Raw Umber + Alizarin Crimson

Color Key
Use these swatches for mixing or when using other paint mediums.

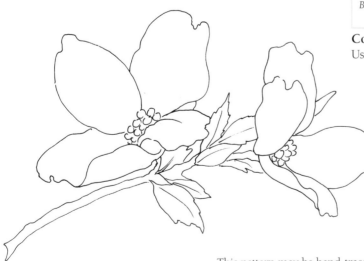

This pattern may be hand-traced or photo-copied for personal use only. Enlarge at 143% to bring it up to full size.

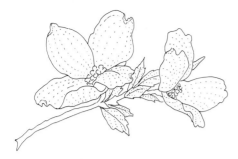

This diagram shows you the growth direction of the bracts and leaf. Check it as you begin to blend each area.

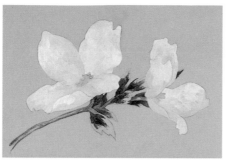

The dark value of the bracts is a pale mix of White plus Raw Sienna plus Sap Green. The light value is White picked up on the dirty brush. The leaves dark value is Black plus Sap Green. The dark value of the stem is Raw Sienna plus Raw Umber. Apply the basecoat sparsely for better control over detail later.

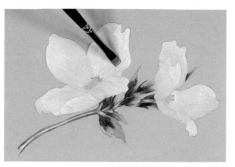

Begin blending the values you laid on the bracts with the growth direction, using a no. 4 or 6 bright. Add White as the light value on the stem, and a light mix of Sap Green plus Raw Sienna plus White for the remaining green areas on the leaves.

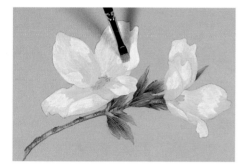

Blend the leaves with a dry chisel. Make a slightly lighter green mix by adding White to the leaf basecoat. Use this mix to vein the leaves and add a little light highlight to leaf tips. Blend the branch lengthwise. Detail the branch with a bit of Raw Umber. Place strong highlights on the bracts with pure White, using sparse paint and plenty of pressure.

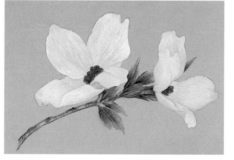

Blend the White highlights, following the growth carefully to shape petals correctly. Base the centers with the dark green mix.

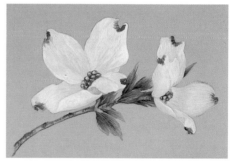

Detail the tips of the bracts with Raw Umber plus Alizarin Crimson, applied with a round brush. Highlight each center section with Sap Green plus White on the round brush. Add a little accent with Raw Umber plus Alizarin Crimson.

Blend the inner edge of the reddish tip on each bract, using a small chisel and blending with the growth, letting a little color streak in.

Let the painting dry overnight. Add wet-on-dry highlights with pure White. The leaves may be rehighlighted with the light value green mix. Blend the final highlights into bracts and leaves, rubbing the edges of paint with cheesecloth or paper towel if the gradations are not soft enough. Wet-on-dry highlights are no risk; if you don't like what you've added, remove it.

PROJECT 19 *Forget-Me-Nots*

The forget-me-not, much-loved and early-blooming spring flower of the genus *Myosotis*, is widely distributed around the world. They have been cultivated in gardens for many years, and one odd name for them from the Old English is mouse-ear. A tiny cluster fits on almost any decorative piece, paints quickly and has a particular charm that you'll find delightful. 🌿

This incredibly sharp photo reference gives you as much information as you need to put on a half-inch (1 cm) blossom. Notice the delicate centers and the interesting white "divider" that bumps up where the base of the petals join. This kind of detail is invaluable to add realism to your work.

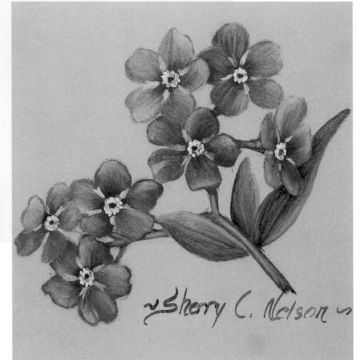

~Sherry C. Nelson~

🌿 Materials List 🌿

- **Brushes:**
 nos. 0, 2, 4, red sable brights no. 0 red sable round

- **Winsor & Newton Artists' Oils**
 Titanium White Ivory Black French Ultramarine
 Raw Umber Sap Green
 Cadmium Yellow Pale

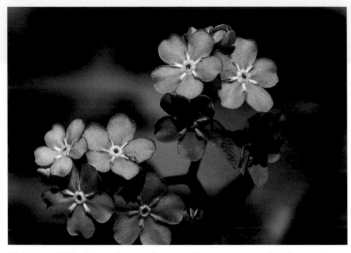

This pattern may be hand-traced or photocopied for personal use only. It is shown here full size.

French Ultramarine + Black + White = Blue mix

Blue mix + White = Blue mix II

Blue mix II + White

Black + Sap Green

Black + French Ultramarine

Dirty Brush + White + French Ultramarine

Cad. Yellow Pale with Raw Umber center

Color Key
Use these swatches for mixing or when using other paint mediums.

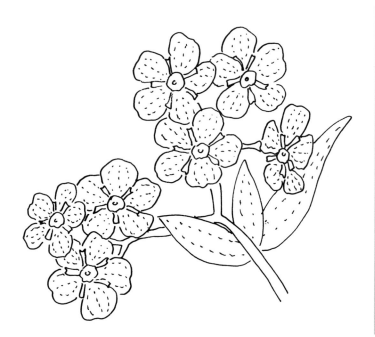

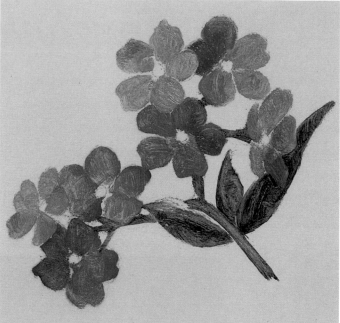

This diagram will help with the all-important growth direction as you begin to blend the individual petals.

Make three dark to light values using French Ultramarine. The darkest mix will have more Black than White, and the lightest, more White. The flowers at the back of the cluster and those underneath other blossoms are based with the darkest mix. Base the petals on top with the lightest value. Base the rest with a medium blue value. Base the leaves and stem areas with a dark green value made with Black plus Sap Green.

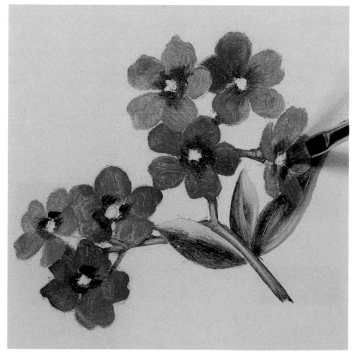

Add a little more Black to the dark value blue mix and shade at the base of the petals, applying color with the no. 2 bright. Use a mixture of French Ultramarine plus White for the light value of the leaves and for a light strip down the center of the stems.

Blend the edges of the dark mix on each petal. Use the Blue mix II to place highlights on the petals. Blend the leaves and stem to allow some streaking for veining.

Blend the highlights to soften the petals. Add more highlight and reblend if needed. At the flower's center, dot in a fuzzy circle of Cadmium Yellow Pale, using the round brush, and a dot of Raw Umber. Using a clean round brush, add little lines of White between the petal bases, fuzzing out the tips.

PROJECT 20 *Foxglove*

Foxglove is a species native to western Europe but is found in many parts of the world. Foxglove's beauty is dramatic but deceptive, since the plant is poisonous yet possesses important medicinal properties. The Latin name is Digitalis Purpurea, and from that comes the word digitalin—a substance found in the leaves that is used in treating certain heart problems. ✤

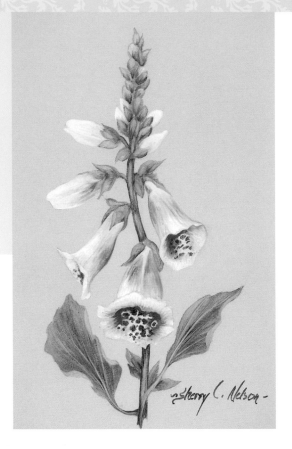

Sketching a flower is the best way to learn about its structure and to gather the information you need to paint it. To hold something in your hand and observe each minute detail is the best teaching tool there is. But when there's simply no time, photography, close up and detailed, is the next best thing.

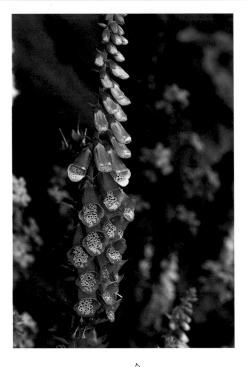

❧ Materials List ❧

• **Brushes**
nos. 2, 4 red sable brights no. 0 red sable round

• **Winsor & Newton Artists' Oils**
Ivory Black Titanium White Raw Sienna
Burnt Sienna Sap Green Cadmium Scarlet
Cadmium Yellow Pale Alizarin Crimson
Purple Madder Alizarin

This pattern may be hand-traced or photocopied for personal use only. Enlarge at 200% to bring it up to full size.

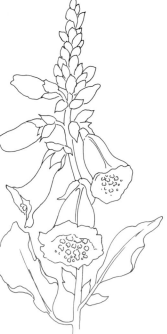

Cadmium Scarlet + Raw Sienna + White

Cad. Yellow Pale + Raw Sienna + White

Black + Sap Green

Sap Green + Raw Sienna + White = Lt. green mix

White + Raw Sienna + Cadmium Scarlet

Lt. green mix + White

Alizarin Crimson + Burnt Sienna = Dark flower mix

Dark flower mix + White

Purple Madder Alizarin + Burnt Sienna

Color Key
Use these swatches for mixing or when using other paint mediums.

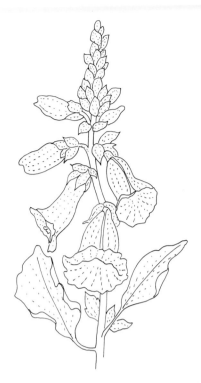

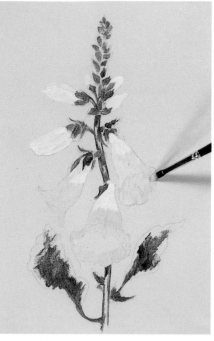

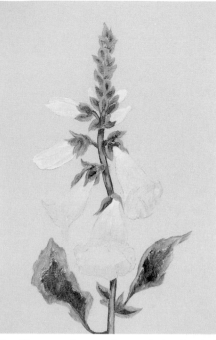

Use this diagram to better understand the contour of the trumpet-shaped blossoms. Depending on the perspective, the blending can be very confusing.

Base the pinkish area on the flowers with a mixture of Cadmium Scarlet plus Raw Sienna plus White. Base the cream-colored areas with Cadmium Yellow Pale plus Raw Sienna plus White. Lay in the dark values on the stems, leaves, bracts and unopened buds with Black plus Sap Green.

Blend between flower values with the chisel of the no. 4 bright. Use the pink flower mix for shading on the buds. Fill in the remaining leaf areas and other green areas with a light value of Sap Green plus Raw Sienna plus White.

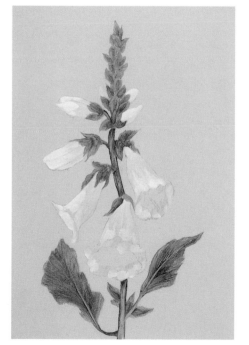

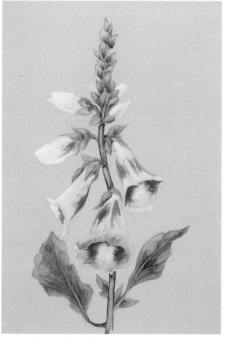

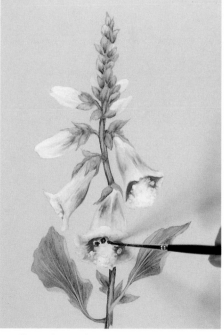

Blend the pink shading on the buds. Highlight the flowers and buds with the pale yellow mix plus more White. Blend between the dark and light values in all green areas, following the growth direction.

Blend highlights on all flower areas to soften. Add shading color on the trumpet areas of the blossoms with the dark flower mix plus Burnt Sienna. Lay in areas of Alizarin Crimson plus Burnt Sienna inside the open trumpets.

Fill in the middle, between the Alizarin areas, with a little of the light value flower basecoat. Place highlights on the leaves with the Lt. green mix plus White.

Blend the Burnt Sienna shading to soften the outside of the trumpet. Blend the edges of the Alizarin shading into the edges of the trumpet opening. Blend the highlights on the leaves and other green areas. Establish the leaf vein structure with the Lt. green mix.

Finally, with Purple Madder Alizarin plus Burnt Sienna on the round brush, lay in irregular shaped dots in the mouth of the open trumpets.

Add some accents on the green areas with Alizarin Crimson plus Burnt Sienna, and complete the spot pattern on the flowers. Additional White highlights may be needed to give the painting a bit more spark.

PROJECT 21 *Fuchsia*

The lovely fuchsias commonly used in hanging baskets are members of the evening primrose family. They come in many combinations of purple, pink and white. Different species may be more slender in shape than others. In years past, our grandmothers sometimes referred to them as Flora's-Eardrops. Use smaller brushes and take your time to develop the distinctive shape. ❧

Here's a reference shot for a different variety of fuchsia. It's more intense pink, rather than red, with white petals. You can use this color combination for a second painting with this photo for a guide.

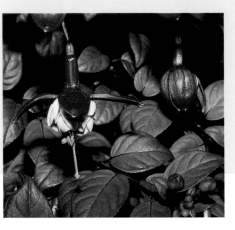

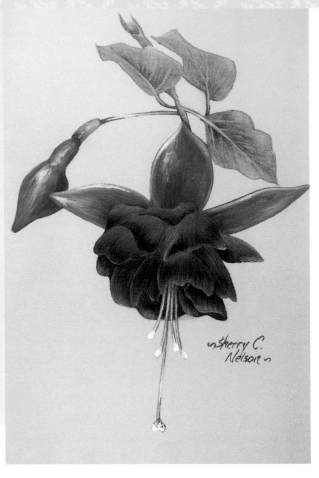

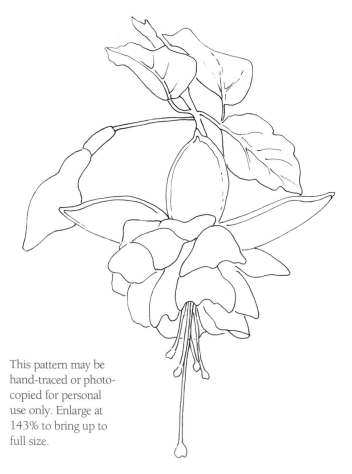

This pattern may be hand-traced or photocopied for personal use only. Enlarge at 143% to bring up to full size.

❧ Materials List ❧

- **Brushes:**
 nos. 2, 4 red sable brights no. 0 red sable round

- **Winsor & Newton Artists' Oils**
Titanium White	Raw Sienna	Winsor Red
Cadmium Scarlet	Bright Red	Sap Green
Permanent Rose	Winsor Violet	

Permanent Rose +
Cadmium Scarlet

White + a little Winsor
Red

Cadmium Scarlet +
White

Sap Green + Raw
Sienna + White = Lt.
green mix

Permanent Rose +
White

Permanent Rose +
White

Lt. green mix + White

Black + Sap Green

Color Key
Use these swatches for mixing or when using other paint mediums.

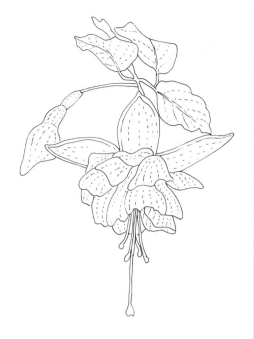

The petal growth direction on this flower can be a bit tricky. Use this guide as you paint and blend the various colors. Keeping the petal movement accurate takes work and constant monitoring of the brush.

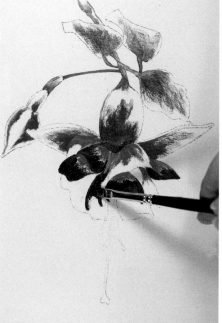

Lay in a dark value of Bright Red on the top calyx lobe. Block in Winsor Violet in the darkest area of the small bottom petals. Fill in the remainder of small petals with a mixture of Permanent Rose and Cadmium Scarlet. In areas where purple meets purple, draw in the petal division line with a stylus after basing and before you forget the location.

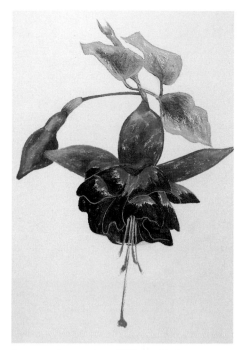

Lay a medium value of Winsor Red next to the dark value on the calyx lobes, and fill in the remainder of the area with a light value of Cadmium Scarlet plus White. Base the leaves and stems with the Lt. green mix of Sap Green plus Raw Sienna plus White.

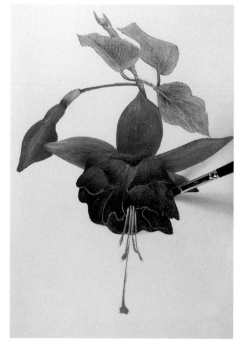

Use a small chisel to blend between the Winsor Violet and the red on the small petals. Make sure the brush is dry and clean before you lay it on the junction of the colors. Do not pull the colors or you will lose the value distinction. Blend the leaves with the chisel in the appropriate growth direction. Base the pistil and stamens with Cadmium Scarlet.

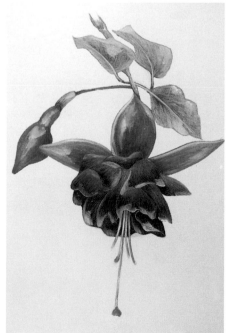

Place highlights on the calyxes with White tinted with a little Winsor Red. Use Permanent Rose plus White for highlights on the red areas of the purple petals, as well as on the purple tips. Highlight pistil and stamens with White. Add some light value green plus more White for highlights on the leaves and stems.

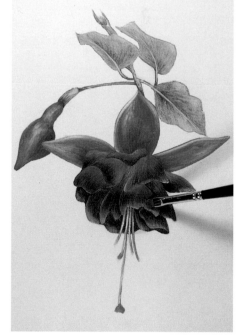

Blend the highlights softly with the growth direction on each petal and calyx. Use a clean, small no. 2 or 4 bright. Blend the light values on the leaves and stems with the proper direction, using the chisel. The final details on stamens and pistil are added with the point of a round using white plus Permanent Rose, stippling for texture.

PROJECT 22 *Geraniums*

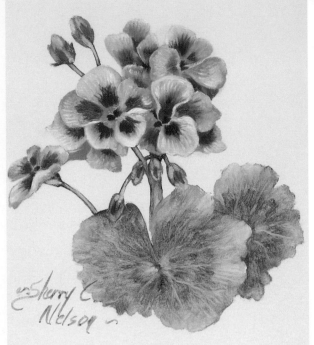

Bright clusters of Geraniums make the most wonderful hanging displays and window boxes, and come in all the colors of the rainbow. What we call geranium is actually of the genus Pelargonium, which has 250 species of mostly tropical distribution, with many of them in South Africa. Still universal favorites, geraniums were at the peak of their popularity during Victorian times.

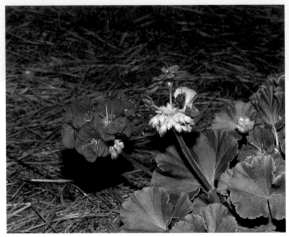

Geraniums are common, making good reference photography easy to get. But low-growing plants need to be shot from the angle at which you wish to paint them. Get down on their level for the most usable photos.

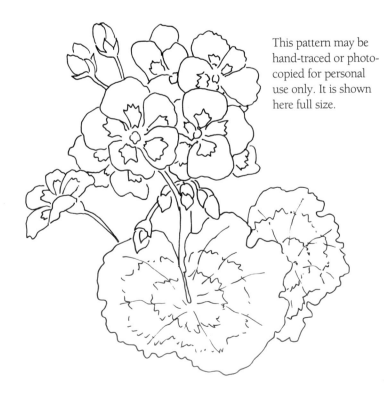

This pattern may be hand-traced or photocopied for personal use only. It is shown here full size.

❦ Materials List ❦

- **Brushes**
 nos. 2, 4, 6 red sable brights no. 0 red sable round

- **Winsor & Newton Artists' Oils**
 Ivory Black Titanium White Raw Sienna
 Raw Umber Sap Green Cadmium Lemon
 Alizarin Crimson Cadmium Red

Alizarin Crimson + Cadmium Lemon + Raw Sienna + White

Black + Sap Green

Sap Green + Cadmium Lemon + Raw Sienna + White = Lt. green mix

Raw Umber + Raw Sienna

Alizarin Crimson + Cadmium Red + Cadmium Lemon + White

Lt. green mix + White

Alizarin Crimson + Sap Green

Color Key
Use these swatches for mixing or when using other paint mediums.

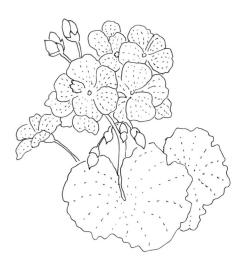

Use this diagram as a guide for the growth direction of the petals and leaves.

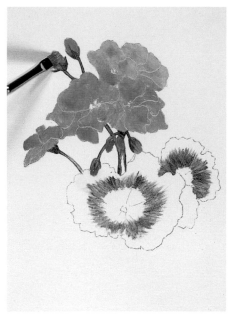

Base all the flowers with a mix of Alizarin Crimson plus Cadmium Lemon plus enough Raw Sienna added to dull the intensity and a little White to lighten the value. After basing the adjacent petals, redraw the design lines with a stylus. Scruff in the brown leaf color with Raw Umber plus Raw Sienna. Make a mix of Black plus Sap Green for the dark value on the stems.

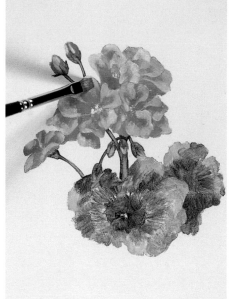

Finish filling in the leaves with a mix of Sap Green plus Cadmium Lemon (1:1) plus a little Raw Sienna to dull intensity and Titanium White to lighten. Put a bit of the light value down the stems' centers. Lay highlights on the petals with Alizarin Crimson plus Cadmium Red plus Cadmium Lemon plus a little White to lighten.

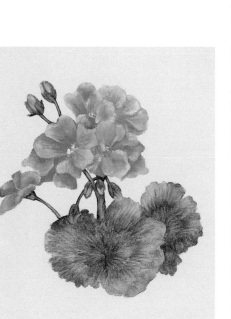

Blend the flower highlights with the growth direction. Soften the lights on the stems. Blend the green values where they meet on the leaves. Then carefully edge the brownish band into the greens on both sides following the growth direction.

Apply the final highlights on the flower petals with the pink mix plus more White. Use either a no. 2 or even a no. 0 for the tiniest petals. Apply the paint sparsely and with pressure.

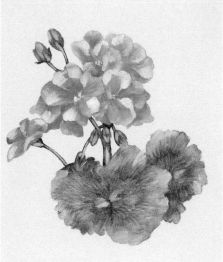

Add a little White to the Lt. green mix, and apply highlights on the leaves and stems. Blend the last highlights into the petals, leaves and stems. Use the Lt. green mix to create leaf veins. Detail the individual flowers with Alizarin Crimson plus Sap Green, using a no. 0 or 2 bright. Use the same mix with a no. 0 round to dot the dark centers. Add fine White directional lines with a clean no. 0 round on the pink areas of the petals. Define a few tiny rolls or petal edges with a bit of White.

PROJECT 23 *Gladiolus*

The lovely spikes of gladiolus are elegant in both form and color. Members of the family Iridaceae, they are cousins to other garden favorites: iris, freesia and crocus. The structure can look complex at first, but the petals are all constructed similarly and have a growth direction much like that of a simple leaf. 🌿

This photo was a good reference for the painting. Only a little redrawing was necessary to clarify the petal structure of the bottom flower. As for color, gladiolus come in so many beautiful hues that you can take your pick.

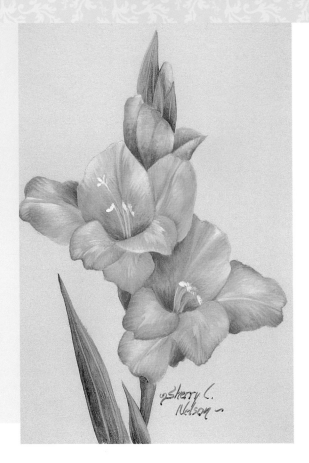

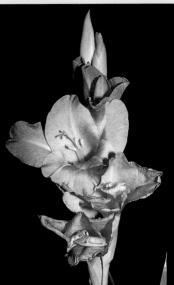

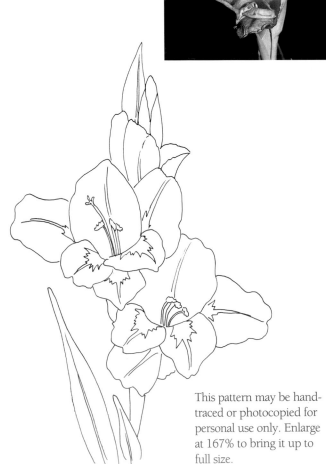

This pattern may be hand-traced or photocopied for personal use only. Enlarge at 167% to bring it up to full size.

🌺 Materials List 🌺

- **Brushes**
 nos. 2, 4, 6 red sable brights no. 0 red sable round

- **Winsor & Newton Artists' Oils**
 Ivory Black Titanium White Raw Sienna
 Burnt Sienna Sap Green Cadmium Yellow
 Cadmium Yellow Pale Cadmium Scarlet

Cadmium Scarlet + Cadmium Yellow + Raw Sienna	Cadmium Scarlet + Raw Sienna + White	Cad. Yellow Pale + Raw Sienna
Cadmium Scarlet + Burnt Sienna + Raw Sienna	Black + Sap Green	Sap Green + Raw Sienna + White = Lt. green mix
Lt. green mix + White	Cadmium Scarlet + Raw Sienna + more White	Sap Green + Raw Sienna + Cad. Yellow Pale

Color Key
Use these swatches for mixing or when using other paint mediums.

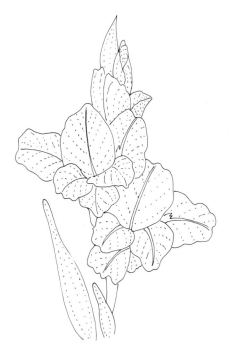

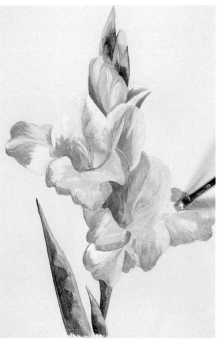

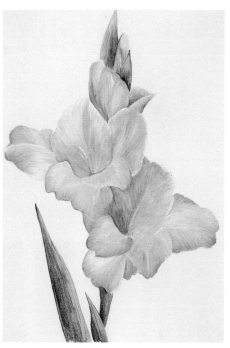

Follow this diagram when you begin blending. The dark value on the petals is a mix of Cadmium Scarlet plus Cadmium Yellow plus Raw Sienna. Fill in the medium value with Cadmium Scarlet plus Raw Sienna plus White. Base the strong central yellow with Cad. Yellow Pale plus Raw Sienna. In the deepest shadow areas, deepen with Cadmium Scarlet plus Raw Sienna plus Burnt Sienna.

The strong yellow at the petals' center is not blended into the other values. Blend between the dark and medium values on the petals letting the chisel edge create texture. The dark value on the leaves, bract and stem is a mix of Black plus Sap Green. The light green value is Sap Green plus Raw Sienna plus White. Blend the leaves with a lengthwise stroke, connecting values.

Place the initial highlights on all petals using a mixture of Cadmium Scarlet plus Raw Sienna plus more White. For the leaves, use the light green mix with additional White. Blend the highlights with the growth direction, following the curve of the petals creating the correct form and contour.

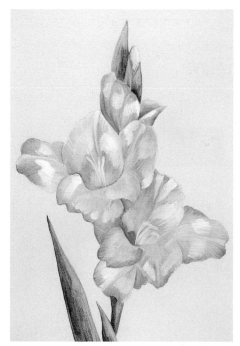

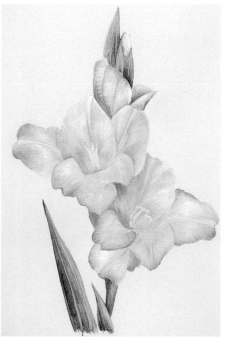

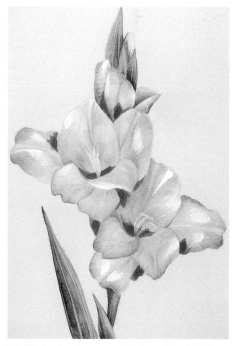

Strengthen the yellow at the throat of the petal with additional Cadmium Yellow Pale, if needed, and edge the petal carefully to connect the surrounding petal color. Blend the highlight colors into the basecoat. Add some light green veining on the leaves.

Add stronger highlights, where shown, with the highlight mix plus additional White to lighten. Shade in the strongest dark areas with Burnt Sienna plus Cadmium Scarlet.

Blend the highlights into the petals. Blend the shading colors to create soft gradations where they meet the petal color.

Highlight the throats with a bit of Cad. Yellow Pale plus White. Base the stamens with Sap Green plus Raw Sienna plus Cadmium Yellow Pale. Highlight the stamens with the base mix plus White. Stipple on the anthers with fuzzy White. After the painting has dried, add a few more highlights with Cadmium Scarlet plus Cadmium Yellow Pale plus White.

PROJECT 24 Hibiscus

Hibiscus belongs to the family Malvaceae, or Showy Mallows. The big, gorgeous blossoms come in many and varied hues, making it a wonderful painting subject. Closely related to hollyhocks and okra, the hibiscus offers us a chance to practice creating the numerous folds, rolls and flips so characteristic of the soft petals. ❦

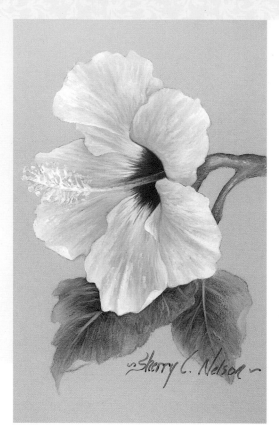

Here's a look at my photo reference for the hibiscus sample. You can easily see the many folds and rippled edges of the petals and the rich Alizarin center. Once you've mastered the techniques on the yellow blossom, you can try the lovely coral one.

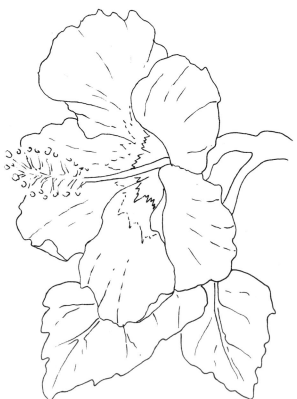

This pattern may be hand-traced or photocopied for personal use only. Enlarge at 115% to bring it up to full size.

❦ Materials List ❦

- **Brushes**
 nos. 2, 4, 6 red sable brights no. 0 red sable round

- **Winsor & Newton Artists' Oils**
 Ivory Black Titanium White Cadmium Yellow
 Raw Sienna Sap Green Alizarin Crimson
 Cadmium Yellow Pale

Cad. Yellow Pale + Raw Sienna	*Black + Sap Green*	*Cad. Yellow Pale + White*
Sap Green + Raw Sienna + White	*Sap Green + Raw Sienna + more White*	*Cad. Yellow Pale + Cadmium Yellow*

Color Key
Use these swatches for mixing or when using other paint mediums.

Look at this diagram carefully before beginning. Note how the ripple and petal folds follow the natural growth.

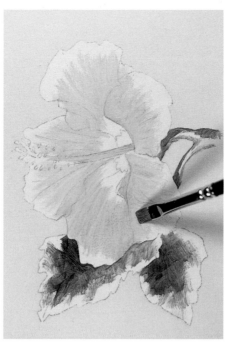

Begin by applying the dark value mix of Raw Sienna plus Cadmium Yellow Pale with a no. 4 bright. Base the basal half of the pistil with Raw Sienna. Lay in the stem and leaf dark value using Black plus Sap Green.

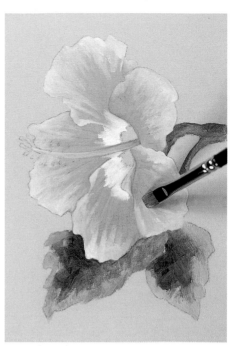

Apply a light value of Cadmium Yellow Pale plus White on the petals. Apply a zig-zag of White at the petal's dark value base. Base the rest of the leaves and stem with a light mix of Sap Green plus Raw Sienna plus White.

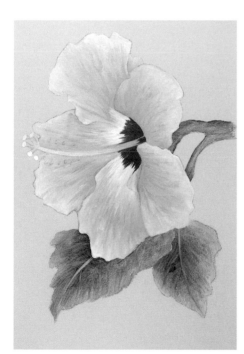

Fill in the rest of the pistil with Cadmium Yellow Pale plus White. Using the chisel, blend the edges of the light petal value into the edge of the dark value. Let some streaks show for surface texture. Then, edge the center White into the Raw Sienna. Using the round brush with Cadmium Yellow Pale, fill in the stamens at the pistil end. Add a dot of White on the ends. Carefully, lay in pure Alizarin Crimson at the flower's center with the no. 2 bright.

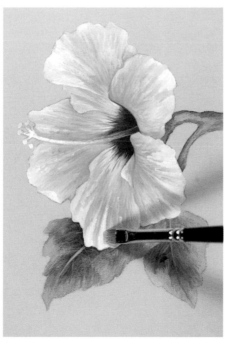

Blend the leaves and stems, but don't make them too smooth. With the chisel of the no. 2 bright, blend where the Alizarin center meets the White. A few fine lines of crimson may extend into the White area. Using a round brush, tap White on the pistil's tip and shade at the base with a bit of Alizarin. Lay strong White highlights on the petal edges. Pull across the petal, working toward the flower center, shortening the stroke as you go. Soften the petal highlights, but don't overwork.

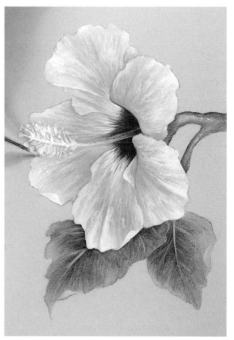

Lay highlight areas on the leaves with the light leaf mix plus more White. Add more White if you lose the highlight. Add some fine lines for stamens on the pistil with a round brush and White and add dots of Cadmium Yellow and Cadmium Yellow Pale on the ends. Blend the leaf and stem highlights with the growth direction. Set in a leaf vein structure with the Lt. green mix. Add flips on the leaf edges with the same mix. Add flips on the flower petal edges with White.

PROJECT 25 *Hollyhocks*

Alcea rosea, the hollyhock, has been a favorite in gardens for more than 500 years and is now believed to have originated in the Mediterranean region. You can see the similarity in the structure of the blossom. Hummingbirds frequent the hollyhocks on our patio garden. Last year a little black-chinned hummingbird perched on a blossom she considered her own. 🌺

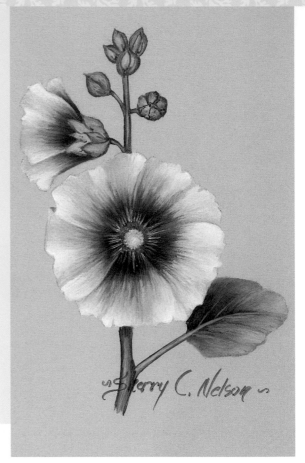

This enticing photo was taken in Nova Scotia and provides a lot of background information. Painting an entire stalk of these pleasant flowers is thoroughly enjoyable, perhaps with a hummingbird.

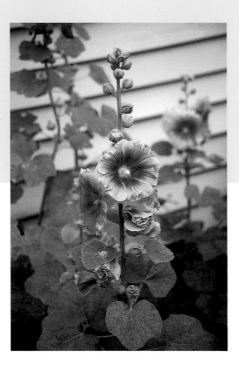

🌺 Materials List 🌺

- **Brushes**
 nos. 2, 4, 6 red sable brights no. 0 red sable round

- **Winsor & Newton Artists' Oils**
 Ivory Black Titanium White Raw Sienna
 Raw Umber Sap Green Alizarin Crimson
 Cadmium Yellow Cadmium Yellow Pale
 Purple Madder Alizarin

White + Raw Sienna + Raw Umber

Black + Sap Green

Sap Green + Raw Sienna + White

Alizarin Crimson + Purple Madder Alizarin

Cad. Yellow Pale + Cadmium Yellow

Black + Alizarin Crimson

Color Key
Use these swatches for mixing or when using other paint mediums.

This pattern may be hand-traced or photocopied for personal use only. Enlarge at 145% to bring it up to full size.

Use this diagram as a blending guide. Notice that the bloom is almost a sunburst in growth direction.

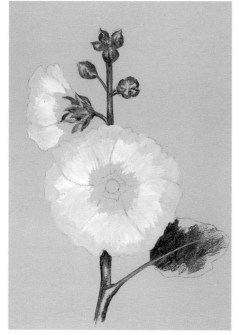

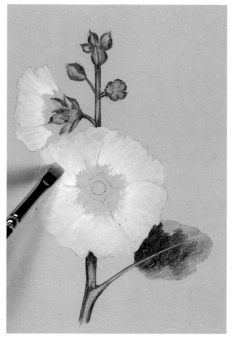

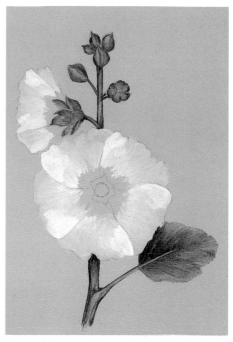

Lay on color with the growth direction. Base a band around the petals' edge with White plus Raw Sienna plus Raw Umber. Base the rest of the flower with White. Mix Black and Sap Green for the leaf, stem and buds dark value.

Blend between values on the flower with the chisel edge of a no. 6 bright. If you are lifting color, hold the brush more horizontal to the surface. Mix Sap Green plus Raw Sienna plus White for the light green value for leaf, stem and buds.

Separate the petals by applying White highlights on the overlapping edges, both on the full blossom and the bud. Blend the leaf and other areas to connect the green values.

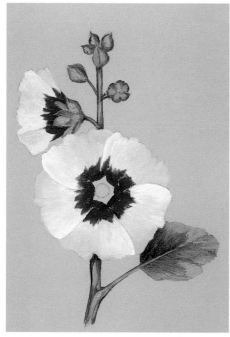

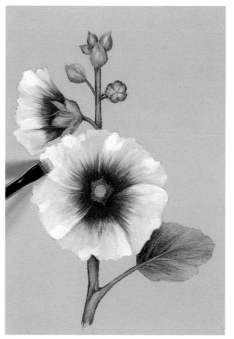

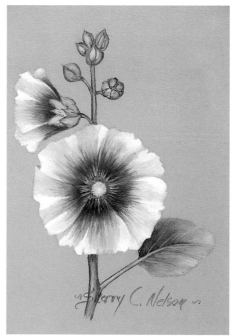

Blend the highlights. Add White to the light green value and highlight the leaf, stem and buds. Make a mix of Alizarin Crimson plus Purple Madder Alizarin, and base a narrow band around the full blossom center, next to the bracts on the bud. Next to that, lay on another irregular band of just Alizarin Crimson.

With a dry, clean no. 4 bright, connect the reds and the edges of the White petals. Keep the brush on the line where the values meet to prevent losing the strong reds or clean White.

Base Raw Sienna plus Sap Green in the center point. Fill around the opening with Cadmium Yellow plus Raw Sienna. Blend the highlight color on the leaf, stem and other green areas. Blend any additional highlights you may have added. Place the final center vein on the leaf with the Lt. green mix. Stipple a little Sap Green plus White onto the center, using a no. 0 round brush. Stipple a little White onto the round center area and fuzz the edge into the surrounding green.

Shade next to the star with Black plus Alizarin Crimson, and soften into the reds. Allow to dry overnight. Using a round brush, detail the buds and bracts with thinned dark green linework. Add White tornadoes (see page 23 for more instructions) with a round brush to create ruffles, and add detail lines of Cad. Yellow Pale plus Cad. Yellow on the red center. Finally, soften the last highlights, creating a soft rolled edge.

PROJECT 26 *Iris*

There are more than 800 species in the wonderful and varied family called Iridaceae, including such garden favorites as crocus, freesia, gladiolus and of course the many spectacular iris cultivars. Irises are predominant in our gardens here in the woodlands of the Southwest, because I love them. Irises' ruffled and complex structure of standards and falls, and their rainbow of colors, lets them blend beautifully into any painting. ❧

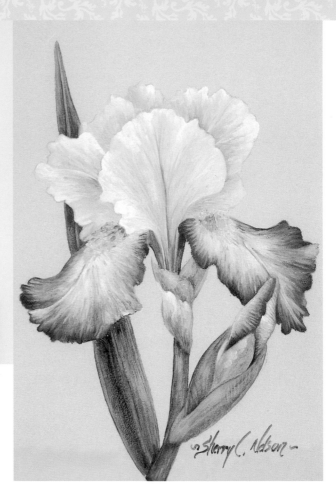

Here are some nice reference slides taken in our patio iris garden. The complexity is very appealing, and that complexity is what makes good photography backup necessary. Look at the interesting out-of-focus background behind the rusty iris. Reference photos often give me background concepts and ideas.

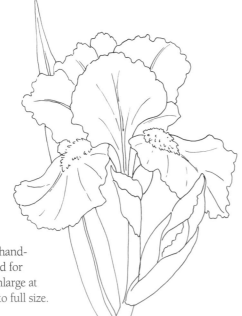

This pattern may be hand-traced or photocopied for personal use only. Enlarge at 150% to bring it up to full size.

❧ Materials List ❧

- **Brushes**
 nos. 2, 4, 6, 8 red sable brights no. 0 red sable round

- **Winsor & Newton Artists' Oils**
 Ivory Black Titanium White Raw Sienna
 Burnt Sienna Sap Green Cadmium Lemon
 Cadmium Yellow Winsor Violet

Cadmium Lemon + White

Winsor Violet + Raw Sienna

Winsor Violet + Raw Sienna + White

Black + Sap Green

Sap Green + Raw Sienna + White

Lt. green mix + more White

Cadmium Lemon + more White

Cadmium Yellow + Cadmium Lemon

Raw Sienna + Sap Green

Color Key
Use these swatches for mixing or when using other paint mediums.

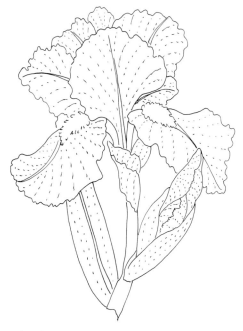

This diagram indicates the growth direction of the iris. As the petals roll and turn, the vein structure changes perspective and thus demands careful brushwork to make it look real.

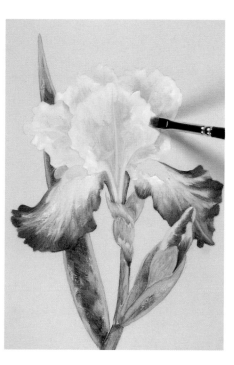

The basecoats are applied very sparsely. The dark value on the yellow petals is Raw Sienna. The light value is Cadmium Lemon plus White. The dark on the falls are Winsor Violet plus Raw Sienna. The light value is the same mix plus White to lighten. When you add White, if the mix seems too intense, use a little more Raw Sienna. The dark value for the leaf, bud and stem is Black plus Sap Green. Base the rest with a light value of Sap Green plus Raw Sienna plus White. Cadmium Lemon may be added to the light green if you want some warmer areas. The calyxes are based with Raw Sienna and Raw Sienna plus Sap Green.

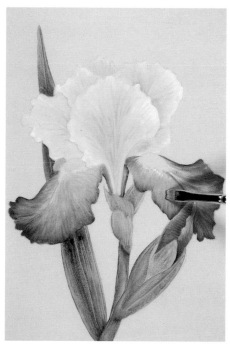

Begin the initial blending between values, using the no. 4 and no. 6 brights. If you get too much texture while you blend, hold the brush flatter to the surface. The brush is held parallel to the growth direction as you blend.

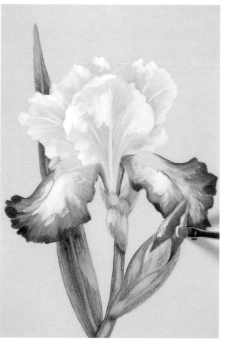

With the basecoat values blended, begin highlighting. Use Cadmium Lemon plus White on the standards, and White with a bit of Raw Sienna added on the purple falls. You can see where some of the edges of the falls are deepened with Winsor Violet plus Raw Sienna. Lay on the light value for the leaf, stem, bud and bracts with Sap Green plus Cadmium Lemon plus White.

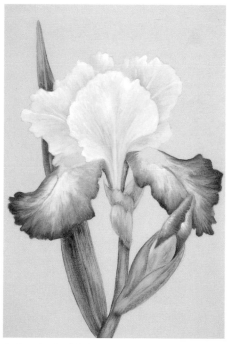

Soften the highlights into the basecoat following the growth direction. Let the chisel edge marks represent the vein structure. If they get too busy, simply lower the brush angle. Finally, using a no. 0 round brush, lay in the beards using Cadmium Yellow. Then, shade it with a bit of Burnt Sienna. Complete the beard tip with Cadmium Lemon. Use a bit of the Winsor Violet mix for veining and shading on the yellow standards, and a bit of Cadmium Yellow accent on the purple bud and falls. Add Winsor Violet accent to the leaves and bracts to tie the colors together.

PROJECT 27 *Johnny Jump-Ups*

The delightful little Johnny Jump-up must have gotten its common name from the habit of popping up all over the garden. A member of the family Violaceae, this viola is a close cousin to the pansy and violet, and their little faces are almost as engaging.

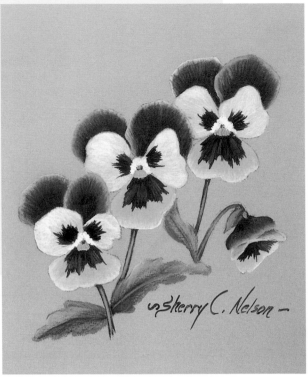

Some buds, a few leaves and a whole raft of funny-faced flowers—that's what good reference shots are made of. Pick a few, put them together in a pleasing design and enjoy.

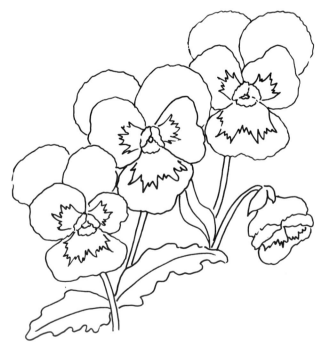

This pattern may be hand-traced or photocopied for personal use only. It is shown here full size.

❧ Materials List ❧

- **Brushes**
 nos. 2, 4 red sable brights no. 0 red sable round

- **Winsor & Newton Artists' Oils**
 Ivory Black Titanium White Raw Sienna
 Sap Green Cadmium Yellow Winsor Violet
 Alizarin Crimson Cadmium Yellow Pale

Winsor Violet + Cad. Yellow Pale

White + Raw Sienna + Cad. Yellow Pale

Cad. Yellow Pale + Raw Sienna

Black + Sap Green

Sap Green + Raw Sienna + White = Lt. green mix

Lt. green mix + White

Winsor Violet + Cad. Yellow Pale + Alizarin Crimson

Color Key
Use these swatches for mixing or when using other paint mediums.

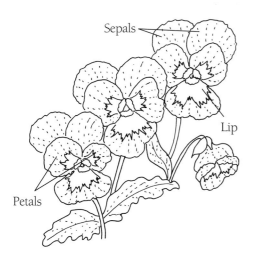

Sepals

Lip

Petals

As you paint, study this diagram for the growth direction of the petals and leaves.

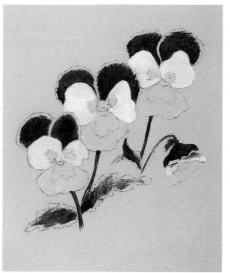

Base the majority of each sepal with a mix of Winsor Violet plus a little Cadmium Yellow Pale. Base the petals with White plus Raw Sienna plus a little Cadmium Yellow Pale. Base the lips with Cadmium Yellow Pale plus Raw Sienna (all but the very outer edge). Base the dark areas of the leaves and stems with a mix of Black plus Sap Green.

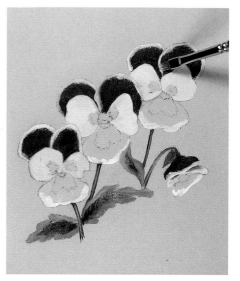

Fill in the edges of the sepals with White. Base lip edges with White. Fill in the remainder of the leaf areas with Sap Green plus Raw Sienna plus White. Use the same mix to highlight the stems.

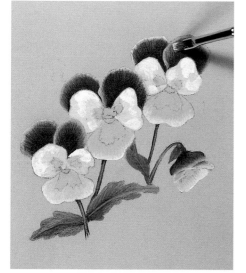

Using the chisel of a no. 2 bright, begin blending between the White edge and the dark value purple on the sepals. Do not overwork; leave some brush marks to indicate growth direction. Blend the same way between the yellow and White on the lip's edges. Lay White highlights on the edges and overlaps of the petals. Blend the leaves to soften the values, following the growth direction.

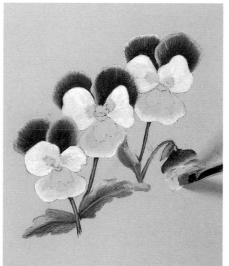

Blend the strong White highlights on the petals with the growth direction, using the chisel of the no. 2 bright. Accent with Cadmium Yellow on the yellow lips to brighten them. Lay on the leaf highlights with the Lt. green mix plus a little more White. Finally, soften the Cadmium Yellow accents on the lips. Blend the leaf highlights and vein with a Lt. green mix. Dip a round brush in a little odorless thinner, and pick up Winsor Violet plus Cadmium Yellow Pale to make a deep purple mix. Apply detail carefully on the White petals, following the growth direction. Pull a bit of Alizarin Crimson into the mix, and use it to fill in the dark face on the lips. This mix will go on smoother if it is thinned with odorless thinner. Now, with just a bit of unthinned Cadmium Yellow Pale on a no. 2 bright, put a few streaks into the central part of the dark face. Finally, using the round brush and unthinned paint, dab on the White fuzzies in an upside-down V at the flowers' center. Dab a green dot in the V. Form the yellow scallop with Cadmium Yellow below the dot.

PROJECT 28 *Lilac*

Lilacs are members of the larger family of shrubs called Oleaceae, which includes jasmine, forsythia and the olive tree. This lovely fragrant flower grows in spikes of densely clustered lavender to purple flowers, and the leaves are heartshaped. Realistic lilacs take time to paint but make a wonderful addition to a mixed floral bouquet. 🌿

This helpful photo reference shows both the unopened, ridged buds and some of the fully-opened blossoms. The smooth, heartshaped leaf is clearly visible as well. Note the difference in the colors of the buds and flower. This sort of photograph provides invaluable information.

This pattern may be hand-traced or photocopied for personal use only. Enlarge at 143% to bring it up to full size. This diagram will serve as a guide for the growth direction of the leaves and petals, and a line drawing for transfer.

🌿 Materials List 🌿

• **Brushes**
nos. 0, 2, 4, 6 red sable brights no. 0 red sable round

• **Winsor & Newton Artists' Oils**
Ivory Black Titanium White Raw Sienna
Sap Green Cadmium Lemon Winsor Violet
French Ultramarine
Purple Madder Alizarin

Purple Madder Alizarin + Raw Sienna + White

Black + Sap Green

Sap Green + Cadmium Lemon + Raw Sienna + White

Sap Green + Cadmium Lemon + White

Winsor Violet + French Ultramarine + Raw Sienna + White

Dirty brush + White

Color Key
Use these swatches for mixing or when using other paint mediums.

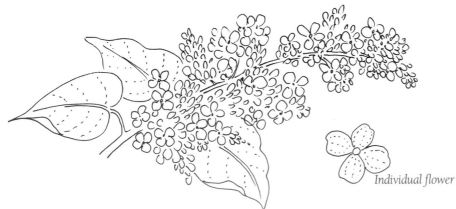

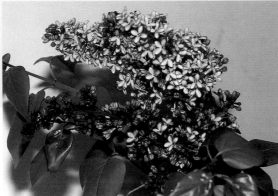

Individual flower

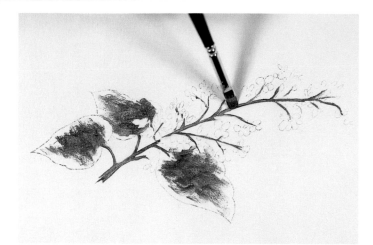

Transfer the line drawing to a prepared surface. Begin by mixing Black and Sap Green to a deep forest green. Base in the dark areas of the leaves and the stems with this mix. Extend some of the stems over the small buds and flowers, adding stems even where you may have a solid cluster of flowers. You will often see a bit of stem showing after the flowers have been placed.

Fill in the remaining areas of leaves with a mix of Sap Green and Cadmium Lemon in a (1:1) ratio. Then, add Raw Sienna to dull the intensity and just a bit of White to lighten. Dip a no. 0 bright in thinner and then blot it on a paper towel. Then load it with Purple Madder Alizarin plus a bit of Raw Sienna plus White. Begin basing in each little flower bud but not the fully-opened flowers. You can do this without thinning the paint at all if you wish.

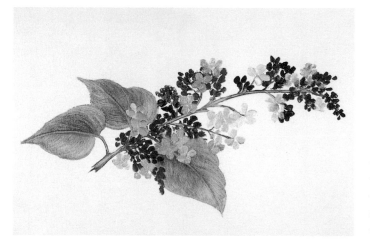

Make a mix of Winsor Violet plus French Ultramarine, adding a bit of Raw Sienna plus a little White. Using the no. 0 bright, dampened with thinner, stroke on the basecoat for each petal of the fully-opened flowers. Use a no. 4 or 6 bright to blend the leaves softly with the growth direction, following the natural curve of each leaf.

Sparsely load White on a no. 0 round, this time without having thinner on the brush. Begin making the tiny overlay strokes on both buds and flower petals to highlight and obtain the flower shape. As tiny as the buds are, use two strokes for each to resemble the overlap of two unopened petals and two or three tiny strokes for each flower petal. Be patient. This takes time but gives a very realistic look to the finished cluster. Lay on the lightest leaf value with a mixture of Sap Green plus Cadmium Lemon plus White. Add a little Raw Sienna to the mix, if it is too intense. Lay on each leaf as indicated. Finally, retouch where needed, and soften any buds or flowers that seem too harsh by reblending or overstroking with more White. Add a few dark areas with straight Purple Madder Alizarin. The highlights placed on the leaves were blended in the growth direction. The same light mix was used to establish the central vein structure.

PROJECT 29 *Lily*

The true lilies, such as this Oriental, are perhaps the most important garden flowers in the large family Liliaceae, which has worldwide distribution and more than 3700 species. Other closely related flowers in this family include daylilies, hostas, lily-of-the-valley and tulips. The complexity of the lily and the brilliant array of colors and detailing make it as fascinating to paint as it is to grow. 🌿

Flower photos taken with a macro lens capture detail often missed with the naked eye. Photos such as this one reveal every secret and are invaluable when you sit down to paint realistic blooms.

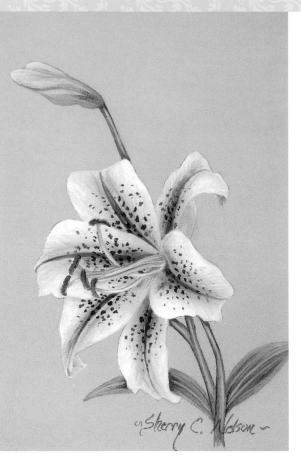

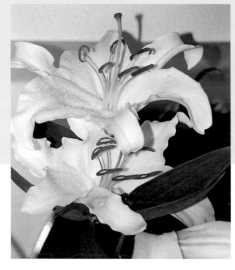

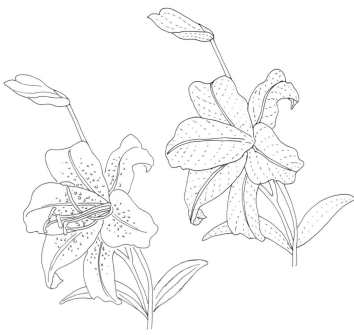

This pattern may be hand-traced or photocopied for personal use only. Enlarge at 200% to bring it up to full size. Use the second diagram as a guide for the correct petal growth direction.

🐝 Materials List 🐝

• **Brushes**
 nos. 2, 4, 6 red sable brights no. 0 red sable round

• **Winsor & Newton Artists' Oils**
 Ivory Black Titanium White Raw Sienna
 Sap Green Alizarin Crimson Burnt Sienna
 Cadmium Yellow Pale

White + Raw Sienna	*Cad. Yellow Pale + Raw Sienna + White*	*Black + Sap Green*
Sap Green + Raw Sienna + White =Lt. green mix	*Lt. green mix + White*	*Alizarin Crimson + Sap Green + White*
Alizarin Crimson + Sap Green		

Color Key
Use these swatches for mixing or when using other paint mediums.

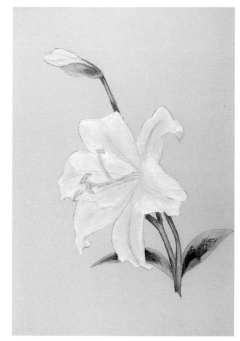

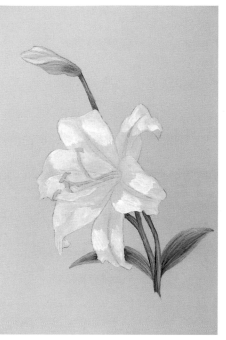

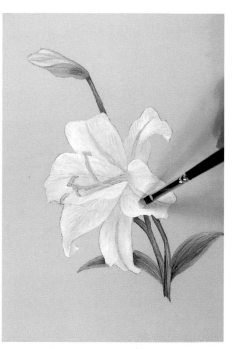

Base the central vein of each petal and stamen with Cad. Yellow Pale plus Raw Sienna plus White. Base the remaining area of each petal with White plus Raw Sienna. Base the dark value of the leaves and stems with Black plus Sap Green. Base the light value area with Sap Green plus Raw Sienna plus White.

Blend the dark and light values of each petal in the growth direction. Lay on areas of strong highlight with White. Blend the leaves lengthwise, and soften the values on the stems.

Blend the highlights with the correct direction for each petal. If the texture gets too heavy, just hold the brush flatter to the surface, but continue to blend with the chisel.

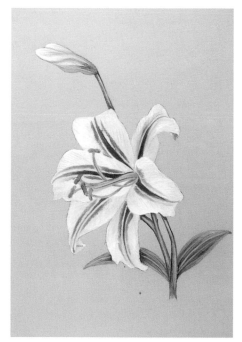

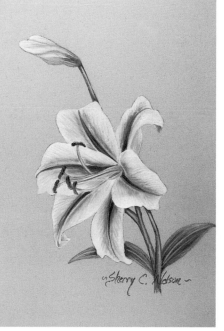

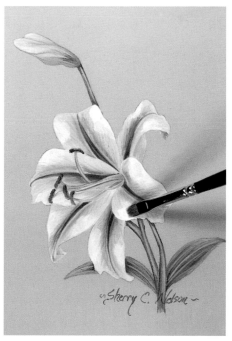

Add White to the Lt. green mix and highlight the bract on the bud, stems, and vein the leaves. Shade the stamens with Black plus Sap Green. Base the anthers with Raw Sienna. Mix Alizarin Crimson plus Sap Green, and use this to place the wide central vein in each petal. Add a little White to the mix, and place veining adjacent to the center vein.

Blend the lighter pink into the petals, with the growth direction, leaving the central vein strong in color. Soften the lights on the stems and bud. Add some dark shading on the anthers with Burnt Sienna. Highlight the forward stamens with White. Highlight the petals with pure White, while the petals are still wet or after they have dried overnight.

Using a short bristled bright, blend the final highlight into the dry petals for a smooth gradation. To give the flower center more depth, add Cad. Yellow Pale plus Sap Green, rubbing outward to glaze the petal base. Finally, using a round brush, apply the darkest dots with Alizarin Crimson plus Sap Green. Touch on paler dots with the same mix plus White. Pat the dots with a soft paper towel if they're too harsh.

PROJECT 30 *Lily of the Valley*

Lily-of-the-valley brings back those treasured memories of times in my grandmother's garden. I remember sitting with my book, up against a huge tree, next to a patch of these wonderfully scented little blossoms. I was fascinated by the tiny bells and the way they attached to the stem. Now, years later, it's just as interesting to delve into the mysteries of painting them. 🌿

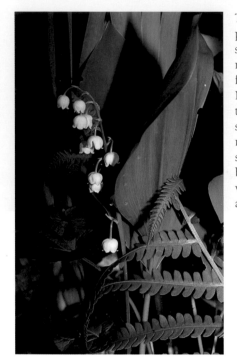

This excellent reference photo shows clearly some of the things that make painting this flower so distinctive. Notice the tiny leaflets that form where each stem attaches to the main branch. You can see the shape of the bells clearly and the way the petals roll up at the ends.

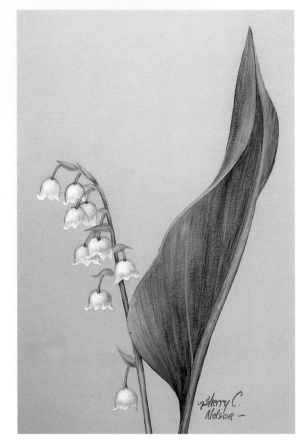

This pattern may be hand-traced or photocopied for personal use only. Enlarge at 182% to bring it up to full size.

🌿 Materials List 🌿

- **Brushes**
 nos. 0, 2, 4, 8 red sable brights no. 0 red sable round

- **Winsor & Newton Artists' Oils**
Ivory Black	Titanium White	Raw Sienna
Raw Umber	Sap Green	Cadmium Lemon

Raw Sienna + Raw Umber + Sap Green

Black + Sap Green

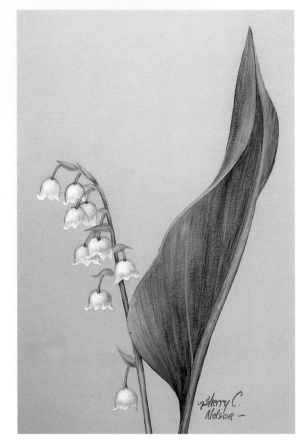
Sap Green + Cadmium Lemon + Raw Sienna + White = Lt. green mix

Lt. green mix + White

Dirty brush + White

Stippled White

Color Key
Use these swatches for mixing or when using other paint mediums.

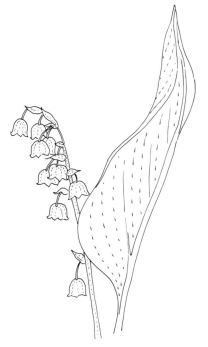

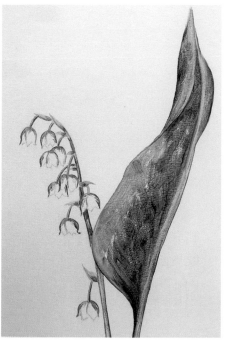

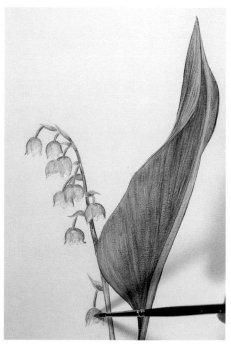

This diagram will make understanding the blending direction a little easier. It takes a bit of study to get the lovely big leaf just right.

With no. 0 bright, apply a mixture of Raw Sienna plus Raw Umber (1:1) plus enough Sap Green for a dull green. This color will form the shadow around the blossom. Lay in the leaf and stem dark values with a mixture of Black plus Sap Green. Base the rest of the leaf and stem with a mix of Sap Green plus Cadmium Lemon (1:1) plus Raw Sienna and enough White to lighten the mix.

Now, with a dry-wiped no. 0 bright, fuzz out the olive green into the central area of the bell. Don't let the green get into the points of the petals. Using the no. 8 bright, blend the values where they meet on the stems and leaf. This leaf is quite ridged, so lines left by the chisel edge of the brush will make the leaf look more realistic.

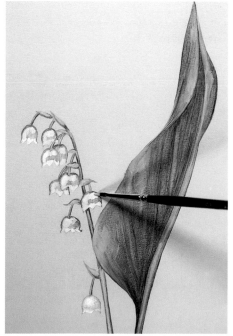

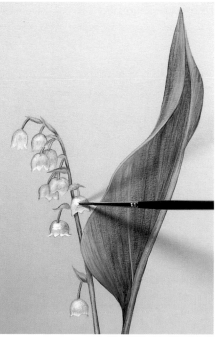

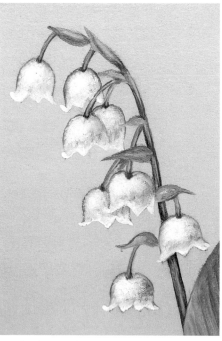

With the no. 0 bright, apply sparse White with pressure for the highlight areas on each tiny blossom. Add highlight values on the leaf, leaflets and stems with a mixture of Sap Green plus Raw Sienna plus White. Blend the White highlights on the blossoms with the no. 0 bright, and soften into the green base.

Begin stippling the tiny blossoms with more White using the tip of the no. 0 round, placing the White in a smaller area than you want. Blend the light values on the leaf and stems. Add veining on the leaf with the Lt. green mix. After you've applied all the highlights, wipe the brush dry and squeeze the tip flat.

Use the flattened tip to blend the White edges by stippling, creating a value gradation. With the no. 0 round, add a bit of White linework to the petals' tips. Check the stems where they join the blossoms. If the ends aren't distinct, redefine them with a little dark green, using a no. 0 bright, so the flowers look attached.

PROJECT 31 *Magnolia*

Magnolia grandiflora, one of a genus of eighty trees and shrubs, is the spectacular state flower of Louisiana and Mississippi and a native American. Studies of five-million-year-old fossils suggest that the Magnolia is one of the oldest plants in the world. Certainly, it is one of the most cherished of the southern trees. ❦

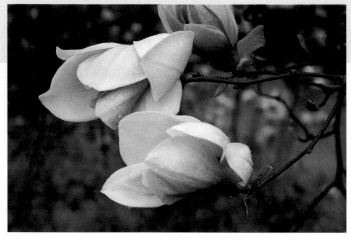

This photo is of another species, the Chinese magnolia. It is equally pleasurable to paint, with lovely pink tinges to the petals. The heavy, stiff petals and the minimal surface texture are similar to the Magnolia grandiflora.

🐜 Materials List 🐜

• **Brushes**
 nos. 2, 4, 6, 8 red sable brights no. 0 red sable round

• *Winsor & Newton Artists' Oils*
 Ivory Black Titanium White Raw Sienna
 Raw Umber Sap Green Cadmium Lemon
 Cadmium Yellow Cadmium Yellow Pale

White + Raw Sienna + Cadmium Lemon	Raw Sienna + Raw Umber + White	Sap Green + Black
Sap Green + Raw Sienna + White = Lt. green mix	Lt. green mix + White	White + Cadmium Lemon + Raw Sienna + Raw Umber
Cad. Yellow Pale + Cadmium Yellow	Raw Sienna + Raw Umber	Raw Sienna + White

Color Key
Use these swatches for mixing or when using other paint mediums.

This pattern may be hand-traced or photocopied for personal use only. Enlarge at 143% to bring it up to full size.

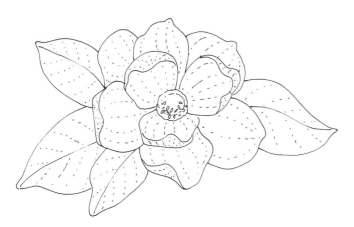

Use this diagram to aid in understanding the petal growth direction while blending.

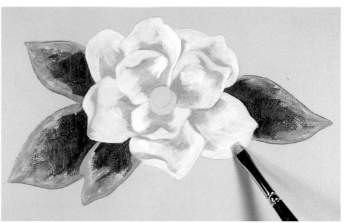

Base the dark petal value with Raw Sienna plus Raw Umber plus White. Base the remaining petal with White plus Raw Sienna plus Cadmium Lemon. Base the dark value on the leaves with Sap Green plus Black. Base the remaining light areas sparsely with Sap Green plus Raw Sienna plus White.

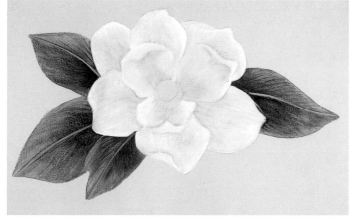

Blend the leaves and petals with a no. 6 bright, following the growth direction. If too much surface texture appears, lower the brush so it's flatter to the surface.

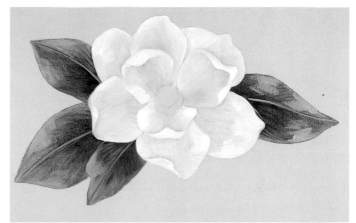

Lay on the first highlights, using a creamy mix of White plus Cadmium Lemon plus Raw Sienna. Define the petal rolls, flip turns and overlapping edges. Add more White to the Lt. green mix, and place the light values on the leaves.

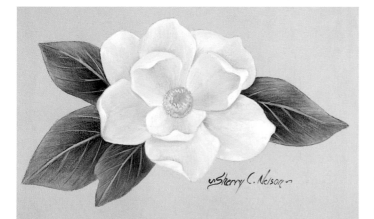

Blend the highlights to create a smooth surface. Blend the leaves to give the impression of a hard surface. Lay on the center vein using Cadmium Yellow Pale plus Cadmium Yellow. In the shadow areas, shade the veins with Raw Sienna. If depth is lacking in the flower, shade with Raw Sienna plus Raw Umber. Base the center with Raw Sienna plus Raw Umber. Stipple on Cad. Yellow Pale just inside the center's outer

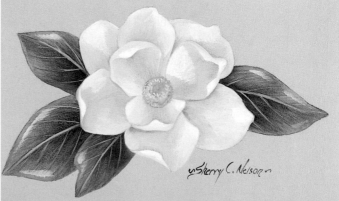

edge. Add a few tiny detail strokes with Cadmium Yellow. Stipple White around the center's outer edge, using the no. 0 round brush. Let this dry overnight. Use Raw Sienna plus White to add the final highlights on the petals and flip turns. With small amounts of paint and a dry brush, apply White plus Raw Sienna on the curves of the leaves for shine. Soften with cheesecloth or a dry brush where the values meet.

PROJECT 32 *Morning Glory*

One of my personal favorites is the morning glory. The lovely trumpet-shaped flowers are not difficult to paint. You do need to be aware of the particular growth pattern of the petals. Morning glories are a decorative painter's delight, with lots of gorgeous rich colors to choose from, tendrils and curving stems that make it easy to adapt to the various shapes of wood pieces. A lovely variety is the Ipomoea Heavenly Blue. 🌿

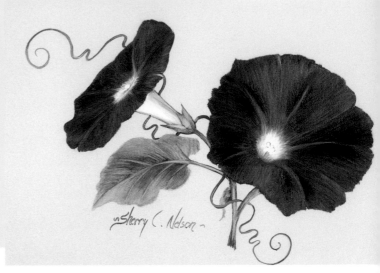

For many years I raised chickens and delighted in growing morning glories around the chicken yard fence to enhance the enjoyment of early morning chores. The old gate with its purple and magenta morning glories gave the perfect inspiration for this painting. Sometimes a photo reference is less important for detail than for setting a mood or suggesting a design or an approach to a painting that you may not have considered.

🌿 Materials List 🌿

- **Brushes**
 nos. 0, 2, 4, 6, 8 red sable brights no. 0 red sable round

- **Winsor & Newton Artists' Oils**
 Ivory Black Titanium White Raw Sienna
 Sap Green Cadmium Lemon Alizarin Crimson
 Winsor Violet

Winsor Violet + Raw Sienna	*Dirty brush + White*	*Black + Sap Green*
Sap Green + Cadmium Lemon + Raw Sienna + White = Lt. green mix	*Lt. green mix + White*	*Winsor Violet + Black*

Color Key
Use these swatches for mixing or when using other paint mediums.

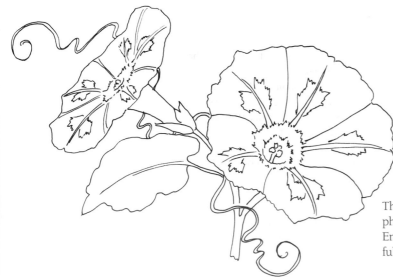

This pattern may be hand-traced or photocopied for personal use only. Enlarge at 154% to bring it up to full size.

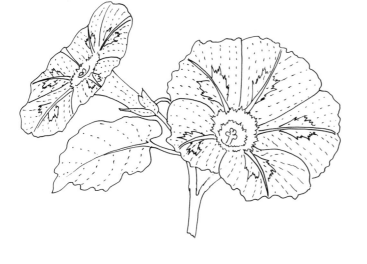

Carefully study this diagram of the structure and growth direction. Notice that the petals, though they are continuous, have a "center vein." The sides of the petal grow into the center vein. Allowing the chisel edge of the brush to leave surface texture will create the correct shape and give your flower a more realistic look.

Begin by basing in the individual sections with Winsor Violet plus a little Raw Sienna to dull it just a bit. Apply color with a no. 4 bright, placing color along the correct growth direction to set the stage for the next steps. Lay in the large central veins with Alizarin Crimson. Fill in the flower centers with White. Base in the dark shadow areas of the leaves and stems with a mixture of Black plus Sap Green. Use this mix to outline the trumpet on the profiled blossom. Fill in the rest of the trumpet with White. Base light value green areas with Sap Green plus Cadmium Lemon (1:1), plus a little Raw Sienna to dull the intensity and a bit of White to lighten the mix. Use the Color Key as a guide for mixing.

Use a clean, dry no. 4 bright to edge the White into the Alizarin Crimson at the flower's center. Alizarin is a strong color; try not to lose the White. Pressure on the dark patches using Winsor Violet plus Black loaded on a clean no. 4 bright. Blend the leaf and stems to soften the values. Blend the trumpet on the profiled flower, softening the green into the White.

Blend the dark edges on the petals in the growth direction. Do not lose the darks. Separate the petals a bit by highlighting with the violet basecoat mix plus a little White, softening and blending with the growth direction. Shade in the flower centers with a bit of the dark green mix. Scruff a little dry Winsor Violet on the leaf for accent. Add the vein structure with the Lt. green mix.

Add detailing by thinning a little of the dark green mix, and apply the tendril with the round brush. Hold the brush vertically and be sure paint is liquid enough to easily flow off the brush like ink. Then wipe the round brush and pick up a little Lt. green mix. Highlight the tendrils on the curves to give more dimension. Use a green leaf mixture for the stamen, and add several small dabs of White on the end. Add a little more White to the Lt. green mix, and use it to highlight the leaf and stems if needed.

PROJECT 33 *Narcissus*

Narcissus are perhaps the most important genus of the family Amaryllidaceae, and daffodils the most widely grown bulb in the world. Masses of nodding yellow heads in the early spring are a spectacular display. The long trumpet-like corona is often ruffled or fringed, and the petal-like perianth segments each has a growth direction like a simple pinnate leaf. The colors vary from the palest of whites and yellows to orange and red-edged trumpets, making this blossom a beautiful addition to almost any spring arrangement. 🌿

Good photo references are usually easy to obtain for the more common flowers, but you must remember to take them! These beauties are from our patio bulb garden, and the detail is there to assist even the most realistic painting.

🌿 Materials List 🌿

- **Brushes:**
 nos. 2, 4, 6 red sable brights no. 0 red sable round

- **Winsor & Newton Artists' Oils**
 Ivory Black Titanium White Raw Sienna
 Burnt Sienna Raw Umber Sap Green
 Cadmium Yellow Cadmium Yellow Pale
 Cadmium Lemon

This pattern may be hand-traced or photocopied for personal use only. Enlarge at 143% to bring it up to full size.

Burnt Sienna + Raw Sienna + Cadmium Yellow	Raw Sienna + Cadmium Lemon + White	Black + Sap Green
Raw Sienna + Raw Umber	Raw Sienna + White	Cadmium Yellow + Cad. Yellow Pale
Sap Green + Raw Sienna + White = Lt. green mix	Lt. green mix + White	

Color Key
Use these swatches for mixing or when using other paint mediums.

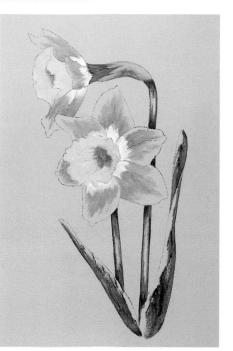

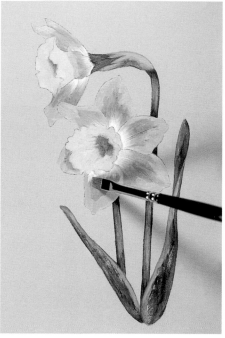

Study the growth direction and flower structure before you begin painting. It helps to begin setting the stage for the finished look even with the basecoat.

Base the dark value on the petals with Burnt Sienna plus Raw Sienna plus Cadmium Yellow using a no. 4 bright. The dark value does not come up to the petal base. Lay in an irregular band of White in that area with a no. 2 bright. On the corona, the dark value is Raw Sienna plus Raw Umber, and the light value, Raw Sienna plus Cadmium Lemon plus White. Base the dark value on the leaves and stems with Black plus Sap Green.

Base the dark area of the spathe (the papery stem covering) with Raw Sienna plus Raw Umber. The light value of the spathe is Raw Sienna plus White.

Add the light value basecoat on the petals with Cadmium Yellow plus Cadmium Yellow Pale. Blend the dark value petal edge into the White edge, following the growth direction. Base the light value of the leaf with Sap Green plus Raw Sienna plus White.

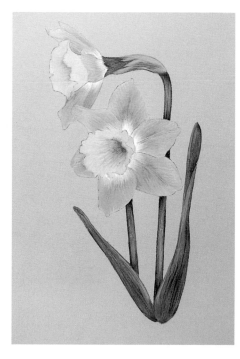

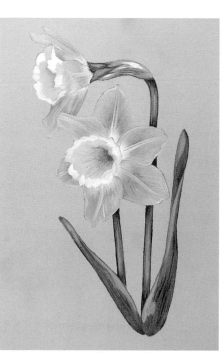

As you begin blending check the growth diagram carefully. Use the chisel edge parallel to that direction, and blend lightly on the line where the values meet. If you lift too much paint or make the surface lines too harsh, simply lower the angle of the brush. Blend between dark and light values on the corona, petals, leaves, stems and spathe, all with a dry-wiped brush on the chisel edge.

Highlight the petals with both Cadmium Yellow and a mix of Cadmium Yellow plus Cadmium Yellow Pale. Vein the petals with White. Add highlight areas on the corona with White. Add more White to the Lt. green leaf mix, and use that for highlights on the stems and leaves. Highlight the tan spathe with a little White. Be sure to blend the highlights following the correct growth direction. Tip the petals with White at the point, and re-define the ruffled edge. Base the stamens with Burnt Sienna, and tip them with dabs of White. Blend the leaves, stems and spathe. Define a subtle vein structure on the leaves with the chisel edge of the brush.

PROJECT 34 *Orchid—Cattleya*

The spectacular cattleya orchid belongs to that amazing and immense plant family called Orchidaceae. I love painting the cattleyas because of the complex forms of the petals and sepals, and because of the often-ruffled and elaborate lip. These flowers come in wonderful colors and patterns, enough to make any painter's heart sing.

It's not often that a reference photo works in all respects. I liked the shape of the flower here and the color combination was striking, so this painting seemed a little easier than most. Many orchid greenhouses are found in the warmer sections of the country and the growers are often willing to let you photograph their plants to build your reference collection with shots like this one.

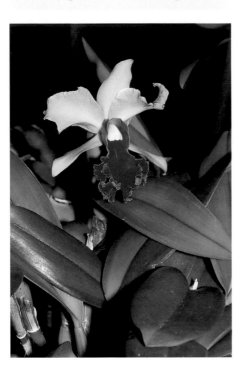

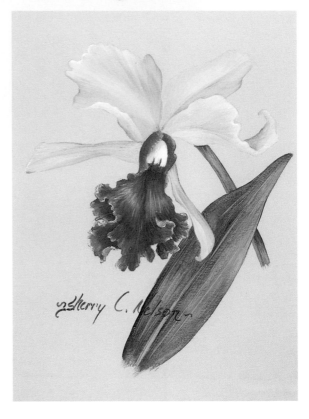

❧ Materials List ❧

- **Brushes**
 nos. 2, 4, 6, 8 red sable brights no. 0 red sable round

- **Winsor & Newton Artists' Oils**

Ivory Black	Titanium White	Raw Sienna
Burnt Sienna	Sap Green	Alizarin Crimson
Cadmium Lemon	Cadmium Yellow	Raw Umber

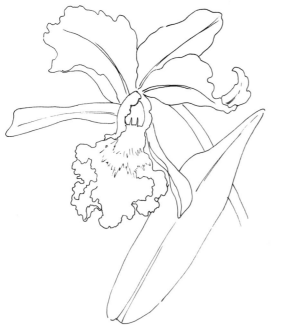

Cadmium Lemon + Cadmium Yellow	Raw Sienna + Raw Umber	Alizarin Crimson + Burnt Sienna
Black + Sap Green	Sap Green + Cadmium Lemon + Raw Sienna + White = Lt. green mix	Alizarin Crimson + Burnt Sienna + Black
White + Alizarin Crimson	Cadmium Lemon + White	Lt. green mix + White

This pattern may be hand-traced or photocopied for personal use only. Enlarge at 167% to bring it up to full size.

Color Key
Use these swatches for mixing or when using other paint mediums.

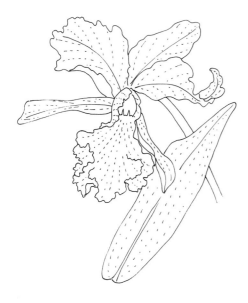

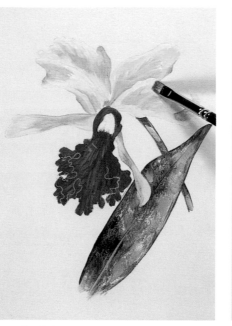

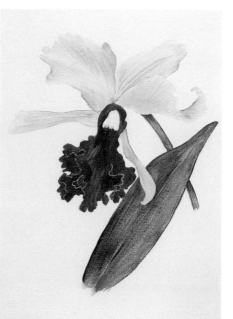

This diagram shows the growth direction for both the flower and the leaf. Study it carefully as you begin to blend, to get the right structure as you paint.

Base the dark area on the yellow petals with Raw Sienna plus Raw Umber. Base the light value with Cadmium Lemon plus Cadmium Yellow. Base the red lip areas with Alizarin Crimson plus Burnt Sienna. Base the dark value on the leaf and stem with Black plus Sap Green. Make a Lt. green mix with Sap Green plus Cadmium Lemon (1:1) plus Raw Sienna to dull the intensity and White to lighten, and base the remaining green areas.

Blend the yellow petals using the directional diagram. Blend between the leaf and stem values, creating a good value gradation. Place shading color on the lip in patches with Alizarin Crimson plus Burnt Sienna plus Black.

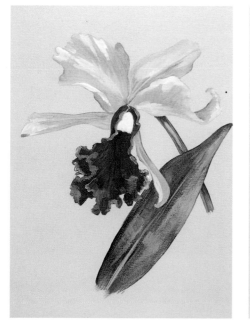

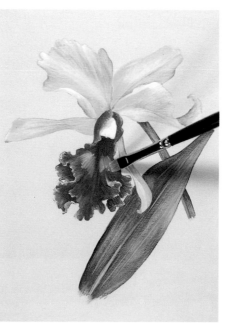

Use a mix of Cadmium Lemon plus White to add highlights to the yellow petals. Add an accent with the dark green mix randomly on the yellow petals. Highlight the leaf and stem with Sap Green plus Cadmium Lemon plus White. Base the flower center with Cadmium Lemon plus White.

Blend the dark shading color on the lip, and lay on the highlights with the basecoat red mix plus White.

Blend the highlights, as well as the accent color, on the yellow petals. Carefully blend the highlights on the lip, keeping the ruffled edges distinct. Now add Cadmium Yellow accent on the yellow petals, and on the lip. Use the round brush to add some ruffles on the lip with White plus Alizarin Crimson. Shade the light flower center with Raw Umber. Blend the leaf highlights, using the no. 8 bright to get a smooth even surface. Add the central vein structure with the Lt. green mix. Soften the strong yellow accent on the petals and the finalize veining. The flower center is highlighted with a bit of stippled White. With the round brush, soften the lip highlight and the yellow accent in the middle of the lip.

PROJECT 35 *Orchid—Moth*

Orchids are an incredibly interesting and diverse plant family. The total known species number more than 18,000 and are found all over the world. The geographical range is just as varied, with orchids found from semi-desert areas to the Arctic and from sea level to elevations more than 14,000 feet (4 km). Certainly you could paint orchids for a lifetime and never run short of beautiful and unusual blooms. This species is often called the moth orchid, for its lovely speckled pattern. 🌿

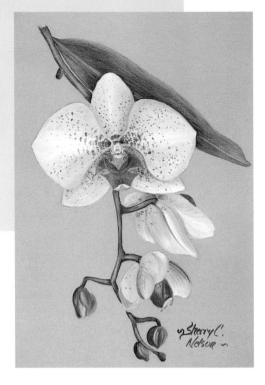

I like to search out orchid growers when I travel, to take advantage of the abundant photo opportunities in their greenhouses. This is a lovely reference shot of a plain white species. I added the patterning for the moth orchid from an example in an orchid book.

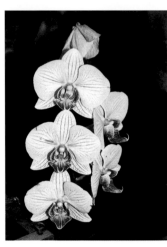

The pattern to the left may be hand-traced or photocopied for personal use only. Enlarge at 182% to bring it up to full size.

The diagram to the right shows the growth direction for blending to ensure the correct blossom, bud and leaf shape.

🌿 Materials List 🌿

- **Brushes**
 nos. 2, 4, 6, 8 red sable brights no. 0 red sable round

- **Winsor & Newton Artists' Oils**

Ivory Black	Titanium White	Raw Sienna
Raw Umber	Burnt Sienna	Cadmium Yellow
Cadmium Yellow Pale		Cadmium Scarlet
Purple Madder Alizarin		Sap Green

White + Raw Umber + Raw Sienna

Dirty brush + White

Black + Sap Green

Purple Madder Alizarin + White

Cadmium Scarlet + Cad. Yellow Pale + Raw Sienna

Cadmium Scarlet + Cad. Yellow Pale + Raw Sienna + White

Sap Green + Raw Sienna + White = Lt. green mix

Color Key

Use these swatches for mixing or when using other paint mediums.

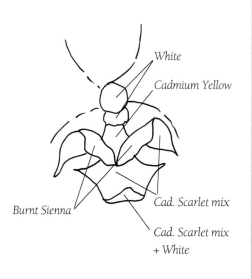

White
Cadmium Yellow
Cad. Scarlet mix
Cad. Scarlet mix + White
Burnt Sienna

This shows the placement of colors on the orchid lip.

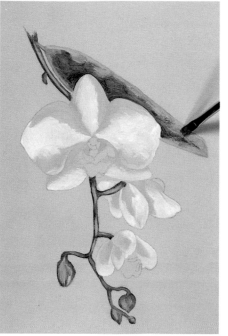

Make a very dirty mix with White plus Raw Umber plus Raw Sienna. Apply this where shadows would form naturally. Fill in the remaining areas of the buds and flower with White. Lay in the central area of the leaf, outer edges of the stems and unopened buds with a

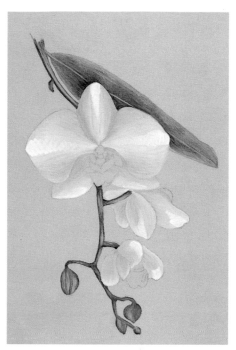

dark mix of Black plus Sap Green. Base the rest of the leaf, the central parts of the stems and buds with a Lt. green value by mixing Sap Green plus Raw Sienna plus White. Notice how the colors meet in uneven edges, with less muddying and overworking.

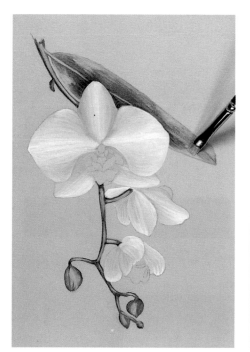

Paint the first highlight on the larger areas of the flowers using straight White and applying pressure with a no. 6 bright. On the smaller buds, use a no. 4 bright. Blend the highlights with the growth direction, leaving some natural streaking to indicate surface texture and ridges. Apply the Lt. green highlight to the leaf, buds and stem with Sap Green plus Raw Sienna plus White.

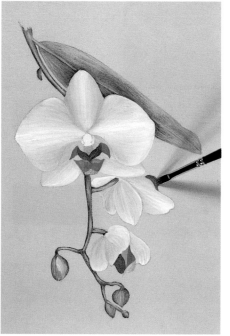

Using a no. 8 bright, softly blend the large leaf with the growth direction. Add a central vein with the light leaf mix. Blend Lt. green into the buds and stems with the growth direction, using a no. 4 bright. Add a bit of accent color to the flower petals and buds with Raw Sienna. Begin to fill in the different color mixes on the lip, starting at the top.

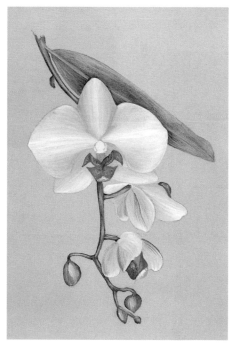

Use a round brush to stipple Purple Madder Alizarin plus White highlights on the lip area. Add Purple Madder Alizarin as shading under the fold of the lower lip. Accent some of the buds with the Lt. green mix, leaving a streaked look. Use slightly thinned Purple Madder Alizarin plus White on a no. 0 round, to apply the speckled pattern. Soften the dots by blotting with a paper towel if too strong.

PROJECT 36 *Pansy*

In the same family as violas and violets, pansies share some of the same painting challenges. They are usually larger, so you can add interesting detail, but be careful not to make mud. Whenever you are dealing with a flower that has many different areas of strong color, you'll need to make a real effort to reduce the amount of paint you carry on the brush. Think sparse, and the payoff will come in flawless detailing at the end. ❧

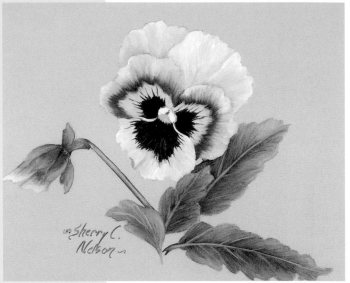

Good reference photos make for wonderfully realistic paintings. You can't make up the kind of detail to be seen in these great close-ups. I can't think of anything closer to my painting heart than my files of photos.

This pattern may be hand-traced or photocopied for personal use only. Enlarge at 133% to bring it up to full size.

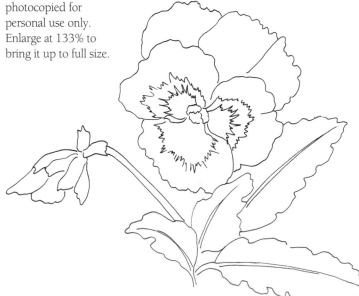

🐝 Materials List 🐝

- **Brushes**
 nos. 2, 4, 6 red sable brights no. 0 red sable round

- **Winsor & Newton Artists' Oils**
 Ivory Black Titanium White Raw Sienna
 Sap Green Cadmium Lemon Cadmium Yellow
 Winsor Violet

Raw Sienna + Cadmium Lemon	Dirty brush + White	Cadmium Lemon + White
Winsor Violet + Raw Sienna	Sap Green + Black	Sap Green + Cadmium Lemon + Raw Sienna + White = Lt. green mix
White + Raw Sienna + Winsor Violet	Lt. green mix + White	

Color Key

Use these swatches for mixing or when using other paint mediums.

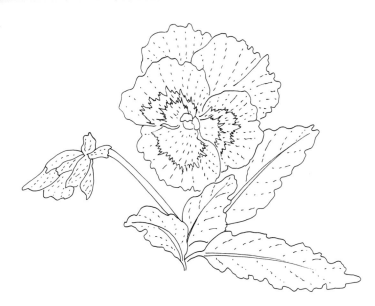

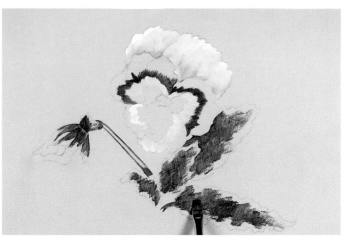

Use this growth direction chart to get just the right look for your pansy. As long as the texture lies with the dotted lines, the petals will look realistic.

Lay a shading mix of Raw Sienna plus Cadmium Lemon at the base of the white petals in the back. Fill in the remainder of the area with White. On the near petal, lay an uneven band of Cadmium Lemon plus White. The purple band is based with Winsor Violet plus Raw Sienna. Next to the purple band lay an uneven band of Cadmium Lemon. Base the dark values of the leaves and stems with Sap Green plus Black. Use small brushes for the narrow areas on the flower, and work the color with the growth direction.

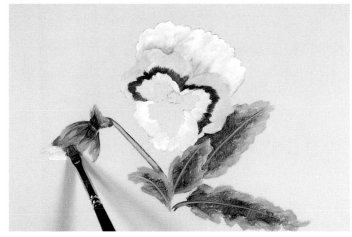

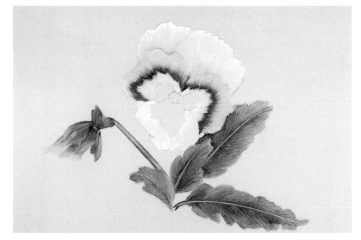

Base the remaining area of the petals with a pale mix of White plus Raw Sienna plus Winsor Violet. Base the dark value on the bud with Winsor Violet plus Raw Sienna. Base the light value on the bud with the dark mix plus White. Fill in the remaining areas of the stems and leaves with a Lt. green mix made with Sap Green plus Cadmium Lemon (1:1) plus Raw Sienna plus White to lighten it.

Begin blending the back petal using small dry brushes, softening the dark and light values where they meet. Blend the yellow into the pale lavender on the near petal. Then edge the purple band into the lavender mix without overworking. The color should be streaked enough to suggest the direction of petal growth. Blend the leaf and between the bud values. Add a little Cadmium Yellow accent on the bud.

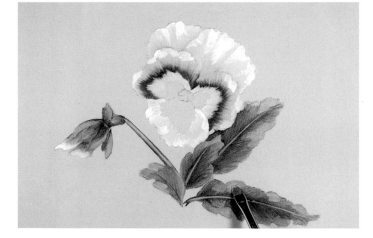

Lay areas of highlight on the flower and bud with White. Add a little White to the Lt. green leaf mix and apply highlights to the leaves, stems and bracts. All the highlights should be softened into the petals. Leave as much texture as you like. Blend the leaf highlights and add the final vein structure with a Lt. green leaf mix. Add a Winsor Violet plus Raw Sienna accent to the leaves in the shadow areas. Finally, lay in the dark face pattern with Winsor Violet plus Raw Sienna. Use a no. 2 bright to carefully pull the color over the yellow and white areas, putting it on top rather than blending it into the surrounding color. With the round brush, stipple on the White fuzzy areas at the center. Add a dot of purple mix in the upside-down V. Then, stipple in the strong Cadmium Yellow for the center. With White, outline the upper edges of the front petal to make them look slightly rolled.

PROJECT 37 Passion Flower

There are 500 species of passion flowers in mostly tropical zones. They belong to the family Passifloraceae. Most species, including this *Passiflora caerulea*, are climbers with attractive foliage and complex, beautiful flowers. 🌿

This spectacular *Passiflora* was blooming at the San Diego Zoo. These reference shots show the character of the plant, but the detail is small and takes study. A macro lens would have given a better close-up shot.

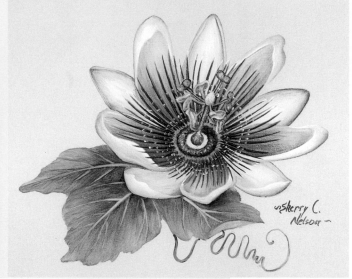

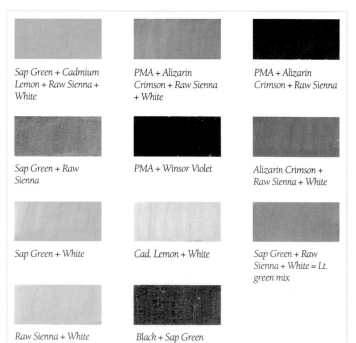

🌿 Materials List 🌿

- **Brushes**
 nos. 0, 2, 4, 6 red sable brights no. 0 red sable round

- **Winsor & Newton Artists' Oils**
 Ivory Black Titanium White Raw Sienna
 Cadmium Lemon Cadmium Yellow Sap Green
 Alizarin Crimson Winsor Violet
 Purple Madder Alizarin (PMA)

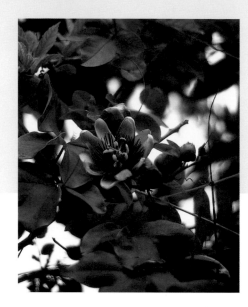

Anthers

Anther

Stamens

gynophore

This pattern may be hand-traced or photocopied for personal use only. Enlarge at 154% to bring it up to full size.

Sap Green + Cadmium Lemon + Raw Sienna + White	PMA + Alizarin Crimson + Raw Sienna + White	PMA + Alizarin Crimson + Raw Sienna
Sap Green + Raw Sienna	PMA + Winsor Violet	Alizarin Crimson + Raw Sienna + White
Sap Green + White	Cad. Lemon + White	Sap Green + Raw Sienna + White = Lt. green mix
Raw Sienna + White	Black + Sap Green	

Color Key
Use these swatches for mixing or when using other paint mediums.

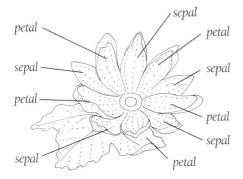

The growth direction shows the leaf is palmate. The challenge in painting Passiflora comes in executing all the detail.

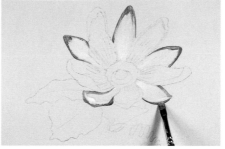

The dark edges of the sepals are based with Sap Green plus Black. The rolled edges are based with Raw Sienna plus White. The light value is Sap Green plus Raw Sienna plus White.

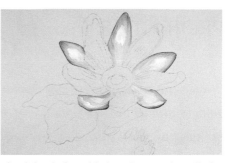

Blend the dark and light values on the rolled sepal edges. Then blend the edges into the center, following the growth direction. Highlight each sepal with White. Add an accent of Alizarin Crimson plus Raw Sienna plus White.

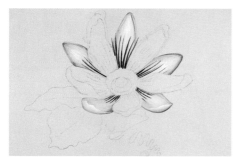

Blend the accent and highlights, following the growth direction. Lay in the corona over the sepals using a no. 4 bright and a mixture of Purple Madder Alizarin plus Winsor Violet. Make the fringe wider at the base and bring it to a point.

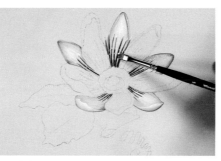

Load the no. 4 bright sparsely with the purple mix. Touch the corner of the dirty brush into White and blend on the palette to soften. Touch onto each corona fringe, marking about midway with a second mark about $\frac{1}{8}$ inch (3mm) below that. Tip the fringe with White using the round brush.

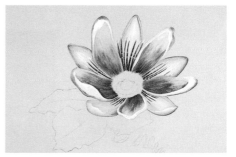

Base the dark petal value with Purple Madder Alizarin plus Alizarin Crimson plus Raw Sienna. Use the dirty brush plus Raw Sienna plus White for the light value. Base the rolled petal edges with a dark value of Black plus Sap Green and a light value of White.

Blend between the petal values. Lay on a White highlight at the petals' tips and rolled edges. Place the dark value on the leaf with Black plus Sap Green. Fill in the remaining area with Sap Green plus Cadmium Lemon plus Raw Sienna plus White. Base the larger doughnut shape at the flower center with the light value green mix. Base the next ring with Purple Madder Alizarin. Base the round center with the same brush plus Cadmium Lemon plus White.

 Blend the petal highlights and leaf segments. Highlight the leaf segments with the same mix plus more White. Add the rest of the corona fringe using the previous fringe as a guide. Stipple a bit of White onto the Purple Madder Alizarin doughnut in the flower center with a round brush. Extend the ends of the corona fringe to connect with the green doughnut. Blend the leaf highlights. Add the final veining with the Lt. green mix. When the flower is totally dry, trace the center and transfer it with White graphite. Base the stem with Purple Madder Alizarin. Base the top with Sap Green plus White. Base the anthers with Sap Green plus Raw Sienna. Using the no. 0 bright, base

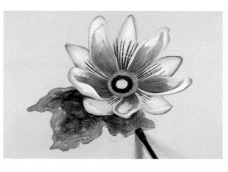

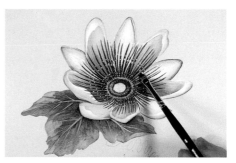

the stamens with the Lt. green leaf mix. The center top and the purple stem are stippled with a White highlight. Highlight the anthers with stippled White, and add dots of Purple Madder Alizarin. Highlight the stamens with

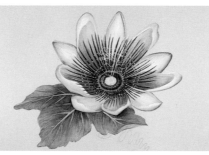

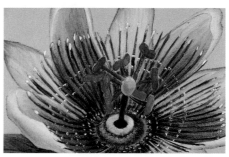

White, and outline one side of each tip with Cadmium Yellow. Thin the dark green mix and paint the tendril. Highlight some of the tendril curves with the Lt. green mix.

PROJECT 38 *Peony*

Peonies are lovely flowers that have been popular in gardens around the world for many centuries. In China, peonies have been cultivated for more than fourteen hundred years. The scientific name Paeonia lactiflora designates the ancestor from which the exciting cultivars such as this one, called Sorbet, gets its name. In terms of painting techniques, they are a bowl-shaped flower and are painted much like a loosely petaled rose.

This flower is way past its prime, but it is helpful in understanding the general bowl-shaped form of the flower, and the loosely arranged petals. Always think about including foliage, buds and any other information in your photos for later reference.

This pattern may be hand-traced or photocopied for personal use only. Enlarge at 133% to bring it up to full size.

🌿 Materials List 🌿

- **Brushes**
 nos. 2, 4, 6 red sable brights

- **Winsor & Newton Artists' Oils**

Ivory Black	Titanium White	Raw Sienna
Burnt Sienna	Sap Green	Cadmium Lemon
Cadmium Yellow	Alizarin Crimson	

Alizarin Crimson + Burnt Sienna

Black + Sap Green

Alizarin Crimson + Burnt Sienna + White = Lt. pink mix

White + Cadmium Lemon

Sap Green + Raw Sienna + White = Lt. green mix

Lt. pink mix + White

Cadmium Lemon + White

Lt. green mix + White

Color Key
Use these swatches for mixing or when using other paint mediums.

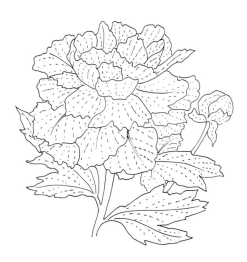

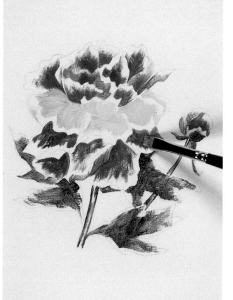

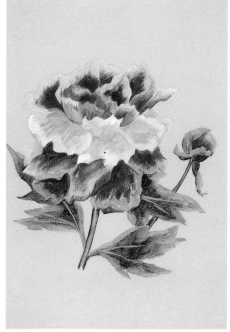

This diagram shows the general petal structure and individual petal growth. It is a big help when tackling flowers with a multitude of petals. Follow it carefully, and take care not to lose individual petals as you begin to basecoat.

Start by basing in the dark value areas on the yellow petals with Raw Sienna. Then, base the dark values on the pink petals with a mixture of Alizarin Crimson and Burnt Sienna. Finally, base the dark leaf and stem values with a mixture of Black plus Sap Green.

Use the Alizarin Crimson mix plus White for the light value on the pink petals. Use Cad. Lemon plus White for the light value on the yellow petals. And make a mixture of Sap Green plus Raw Sienna plus White for the Lt. green mix on the leaves and stems.

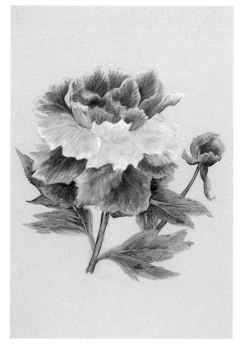

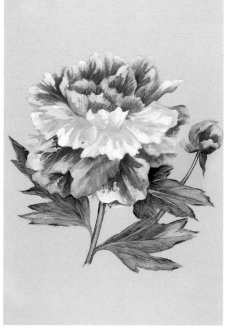

Begin placing the yellow petal highlights with a no. 4 bright using White plus Cadmium Lemon. Use a bit of the Lt. pink mix plus White for the highlight on the pink petals. Add more White to the Lt. green mix and use this for a few highlights on the leaves and main stems. Add a bit of Burnt Sienna accent on the edge of the leaves, using a no. 4 bright. Softly blend the highlight into each petal, leaving as much texture as you wish. I felt the loose, flowing nature of the flower called for more texture. Add some Cadmium Yellow accents on both pink and yellow petals to help meld the colors and make these areas seem less separated. Carry some pink accent into the yellow petals, also. Retouch the highlights with more White if needed. Blend the light values on the leaves, and add the veins with the Lt. green mix. Soften the Burnt Sienna edges.

Begin with the pink petals, blending one at a time, using the chisel edge of the brush parallel to the growth direction, softening the values where they meet. Allow some chisel edge texture to show. You will soften it more as you add highlights. When the pink petals are finished, blend the yellow ones, checking the diagram for growth direction. Then blend the leaves following the growth direction.

PROJECT 39 *Petunia*

The petunia is a member of a very diverse family called Solanaceae, with more than 2000 species, including such varied plants as potatoes, tomatoes and tobacco, as well as lovely flowering plants, such as angel's trumpet. Also included is the eggplant and the many varieties of peppers, from sweet green to chiles. The trumpet structure and the connected petals offer some very interesting painting challenges. 🌸

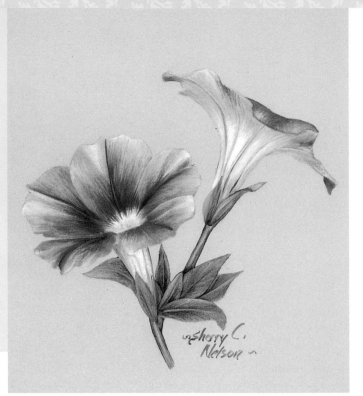

This photo reference shows the flowers at various angles, which is helpful when putting together a well-balanced line drawing. Some of the foliage shows up well, too, giving a little more information to start your painting.

🐜 Materials List 🐜

• *Brushes*
nos. 2, 4, 6 red sable brights no. 0 red sable round

• *Winsor & Newton Artists' Oils*
Ivory Black Titanium White Raw Sienna
Sap Green Alizarin Crimson Cadmium Lemon
Cadmium Yellow Pale
Purple Madder Alizarin

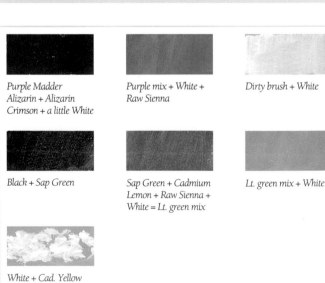

Purple Madder Alizarin + Alizarin Crimson + a little White

Purple mix + White + Raw Sienna

Dirty brush + White

Black + Sap Green

Sap Green + Cadmium Lemon + Raw Sienna + White = Lt. green mix

Lt. green mix + White

White + Cad. Yellow Pale stipple

Color Key
Use these swatches for mixing or when using other paint mediums.

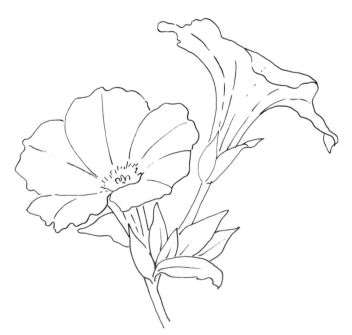

This pattern may be hand-traced or photocopied for personal use only. Enlarge at 133% to bring it up to full size.

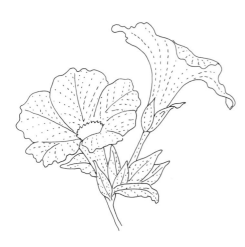

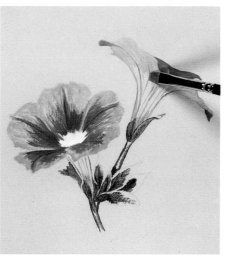

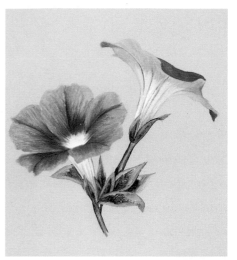

In this diagram, you can see the petal structure indicated with the dotted lines. Now look back at the reference photo. It makes a realistic painting of this flower much easier.

Begin by basing in the dark value on the flowers with a mix of Purple Madder Alizarin plus Alizarin Crimson plus White. Fill in the light value area with the same mix plus more White plus some Raw Sienna to cut the intensity. Fill in the flower center with White. Base the dark value areas on the stems, leaves and a few trumpet veins with Black plus Sap Green.

Fill between the veins on the trumpets with White. Make a Lt. green mix of Sap Green plus Cadmium Lemon (1:1) plus a little Raw Sienna plus a little White to lighten, and base the remaining areas of the leaves and stems. Blend the petals, paying close attention to the directional diagram. Notice on the petals that the side veins come out at an angle to the center vein.

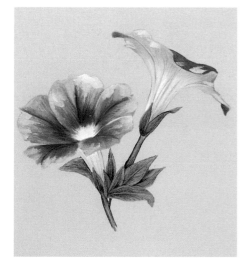

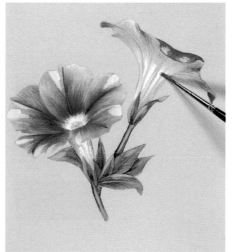

Carefully edge the White on the trumpet into the pink areas on the profiled blossom. Blend the leaves and stems where the values meet. Soften the green veining on both trumpets if necessary. Apply the first highlights on the petals and trumpets with White.

Blend the highlights on the flowers. Strengthen the highlight by using clean White. Stipple some White highlight between the closer veins on the trumpets. Add a bit of green mix at the flower center. Add highlights on the leaves with the Lt. green mix plus more White. Add the final detailing by softening the strong highlights, blending them into the petals and folds. With the flattened tip of the no. 0 round brush, soften the stippled lights on the trumpets. Add a center dot or two with Cadmium Yellow Pale using the round brush. Blend the highlights on the green leaves and stems with a no. 4 bright. Add the center veining with the Lt. green mix.

PROJECT 40 *Poinsettia*

The poinsettia, popular here and in Europe, is one of 2000 species in the genus Euphorbia. The most interesting thing about this tropical plant is that the flowers are actually the tiny buds found at the center of the array of red petal-like bracts. The leaves are distinctive too, often with bright red stems. Euphorbia pulcherrima comes in several colors, from the brightest of reds to pinks, and even a lovely white. 🌿

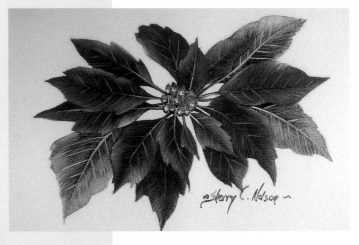

This reference photo clearly shows the varied shapes of the petal-like bracts in the typical red color, along with some green leaves underneath. It was taken at a botanical garden in Japan, proving the plant's popularity worldwide.

🌺 Materials List 🌺

• **Brushes**

nos. 2, 4, 6 red sable brights no. 0 red sable round

• *Winsor & Newton Artists' Oils*

Ivory Black Titanium White Raw Sienna
Sap Green Cadmium Yellow Pale
Cadmium Red Cadmium Scarlet Alizarin Crimson

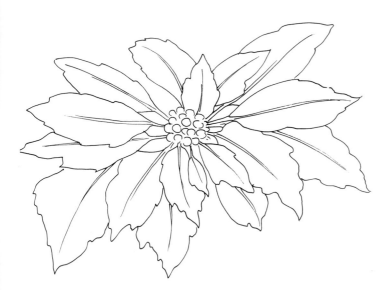

This pattern may be hand-traced or photocopied for personal use only. Enlarge at 167% to bring it up to full size.

Alizarin Crimson + Black

Alizarin Crimson + Cadmium Scarlet + Raw Sienna + White

Sap Green + Raw Sienna + White = Lt. green mix

Black + Sap Green

Dirty brush + Cad. Yellow Pale + White

Lt. green mix + White

Cad. Yellow Pale + Raw Sienna

Color Key
Use these swatches for mixing or when using other paint mediums.

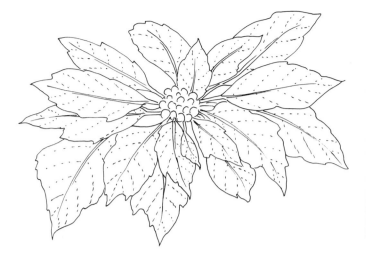

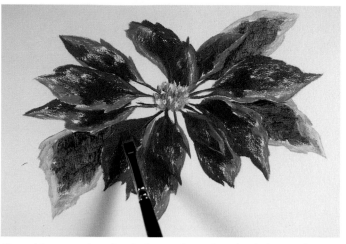

Use this diagram as a reference as you begin blending the red bracts and the green leaves. The side veins of both are at a sharper angle to the central vein than usual, making the bracts and leaves appear a bit stiff and the vein structure somewhat like a cartoon fish skeleton. But they are indeed very angular, and painting them that way makes them look real.

The red bracts are based with three values. Place the dark mix of Alizarin Crimson plus Black at the base of the bracts and under overlapping bracts. The middle value is Cadmium Red, placed next to the dark. The lightest value is a mix of Alizarin Crimson plus Cadmium Scarlet with a little Raw Sienna and White to lighten the value. Base the darkest leaf areas with a mixture of Black plus Sap Green. Base the outer edges of each of the little flower buds at the center with this dark mix. Base the remaining leaf areas with a light mix of Sap Green plus Raw Sienna plus White.

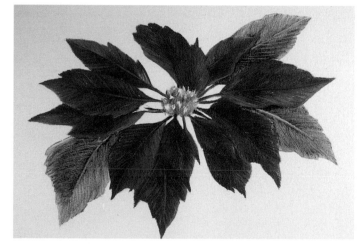

Using a clean, dry no. 4 or 6 bright, blend the bracts with the growth direction. Wipe the brush frequently so the colors don't blend together and the values don't become lost. Blend the leaves the same way.

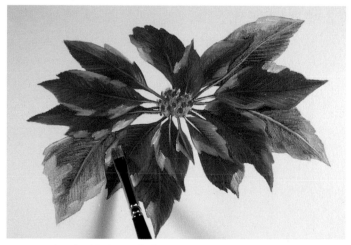

Begin to place highlights with firm pressure, using the same dirty brush with which you blended the red bracts. Pull some Cadmium Yellow Pale and White, each from their loading zones, and make a mix, using the dirty brush, giving the yellow mix a pinkish tone, perfect for the highlights. Apply this mix as shown here. Apply the leaf highlights with the Lt. green mix plus a bit more White. Use Cadmium Red to base the tiny flower forms in the center.

Finally, blend the highlights on the red bracts with the growth direction. Then, use the highlight color to create the central vein structure of the bracts. Do the final blending on the leaves, working with the growth direction. Make the vein structure with Cadmium Yellow Pale plus Raw Sienna. Add a little Cadmium Yellow Pale plus White highlight to each of the tiny center flowers with the round brush.

PROJECT 41 *Poppy*

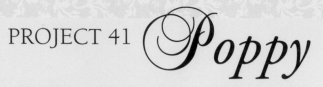

Poppies are a varied group of showy plants, perhaps best known for the Opium Poppy, which produces crude opium in the maturing seed pods. The poppy seeds used for baking contain no opium but are rich in oil and used for making soaps, paints and salad oil.

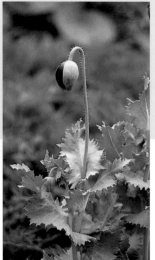

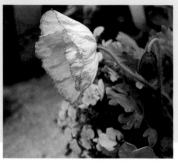

This lovely poppy, with its softly folded petals and dramatic pink edging, just begged to be painted. The photograph of the bud and leaf is a good resource, too. It shows the unusual way the leaf forms around the stem. When you have no time to sketch, photography is a wonderful help.

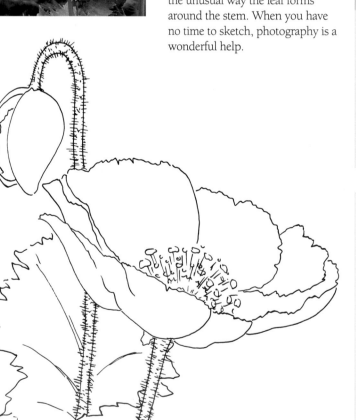

This pattern may be hand-traced or photocopied for personal use only. Enlarge at 125% to bring it up to full size.

❧ Materials List ❧

- **Brushes**
 nos. 2, 4, 6, 8 red sable brights no. 0 red sable round

- **Winsor & Newton Artists' Oils**
 Ivory Black Titanium White Raw Sienna
 Burnt Sienna Oxide of Chromium
 Sap Green Cadmium Yellow Alizarin Crimson
 Purple Madder Alizarin
 Cadmium Yellow Pale

Oxide of Chromium + Black

Oxide of Chromium + Black + White = Lt. green mix

Cad. Yellow Pale + Raw Sienna + White

Cad. Yellow Pale + White

Lt. green mix + White

Alizarin Crimson + Purple Madder Alizarin

Raw Sienna + Burnt Sienna

Color Key
Use these swatches for mixing or when using other paint mediums.

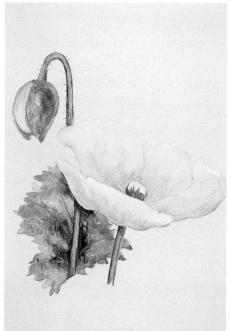

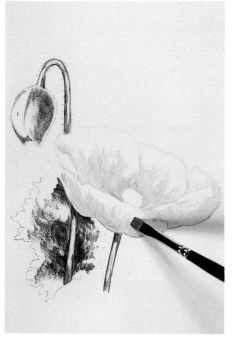

This diagram will help you to understand the particular growth pattern of the leaf and petals. Notice the wraparound direction of the petals.

Base the dark value on the poppy with Raw Sienna. Base the leaves and stems dark value with Oxide of Chromium plus Black. Keep the paint dry, and break the edges where the value meet adjacent values.

Fill in the poppy with Cadmium Yellow Pale plus Raw Sienna plus White. Scruff a little Sap Green at the base of center. Fill in the green leaf and stem areas with the dark mix plus White. If the mix seems gray, add more green.

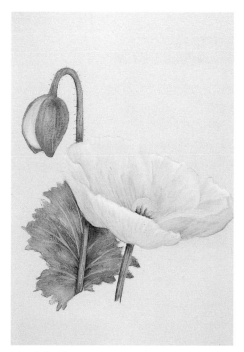

Blend the flower petals where the values meet, following the growth direction. Fill in the center with Cadmium Yellow Pale. Blend the leaves, stems and green areas on the bud.

Lay on the yellow highlights with Cadmium Yellow Pale plus White. Add highlights in the green areas with the Lt. green mix plus more White. Soften the highlights on the petals, blending for the texture you want.

Lay on the edge color around the petals with a slightly thinned mix of Alizarin Crimson plus Purple Madder Alizarin. Apply with a round brush. Stipple White on top of the center. Blend the highlights in the green areas. Add some veining on the leaf with the Lt. green mix.

With a no. 2 bright, blend the poppy's pink edge slightly into the yellow petals, but don't overwork it. A few longer streaks can help divide and separate the petals.

Rehighlight with more White on the petals. Pull lines of Cadmium Yellow Pale plus White from the center. Add some pollen dots with Cadmium Yellow Pale and Cadmium Yellow. Then make a very thin mix of Burnt Sienna plus Raw Sienna loaded on a round brush to place fuzz on the stems. Pull short strokes perpendicular to the stem. Then make a thinned mix of Oxide of Chromium plus White and repeat the process.

PROJECT 42 *Rose*

Of all the garden flowers, the rose is perhaps the most loved and most difficult for flower painters. The family Rosaceae includes more than 2000 species, which include other garden favorites such as apples, pears, plums, strawberries and raspberries. Plants from this wide-spread family are common in all parts of the world, and there is hardly a garden that doesn't have its rosebush or fruit tree. ❧

The bowl-like structure of the rose and the beautifully crafted buds are complex, so good reference photography is helpful in understanding growth direction. I like to have a lot of photos to choose from. I pick my palette from any photo that I find pleasing. In this case, I used the design from the bud but used the rose colors from the other photo.

This pattern may be hand-traced or photo-copied for personal use only. Enlarge at 167% to bring it up to full size.

Sap Green + Raw Sienna + White = Lt. green mix

Black + Sap Green

Cadmium Scarlet + Cadmium Yellow (1:1) + Raw Sienna + White = Lt. petal mix

Lt. green mix + White

Lt. petal mix + White

Raw Sienna + Cadmium Scarlet

Color Key
Use these swatches for mixing or when using other paint mediums.

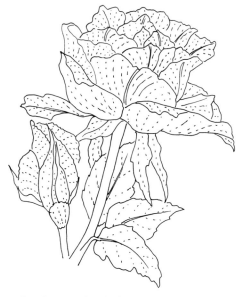

This diagram details the growth and structure of the rose and the bud. Follow it closely as you begin laying on base colors and blending so the finished rose is formed realistically.

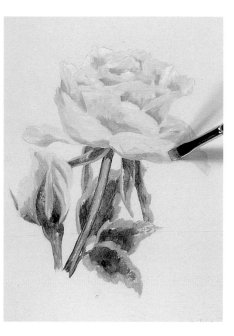

The more complex the flower or the more realistic you wish it to appear, the less paint you should use. Begin basecoating with Raw Sienna in the dark value areas of the petals. Apply the paint sparsely and break the edges where the next value will meet it. Then make a mix of Cadmium Scarlet plus Cadmium Yellow, (1:1) and add Raw Sienna to cut the intensity and a bit of White to lighten. Use this for the light value area of the petals. For the dark value of the leaves and stem, use a mix of Black plus Sap Green. For the Lt. green mix, use Sap Green plus Raw Sienna plus White.

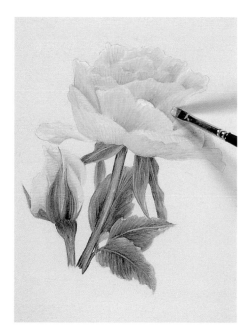

Begin to blend between the dark and light values on the petals, leaves and stems. Use a dry brush to let the chisel begin to establish the growth direction for each petal.

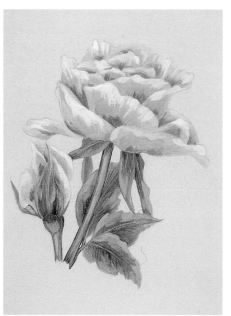

When the blending is complete, shade at the base of some petals with Raw Sienna plus Cadmium Scarlet. Add a little accent color with Cadmium Yellow. Place the highlights where the emphasis is needed with the Lt. petal mix plus more White. Place highlights on the leaves and stems with the Lt. green mix plus more White. Blend the shading, accent and highlight colors in the growth direction of each petal and leaf. Add more White to the rose petals for stronger lights if desired, either before the painting dries or afterward. You may want to add stronger accents with Cadmium Scarlet plus Raw Sienna. The same mix can be used on the leaves for accents.

PROJECT 43 *Rosebud and Bumblebee*

A rosebud can have just as much charm as a full-blown rose, with half the work. Add a little creature that appreciates them as much as we do, and you have a delightful composition. Adding life and movement to any static floral arrangement with a butterfly, bee or ladybug lends excitement and brings your painting out of the ordinary. I've included a few critters in these projects for you to mix and match into any design you choose. ❧

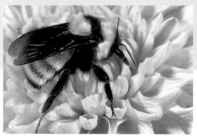

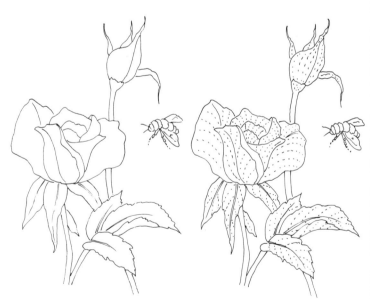

Sometimes I may use half a dozen or more reference photos to get what I need for a single painting. It's like putting together a jigsaw puzzle: Each piece has to fit. Be aware of your subject's natural habitat. Don't paint an Arctic bird or butterfly with a flower found only in the tropics.

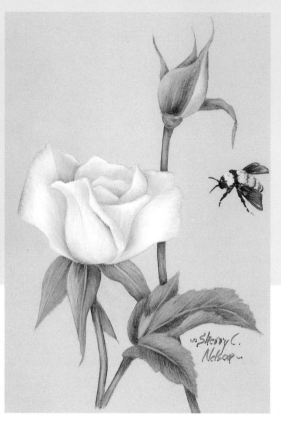

This pattern may be hand-traced or photocopied for personal use only. Enlarge at 222% to bring it up to full size.

❧ Materials List ❧

- **Brushes**
 nos. 0, 2, 4, 6 red sable brights no. 0 red sable round

- **Winsor & Newton Artists' Oils**
 Ivory Black Titanium White Raw Sienna
 Cadmium Lemon Sap Green Raw Umber
 Cadmium Yellow Pale

Raw Sienna + Cadmium Lemon + White

Black + Sap Green

Sap Green + Raw Sienna + White = Lt. green mix

Cad. Yellow Pale + Cadmium Lemon

Black + Raw Umber + White

Raw Umber + Black

Cadmium Lemon + White

Lt. green mix + White

Color Key
Use these swatches for mixing or when using other paint mediums.

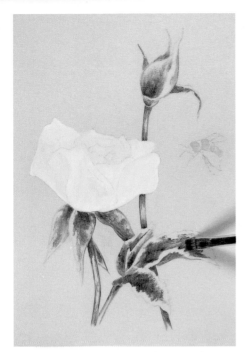

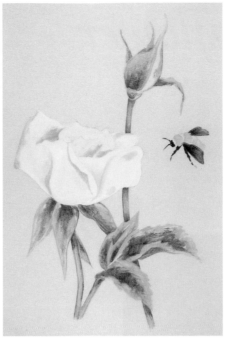

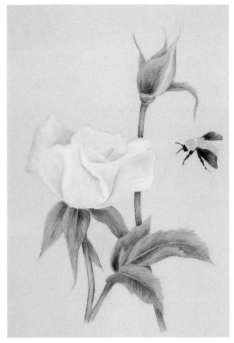

Base the rosebud sparsely with a mix of Raw Sienna plus Cadmium Lemon plus White. Stipple in fuzzy Raw Sienna on the yellow areas of the bee. Base the dark values on the leaves, bracts and stems with Black plus Sap Green.

Lay on small areas of shadow color on the rosebuds with an equal mix of Black plus Raw Umber and lightened with White. Lay on an accent with Cadmium Yellow Pale plus Cadmium Lemon. Base the bee's wing tips with Raw Sienna and the bases with Black. Use the round brush with Black for the head and legs. Base the remaining leaf areas with Sap Green plus Raw Sienna plus White.

Blend the values on the rosebuds, following the growth directions, which vary from petal to petal. Blend between values on the bee's wings. Blend between values on the leaves and stem, adding a center vein as a guide.

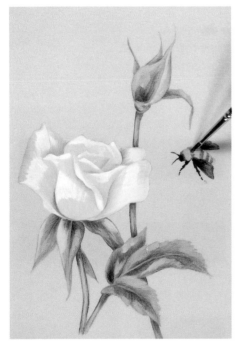

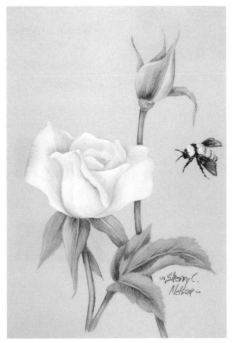

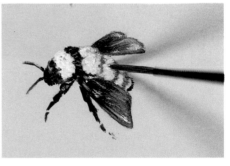

If the bee's yellow seems dull, stipple on some Cadmium Yellow Pale with the round brush. The shiny highlights on the bee's wings are added with White, touched on with a very dry round brush. Let the painting dry overnight. Then, add a little rubbed-on Raw Sienna glaze to strengthen the yellows. Also, add stronger Cadmium Lemon plus White highlights in a few areas. A few soft accents with Raw Sienna on the leaves will warm them up, unifying the colors.

Apply highlights on the petals with White. Add more White to the Lt. green mix and apply this highlight to the leaves and stem. With the no. 0 bright, apply the dark shadow stripes on the bee using Raw Umber plus Black.

With a dry-wiped brush, blend the highlights on the petals, following the directional line. If your rose is too rough, lower the brush angle. Blend the highlights into the leaves, bracts and stems, adding the final vein structure with the Lt. green mix. Stipple a bit of Cadmium Lemon plus White highlight on the bee's back.

PROJECT 44 *Sunflower*

Such a cheerful flower—who could resist painting a sunflower? It's easy to create the basic ray structure that demands only simple shadows and highlights to give it proper form. Just remember that each petal is ridged, not flat, so the blending will be done to enhance that feature and to give the painting a natural look. 🐝

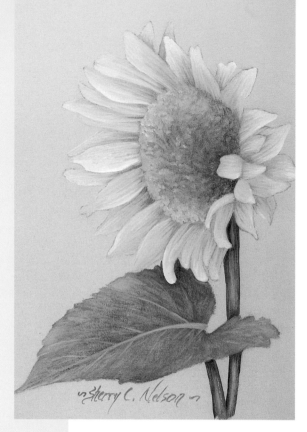

This sunflower came up as a volunteer, from seed dropped near the bird feeders. The camera was kept handy, and photos were shot at every stage of growth. Notice the ridged petals, and the darker values that form at the petals' base and under the overlapping petals.

This pattern may be hand-traced or photocopied for personal use only. Enlarge at 154% to bring it up to full size.

🐝 Materials List 🐝

- **Brushes**
 nos. 2, 4, 6 red sable brights no. 0 red sable round

- **Winsor & Newton Artists' Oils**
 Ivory Black Titanium White Raw Sienna
 Cadmium Yellow Yellow Ochre Raw Umber
 Sap Green

Raw Sienna + Yellow Ochre

Sap Green + Raw Sienna

Sap Green + Black

Sap Green + Cadmium Yellow Pale + White = Lt. green mix

Raw Sienna + Raw Umber

Cadmium Yellow Pale + White

Sap Green + White

Lt. green mix + White

Color Key
Use these swatches for mixing or when using other painting mediums.

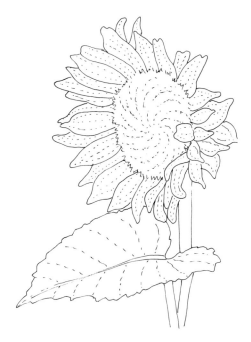

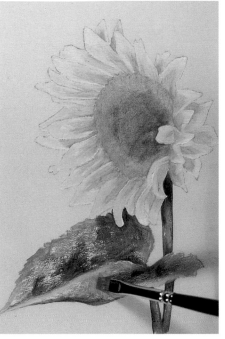

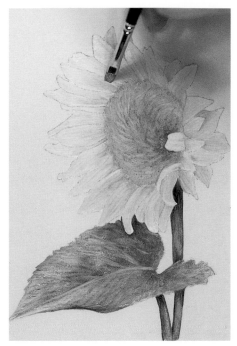

Here's your guide for the petal and leaf structure. Petals are simply blended with their shape, but note the swirl that forms in the textured flower center and the change of perspective on the large leaf.

Begin laying in the dark value, a mixture of Raw Sienna and Yellow Ochre, at the base of the petals and under the edges of overlapping petals. Base the remainder of each petal with Cadmium Yellow. Roughly base the inner area of the center with Sap Green plus Raw Sienna and the remaining center with straight Raw Sienna. Place the dark values on the leaf and stem with Sap Green plus Black. Fill in the light green areas with Sap Green plus Cadmium Yellow Pale plus White.

Begin blending the petals, using a no. 4 bright, holding the brush parallel to the growth direction. The chisel edge of the brush will keep the two values from becoming lost and will leave lines in the paint to help indicate the petals' structure. Blend between the dark and light values in the center of the flower with a no. 2 bright, using short chisel strokes and working in the direction indicated. Blend the stems and leaf slightly with the chisel of a no. 6 bright, leaving a rough, unrefined surface.

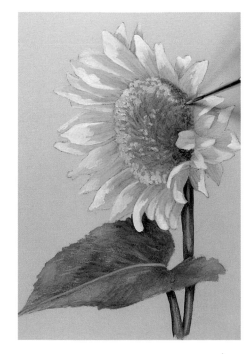

Apply highlights on dominant petal tips using Cadmium Yellow Pale. Lay in shading on some petal bases with Raw Sienna plus Raw Umber. Use the same mix with a round brush to tap in darks at the right side of the center. With a round brush, stipple in Cadmium Yellow Pale plus White around the outer edge of the center, and a little Sap Green plus White in the middle of the center. Lay on the leaf and stem highlights with the Lt. green mix plus more White.

With the chisel of a no. 2 or 4 bright, connect the highlight on each petal into the basecoat. Be careful to leave the ridged effect left by the chisel edge. Soften the shading the same way. For the flower's center, flatten the tip of the dry round brush and tap with the tip to soften the shadow color and light values with the growth direction. Soften the leaf highlights, establishing the growth structure. Use the light leaf mix and the chisel of a no. 4 bright for veining.

PROJECT 45 *Trumpet Vine*

The trumpet vine, or trumpet creeper, as it is sometimes called, is one of the most beautiful of the flowering deciduous climbers. Native to the eastern United States, the flower structure is a fairly simple trumpet that varies in color from the palest of oranges to almost scarlet. The petals are attached at the mouth of the trumpet, so the conical base of the flower is a true tube.

This close, focused shot of a trumpet vine shows the buds, the fully opened flowers and even the pistil extending from the calyx of a fallen blossom. Trumpet vines are fairly messy, but the photo of the blue-throated hummingbird shows why they are necessary. With eleven species of hummingbirds here in southeastern Arizona, plants as well as feeders are needed to keep them content.

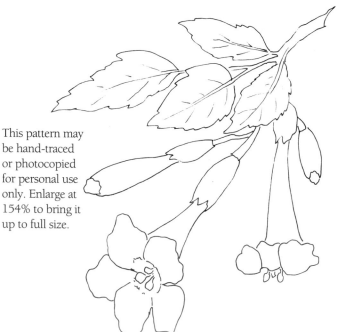

This pattern may be hand-traced or photocopied for personal use only. Enlarge at 154% to bring it up to full size.

⚜ Materials List ⚜

- **Brushes**
 nos. 2, 4 red sable brights no. 0 red sable round

- *Winsor & Newton Artists' Oils*
 Ivory Black Titanium White Raw Sienna
 Burnt Sienna Winsor Red Cadmium Orange
 Cadmium Yellow Pale Sap Green

(Cadmium Orange + Winsor Red 1:1) + Burnt Sienna + White

Black + Sap Green

Sap Green + Raw Sienna + White = Lt. green mix

Lt. green mix + White

Color Key
Use these swatches for mixing or when using other paint mediums.

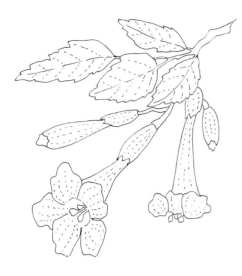

Here's a guide for the trumpet vine growth direction. Small brushes will help get the shape right in the small confined petal areas.

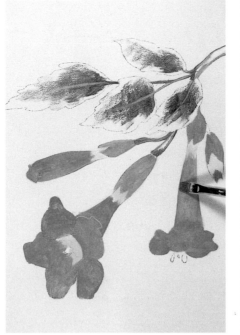

Basecoat the yellow areas with Cadmium Yellow Pale, using a no. 2 bright. Then, make a mixture of Cadmium Orange and Winsor Red (1:1) plus enough Burnt Sienna to dull the intensity and enough White to lighten. Base the rest of the conical tube, petals and bud bases with this mix, using a no. 2 or 4 bright. Lay in the dark value on the leaves and stems with plus Sap Green.

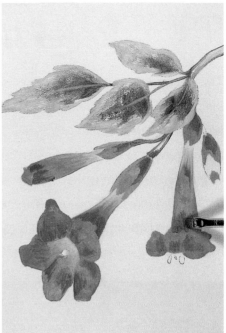

Using the chisel edge, blend the yellow where it meets the orange at the flowers' center and on the tubes. Lay in some shading with Burnt Sienna where shown. Finish filling in the leaves and stems with a Lt. green mix of Sap Green plus Raw Sienna plus White.

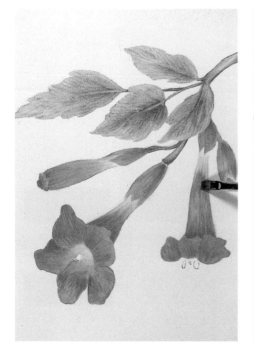

Using the chisel for texture and following the indicated growth direction, blend the shading where it meets the basecoat. Blend the leaves in the natural direction, with the chisel of the no. 4 bright.

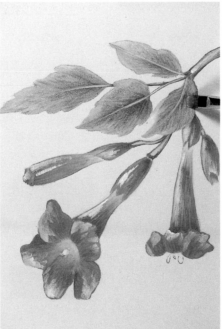

Place highlights with White where shown. Add some more White to the Lt. green mix, and highlight the stems and the leaves. Slightly soften the highlights both in the flowers and leaves, re-highlight with pure White, if necessary. Add the leaves' central vein structure with the Lt. green mix. Add stamens with a round brush, using White.

PROJECT 46 *Tulip*

The lovely shapes, incredible colors and detailed streaking of Tulips make them one of my favorite subjects. I have painted them in many different shades and never tire of striving to emulate their extraordinary patterns. Originally, tulips came from Turkey, and are members of the family Liliaceae. They are still a major industry in Holland and are immensely popular in gardens the world over, including my patio bulb garden in Arizona.

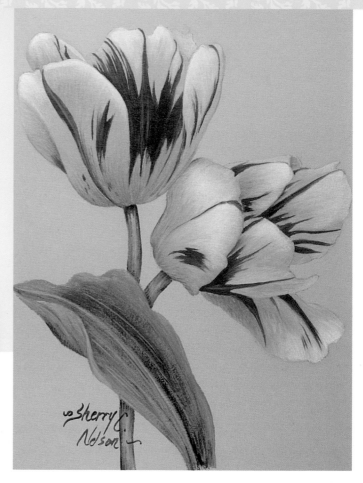

This lovely patch of Rembrandt tulips was at the Kyoto Botanical Gardens in Japan—and instantly made me want to paint them. The backup photography is a wonderful help for really understanding the complex patterning and for translating it onto the painted surface.

Materials List

- **Brushes**
 nos. 2, 4, 6 red sable brights no. 0 red sable round

- **Winsor & Newton Artists' Oils**
 Ivory Black Titanium White Raw Sienna
 Burnt Sienna Sap Green Cadmium Lemon
 Alizarin Crimson Cadmium Yellow
 Cadmium Yellow Pale

This pattern may be hand-traced or photocopied for personal use only. Enlarge at 200% to bring it up to full size.

Raw Sienna + Cad. Yellow + Cad. Yellow Pale	Raw Sienna + Cad. Lemon + White	Black + Sap Green
Sap Green + Raw Sienna + White = Lt. green mix	Cad. Lemon + White	Burnt Sienna + Raw Sienna
Lt. green mix + White	Alizarin Crimson + Sap Green	

Color Key
Use these swatches for mixing or when using other paint mediums.

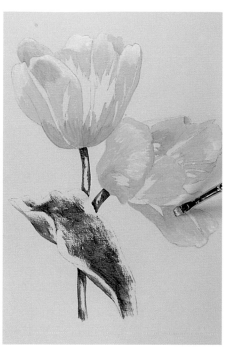

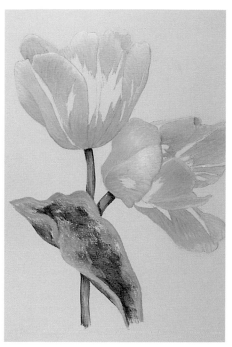

Study the directional growth diagram carefully. Note that the direction of the red streaks emulates the veining and growth of the petals. This will serve as a reminder of where and how to apply the paint.

Base the petals' dark value with Raw Sienna. Keep the paint dry and sparse. Paint the medium value areas with a mix of Raw Sienna plus Cadmium Yellow plus Cadmium Yellow Pale. The light values are Raw Sienna plus Cadmium Lemon plus White, sparsely applied. Base the dark values in the leaf and stems with Black plus Sap Green.

Begin blending with a dry no. 4 or 6 bright. If too much texture occurs or paint lifts, lower the brush angle. Lay in the light value on the leaf and stem with Sap Green plus Raw Sienna plus White. Blend the values on all green areas, using a dry brush, following the growth direction.

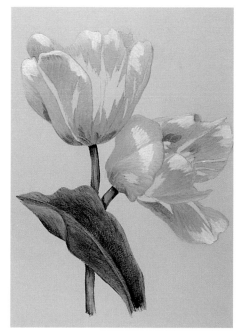

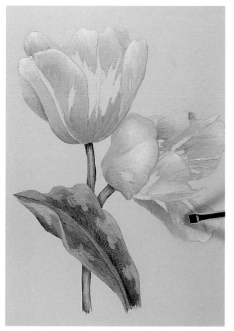

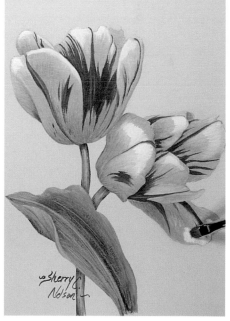

Begin laying on the first highlights, using Cadmium Lemon plus White. Add a few small areas of deeper shading with Burnt Sienna plus Raw Sienna. Using a dry brush, blend the highlight and shadow areas softly. Pay careful attention as you blend to make sure the petal growth is correct. Add a bit more White to the Lt. green mix, and place it on the leaf and stems for highlights.

Blend the leaf and stem, and add a stronger central leaf vein. Let some streaks show in the blending to indicate the ridges of the tulip leaf. With a no. 2 bright, lay in the red streaks, using a mixture of Alizarin Crimson plus Sap Green and pure Alizarin Crimson. Do *not* blend the reds into the surrounding yellows. Simply connect them with chisel to gently soften the edges where the colors meet.

Allow the painting to dry overnight. Add the final highlights using Cadmium Yellow Pale plus White to the strongest areas. Blend the edges of the highlights into the petals to form value gradations. On a dry surface, you may have to rub a bit with cheesecloth, to get the edges smooth. This method helps to provide beautiful and dramatic highlights.

PROJECT 47 *Violet*

The family Violaceae includes pansies, violas and violets, and 900 species around the world. The tiny purple violets painted here are a delight and can be used in clusters on even the tiniest of decorative items. It's great to have some little designs that you can paint quickly for gifts, but look really special. Wrap a little ribbon around these blossoms painted on a card for Mother's Day or any day. 🌿

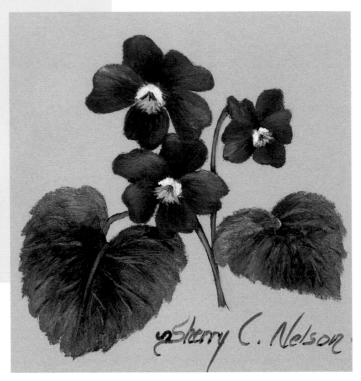

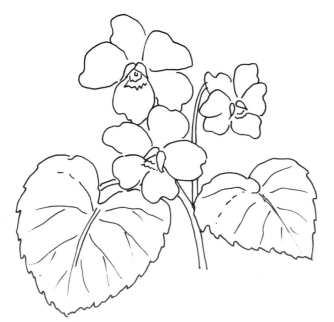

This reference photo has excellent color and shows the form of both the leaves and blossoms. When I have something this sharply focused, I can comfortably proceed with the painting. I have all the information I need to make good decisions about the painting.

🐾 Materials List 🐾

- **Brushes**
 nos. 0, 2, 4, 6 red sable brights no. 0 red sable round

- **Winsor & Newton Artists' Oils**
 Ivory Black Titanium White Raw Sienna
 Sap Green Cadmium Yellow Pale
 Winsor Violet French Ultramarine

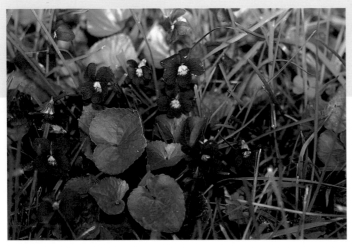

Winsor Violet + Black	Winsor Violet + French Ultramarine + White	White + a little Winsor Violet + French Ultramarine
Sap Green + Raw Sienna + White = Lt. green mix	Lt. green mix + White	Black + Sap Green
White + Raw Sienna	Winsor Violet + French Ultramarine + more White	

This pattern may be hand-traced or photocopied for personal use only. It is shown here full size.

Color Key
Use these swatches for mixing or when using other paint mediums.

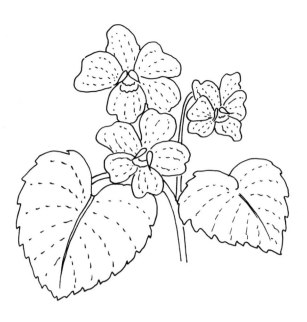

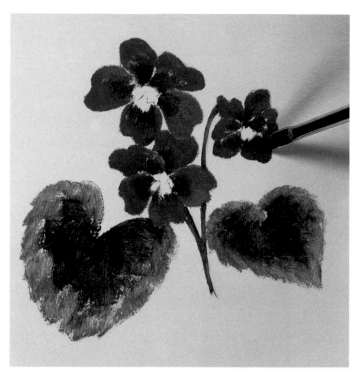

The growth direction on the petals shown here is fairly straightforward. The leaves' heart shape needs to be emphasized. It always helps to check the diagram as you paint.

Make a rich purple mix with Winsor Violet plus Black, and apply in the darkest petal areas. Make a second mix with Winsor Violet plus French Ultramarine plus a little White, and use this to fill in the rest of the petal. A little too much White in these mixes and the purple will look neon. Base the leaf and stem a dark value with Black plus Sap Green, and the light value with Sap Green plus Raw Sienna plus White.

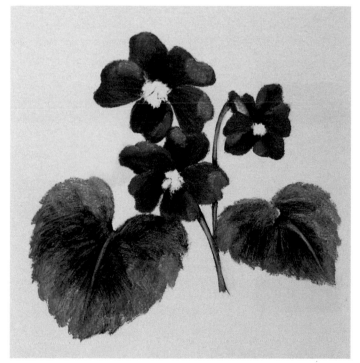

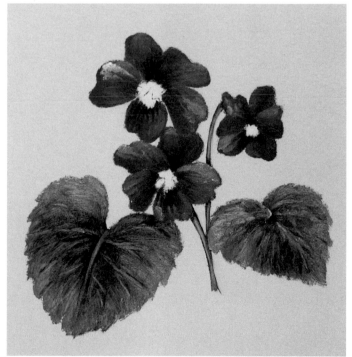

Using a dry no. 2 bright, blend the petals where the values meet, following the growth direction. Then, blend the leaves with the no. 6 bright. Now, go back to the light mix for the petals and add a bit more White to it. Use this to place the first petal highlights. Do the same for the leaves, adding more White to the Lt. green mix and filling in the remaining stem and leaf areas.

Blend the light values with the growth direction using small brushes. Add more of the light petal mix if you need separation between petals. Add the vein structure in the leaves, using the Lt. green mix. Use a round brush to stipple in the fuzzy White upside-down V at the top of the center. Then, add a dark green dot in the V. Pull little lines of Cadmium Yellow Pale to complete.

Water Lily

The water lily has a long history as a cultivated orna-
mental and was especially favored for ceremonial and
home use by the ancient Egyptians. These interesting
plants are of the family Nymphaeaceae, which consists of
75 species. All of these species are closely related to the
native water lily of North America, painted here. 🌿

This helpful reference slide gives some good information
about the leaves and blossoms, as well as the shadows
under the edges of the pads. Note the dark water and the
strong highlights that catch where the leaf edge interrupts
the surface.

🌸 Materials List 🌸

- **Brushes**
 nos. 2, 4, 6, 8 red sable brights no. 0 red sable round

- **Winsor & Newton Artists' Oils**
 Ivory Black Titanium White Raw Sienna
 Burnt Sienna Raw Umber Sap Green
 Cadmium Scarlet Cadmium Yellow Pale

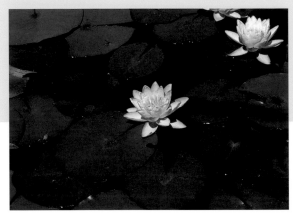

Burnt Sienna + Raw Umber	Black + Sap Green	Raw Sienna + Raw Umber + Cad. Yellow Pale
Raw Sienna + White	Cadmium Scarlet + White	Raw Umber + Raw Sienna
Raw Umber + Black		

This pattern may be hand-traced or photocopied for personal use only.
Enlarge at 154% to bring it up to full size.

Color Key
Use these swatches for mixing or when using other paint mediums.

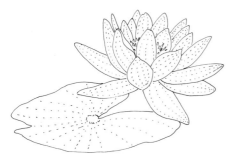

Use this diagram as a guide for blending, especially on the large pad.

Base the flower sparsely with Raw Sienna plus White. Base the darkest value on the leaf with Black plus Sap Green. Add an irregular edge of Burnt Sienna plus Raw Umber. Fill in the lightest green area with Sap Green. Base the center with Cadmium Yellow Pale.

Shade between some petals on the flower with Cadmium Scarlet plus White. Blend the water lily pad with the no. 8 bright in the growth direction. Place shadows under the edges of the pad and between the pad and blossom with Raw Umber plus Black.

Buff the shadows horizontally with a soft pad of cheesecloth. Shade in some darker areas of the pad with Black plus Sap Green. Shade the undersides of the petal blossoms with Raw Umber plus Raw Sienna.

Thin a little Burnt Sienna with odorless thinner, and using a no. 0 round brush, touch on the irregular splotches and spots on the pad. Place strong Cadmium Yellow Pale accents within the central petal blossom, using a no. 2 or 4 bright.

To soften the spots you applied and push them to the surface, pat them with a pad of cheesecloth. Blend the yellow accent into the petals, and add the first highlight with White.

Blend the White highlights. Then, with a little White on the no. 2 bright, lay a rolled edge on several petals.

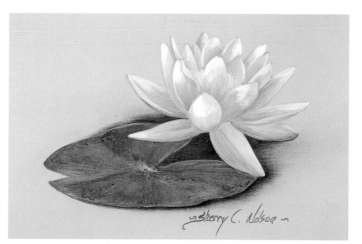

Let the painting dry overnight. Then add a final White highlight on most petals. With the round brush, lay in stamens at the flower center with Cadmium Yellow Pale. Soften the final Whites into the dry petals. Shade at the bottom of the yellow center detail with Raw Sienna.

PROJECT 49 *Wild Rose*

The beautiful wild roses are delightful in and of themselves. The one I chose here is the English briar rose, which is very climate tolerant and in hedgerows forms a wonderful protective cover for wildlife. It is an interesting fact that roses are native only to the northern hemisphere. They are quite ancient and well represented in fossil remains dating back 35 million years. 🍂

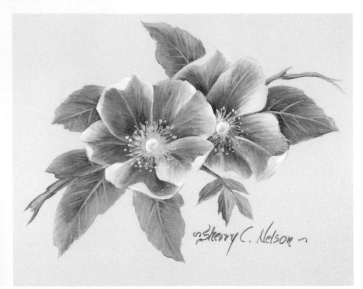

These photo references help you understand how fragile and paper-thin the rose petals are. Flipped petal edges and rolls are normal and fun to paint on these flowers. Note also the notched edges of the leaves.

🐝 Materials List 🐝

• *Brushes*
nos. 2, 4, 6 red sable brights no. 0 red sable round

• *Winsor & Newton Oil Paints*
Ivory Black Titanium White Raw Sienna
Cadmium Lemon Cadmium Yellow Sap Green
Magenta Cadmium Yellow Pale
Purple Madder Alizarin

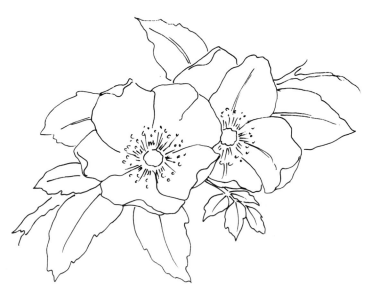

Purple Madder Alizarin + Magenta

Black + Sap Green

Cadmium Lemon + White

Sap Green + Cadmium Lemon + Raw Sienna + White = Lt. green mix

Raw Sienna + Cad. Yellow Pale

Lt. green mix + White

Color Key
Use these swatches for mixing or when using other paint mediums.

This pattern may be hand-traced or photocopied for personal use only. Enlarge at 143% to bring it up to full size.

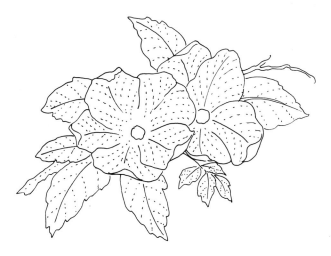

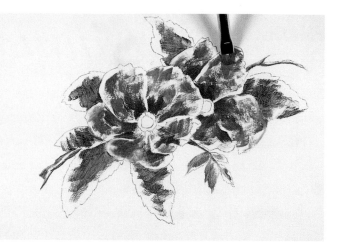

This guide to the directional growth of the petals and leaves will help you understand how to blend them. The brush movement naturally leaves some texture in the painted surface, so use that texture to indicate the shape and form of the elements. Notice that the wild rose petals are leaflike in structure and the side veins radiate from a central vein at an angle, much like leaves.

Lay in the darkest value at the base of the petals and in darker shadow areas using a mixture of Purple Madder Alizarin plus Magenta. Next to those areas, in the middle value areas, apply Magenta. On the leaves and stem, lay in the darkest value with a mixture of Black plus Sap Green. Remember to keep the paint dry and sparse, and let the edges, where the values join, be very ragged for easy blending.

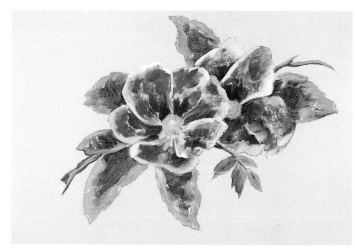

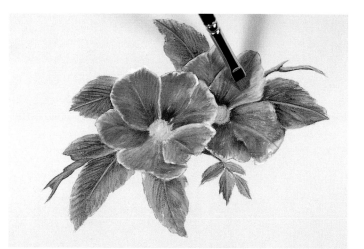

Base the lightest area of each flower petal with a mixture of Cadmium Lemon and White. Fill in the center rather sparsely with Raw Sienna plus Cadmium Yellow Pale. Base the light values of the stem and leaves with a mixture of Sap Green plus Cadmium Lemon (1:1), with enough Raw Sienna added to dull the intensity and a bit of White to lighten the value.

Blend between the values, with the growth direction. Use the chisel edge of the brush, held parallel to the growth direction to leave some texture indicating how the petals and leaves grows.

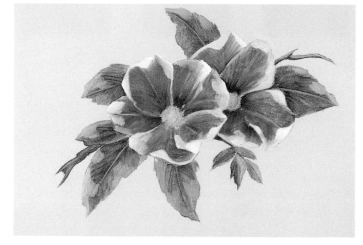

Now add White highlights on the flower petals. Use a no. 4 bright, adding pressure when you apply the color. At the same time, I use the White to add flips on some of the petal edges. Add a little more White to the light leaf mix, and apply here and there on the leaves for the highlight color. Blend the highlights into the petals and leaves with the natural growth, leaving the flip turns on the petals strongly White. With a bit of White on the tip of the round brush, stipple some texture into the flower centers. Add Cadmium Yellow Pale lines for stamens and Cadmium Yellow and Cadmium Yellow Pale dots for pollen. Add veins in the leaves with the Lt. green mix.

PROJECT 50 Zinnia

Zinnias come in a lovely range of colors to tempt the artist in you. The genus Zinnia even includes a variegated species called Peppermint Stick and one in chartreuse. When you've learned the simple techniques shown here for achieving the basic flower form, you can use zinnias in almost any floral arrangement knowing that one of the many colors will work beautifully. 🌱

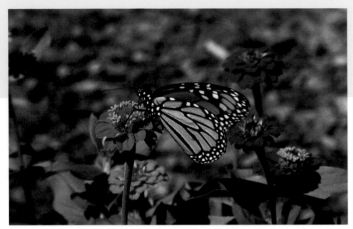

One of the most delightful things about a garden is the creatures it attracts. While these colorful zinnias are exciting, their drama is truly enhanced by the monarch butterfly. This is a great reference photo for both. Note the flowers' centers—each is in a different stage of development, lending yet another idea for creating interest in the painting.

This pattern may be hand-traced or photocopied for personal use only. Enlarge at 133% to bring it up to full size.

🌱 Materials List 🌱

- **Brushes**
 nos. 2, 4 red sable brights no. 0 red sable round

- **Winsor & Newton Artists' Oils**
 Titanium White Ivory Black Cadmium Orange
 Winsor Red Alizarin Crimson Raw Sienna
 Burnt Sienna Sap Green
 Cadmium Yellow Pale

Burnt Sienna + Alizarin Crimson

Sap Green + Black

Cad. Yellow Pale + Sap Green + Raw Sienna

Cad. Yellow Pale + Sap Green + Raw Sienna + White

Cad. Yellow Pale + Cadmium Orange

Cad. Yellow Pale, detail

Color Key
Use these swatches for mixing or when using other paint mediums.

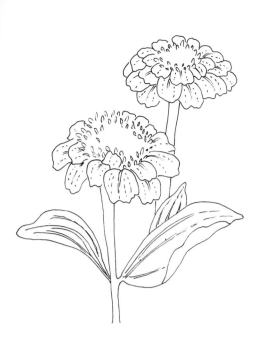

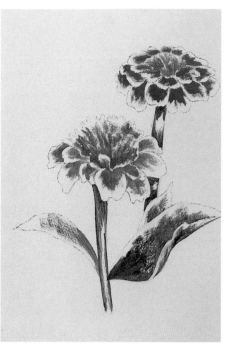

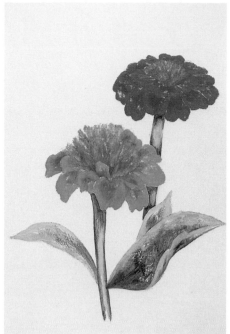

The form of a zinnia is a simple ray, making it easy to understand the growth direction. Note, too, that the large leaf veins start from the stem end of each leaf.

Using a sparse amount of Burnt Sienna on a no. 2 bright, scruff in the dark areas on the orange flower. Use Burnt Sienna plus Alizarin Crimson for the dark area on the red blossom. Base the darkest areas of the centers with short chops of Burnt Sienna, applied with the no. 2 bright. Make a mix of Sap Green plus Black for the dark value on the leaves and stems, applied with the no. 4 bright.

Fill in the remainder of the orange petals with Cadmium Orange, and the rest of the red blossom petals with Winsor Red. Chop Raw Sienna into the remaining center with a no. 2 bright. Base the rest of the leaf and stem areas with a lighter value mix made with Cadmium Yellow Pale plus Sap Green plus Raw Sienna to control intensity.

Lay highlights on the orange petals with Cadmium Yellow Pale plus Cadmium Orange, and on the red petals with Cadmium Orange. Apply the highlight on the leaf with the light leaf mix plus more White. Apply center details with Cadmium Yellow Pale and small strokes using a round brush. Soften the petal highlights with the chisel, leaving a central vein on the larger petals and a ridged look. Leaf veining is done with the lightest leaf mix.

Using a dry-wiped no. 2 bright, begin blending to connect the values on the blossom petals. Blend one at a time, using the chisel parallel to the line of growth, leaving a little texture. Blend the leaves pulling with the growth direction, using the no. 4 bright. Soften the values together on the stems.

Put It All Together

You've learned to paint many individual blossoms. The next step is to group them into a pleasing floral arrangement. Even a simple container filled with a few blooms will give you a chance to practice composition and color theory that will help you create your own effective and attractive floral designs.

Blossoms in a Crock

Blossoms in a Crock started with this reference shot of a simple crockery milk pitcher filled with a random selection of flowers from a grocery store bouquet. The many possibilities with the pitcher are evident, and it could be painted in almost any color that would work well with the chosen blossoms.

Limit the Variety of Blossoms

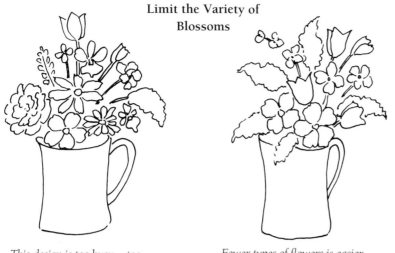

This design is too busy—too many different kinds of flowers and no repetition.

Fewer types of flowers is easier to understand, and easier to unify with color.

Balance the Variety Across the Design

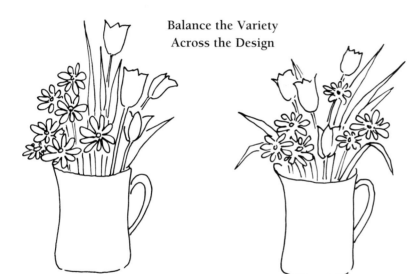

This design is off balance, divided "half and half."

Now it's a pleasing, rhythmic arrangement with good repetition of flower types and sizes.

Let One Area Dominate the Design

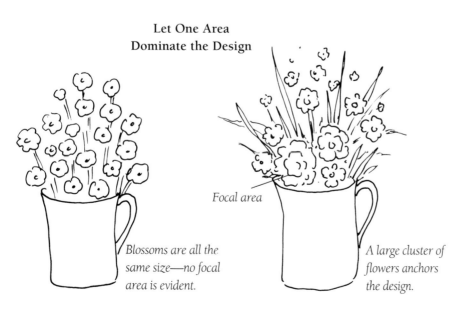

Focal area

Blossoms are all the same size—no focal area is evident.

A large cluster of flowers anchors the design.

Before choosing the blossoms to be included, it is wise to consider the design concepts that affect your decision. Limit the variety of blossoms to be included. You can see in the first sketch that too many different kinds of blossoms or even too many of one kind will quickly lead to visual confusion. Three or four flowers usually work well; more than that and it is difficult to achieve unity in the painting.

Repeat each flower variety to obtain a good rhythm in the design. Even though too many flowers can be confusing, each blossom type chosen must be repeated in a place or two to insure good balance across the design. Remember, repetition of the flower and leaf types will help move the eye through the design. When one type of blossom is confined to a single area in the design, the eye often stops there.

A dominant area must be created in the design. Create a dominant or focal area within the design by your choice of flowers and by their placement. You can see in the sketch that all major flowers are of a similar size. Your eye is not drawn to any one of them. Now, look at the finished painting. The larger rose clearly draws the eye, while the smaller, less focally placed flowers, such as the daisies and the jonquils, are clearly less important.

Create Color Harmony

When choosing the flowers you wish to include in your floral arrangement, keep design concepts in mind that we discussed on pages 130-131. You also must consider the color unity of the design. It is easy to create a pleasing color scheme if it is limited, just as you limit the number of blossoms you include in the design. Let's look at how limiting the palette colors will make a painting more harmonious.

A limited color scheme can be chosen with the help of a color wheel, which arranges colors in such a way that you can easily understand terms such as *complement* and *harmonies*. Some limited color schemes that work well for floral paintings are single hue, complementary, analogous harmonies, and analogous harmonies plus direct complement.

When the number of color families used for any particular painting is limited, it becomes easier to create harmony and unity. Using fewer colors means colors will be repeated throughout the painting, thus creating rhythm through repetition of color.

This watercolor sketch is an example of a single hue plus neutrals color scheme. Only colors from the yellow color family have been used here, along with the neutrals, black and white. Even the leaves, which are green, began as yellow, which was toned with Black plus White to produce the greens. Now study this for a minute. Do you see how limiting the palette colors very strictly can help ease visual confusion and create a pleasing painting? With white to balance the repetition of the yellows, the colors play nicely throughout.

Complementary colors are those that lie directly across from one another on the color wheel. Here red and green were used. A complementary color scheme demands quite a bit of control over the intensity in each color family, but controls visual confusion in the painting by only including two color families.

Analogous harmonies are those colors (usually three to five) that lie adjacent to one another on the color wheel and thus, because of their nearness, harmonize well with each other. This analogous harmonies scheme relies on the adjacent harmonies from red to yellow, with the green tones coming from the toned yellow family. This color scheme is a good one for florals, since the colors unify well and the number of colors included offers flexibility when painting several different kinds of flowers.

Analogous harmonies plus direct complement is a color scheme that uses adjacent harmonies (in this case yellow to red-orange) plus the direct complement which is blue. There are several major and diverse color families included, so it is important that the colors be nicely controlled in terms of intensity. This will keep the overall painting from becoming too busy. The wide range of colors that is found in this scheme offers a lot of choice when painting a complex floral arrangement.

The most important thing to remember is that the color choices you make for any design must be limited, just as the design itself is limited. Too many objects or too many colors in a design lead to visual confusion instead of unity.

Design for Decorative Shapes

Principles of good design always apply, whether to a wood surface or a painting done on canvas. However, some concessions to wood's unique form must be made in order to bring out the best of both the wood and the design.

The size of the elements in a design
The size of the major design elements should relate well to the size of the painting surface. The guest book shown here is quite large, so to fill the area and give rhythm to the design, I chose a large sunflower to give focus and relate well to the surface area.

Use striping or banding to divide a surface
Interest can be added to a plain surface by dividing it with contrasting bands or stripes of color. Here the lilacs and butterfly would have seemed rather uninteresting without the drama of the gold-leafed stripe.

Designing with negative space
The use of open space to enhance the design is very evident in this painting of *Orchids on a Dresser Box*. When designing for wood, do not feel the design must cover every inch of the surface to be effective. Negative space is as important as the design itself, allowing the eye to move comfortably from element to element.

Enhance the shape of the wood
In *Heavenly Blues and Butterflies*, the movement of the tendrils, leaves and flowers around the curved edge of the lazy Susan gives rhythm to the painting. Painting a design with a horizontal line on a round surface would create conflict instead of unity. Go with the flow when designing with wood.

Choose the Background Color

A background should stay in the background. Remember that simple statement as you begin the process of choosing the most appropriate color, value and intensity for the background of a new design.

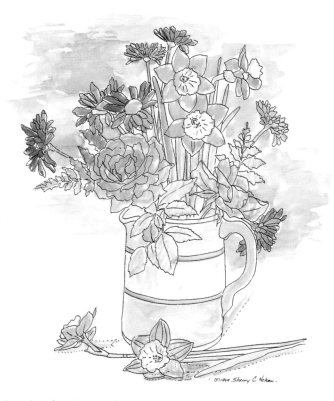

The colors found in the focal area of your painting are the most important in the design and should be slightly more intense to bring them out. Contrast there needs to be greater than in any other area of the design. The color, value and intensity you choose for your background can help you accomplish that. In this example, the important yellows show up well against the purple wash. At the same time, the purple wash allows me to lose the less important purple daisies against it. Don't forget—the intensity of the background should be less intense than any area of the same color found in the design. That keeps it in the background, where it belongs.

In this example, the bright blue does not relate well to the design because it's not found in the limited color scheme used for the floral area. Worse yet, it's too intense. It does not stay in the background, but jumps forward to the eye and distracts from the design.

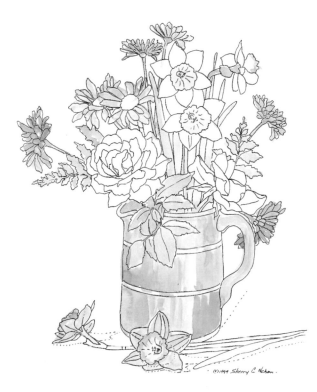

As a general rule, a container that has flowers in it should be painted to be less important than the flowers. Look how this bright yellow container overwhelms the softer floral area. Containers should play second fiddle to the flowers that are in them—and only be a little more intense than the backgrounds upon which they are found.

Photography as a Reference

Photo references can help give direction in the early stages of a design. As you begin pulling shots from your reference files of different containers, specific flowers, and background ideas that may prove useful, you'll likely find that your rather vague ideas about the painting begin to come together.

Let photos inspire you. Good photos can start the creative juices flowing and great ideas appear. The rich color and exceptional detail of these luscious pansies or this fabulous array of Iceland poppies begs to be captured with brush and paint.

Expensive equipment is not essential. A good-quality point-and-shoot camera equipped with a macro lens will produce flower photography that will give you terrific reference material for your painting.

Use your photographic resources with flair and flexibility. The gladiolus close-up has the detail you need for a painting reference; let the graceful spike of flowers be the starting point for your design. Want to paint a red hibiscus? Use your photo of a pink one for your design and a photo from a seed catalog or other book for color inspiration.

You may wish to take sketches such as this one directly from a photograph in order to shortcut design time. However, the photo must be yours or one you have received permission to use from the copyright owner. If your design is recognizable as having come from a photo, be sure you have permission so you do not infringe on the photographer's copyright. Another important word: profit. If you will be using a sketch from someone else's photo for your own use, you are not likely breaking the law. But as soon as you sell the painting or make money from a class, you are in violation.

How a Painting Evolves

Theory is just that—until we put it into action. So let's take the important concepts we've discussed and apply them in the development of a painting. It is fun to complete a painting of your own design, so I hope you'll be encouraged to give it a try. In the following pages, you'll see I've started with photo references and pulled sketches from which the final design is arranged. A water-color sketch of that design helps me with initial color and palette decisions. Then comes deciding what surface to paint on and the steps involved with preparing that surface. Finally, we're ready to transfer the design and actually put brush to paint.

If you've never created an original painting, perhaps you'll find some of my methods helpful. The rewards are tremendous: It is a wonderful sense of accomplishment when you've designed and painted your own original.

Photo references are almost always my first step in creating a design. To get the ideas moving, I pull the slides that relate to what I want to paint. Here you see some of the photos that went into *Blossoms in a Crock*. The one with the crock was a great starting point. Roses, jonquils, asters and mums gave me a range of sizes and colors to work with. I sketched individual blossoms from each photo and began to arrange and rearrange them. I especially liked the photo of the jonquils lying on the table and used it "as is" since I didn't think I could improve on it.

Here are my rough sketches taped together in a semblance of a final design. When a design is really complex, such as this one, I usually lay tracing paper over it and do an ink drawing, which I transfer to the prepared painting surface.

Once my design pleases me, I'm ready to think more seriously about the color scheme. In looking through the watercolor sketches I did to demonstrate color, I really liked the one using the yellow/purple complementary scheme. A few adjustments, such as allowing the neutral whites to carry more emphasis, and I think it will work for this design.

The palette is an easy one. Using the complementary scheme yellow/violet and the neutrals black and white, gives a range of yellows, violets and magentas, as well as the yellow family earth colors Raw Umber and Raw Sienna. Most of the leaf areas will be painted with toned dirty yellows; however, put out Sap Green, in case you want a bit of stronger green. It's OK to "cheat" on your color scheme in a few tiny places; if you plan to use larger amounts of a color outside the scheme, however, you might do better to consider a different color scheme that "fits" your plan better.

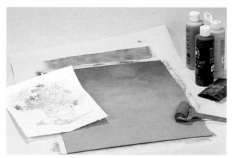

Background decisions are very important. If the background is not the right color, value or intensity, it can really hurt the rest of the painting, no matter how much work you've put into it. This photo reference, with its lovely out-of-focus look, had a great influence on the final background choice for this painting. I felt hues from the complementary color scheme would help to unify the painting. And repeating colors found in the design would give better control of the strong intensities, such as those found in the asters.

When the surface and design work well together, the painting is more likely to be successful. This garage sale tray had collected dust for some years. It seemed the perfect match for this design. A large painted area in the center of the tray had to be completely removed and the remainder sanded well so the paint would adhere.

Painting a "test panel" can help you get the background colors just right before you tackle the actual project. This combination of acrylic colors was a bit too intense, so I used more neutral tan and less lilac and plum for the actual piece.

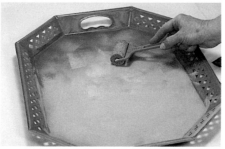

I began the rather difficult job of preparing the tray surface using a small sponge roller for all the flat areas. I like the slight tooth that it gives the surface. The oil paint adheres well, and blending is more easily controlled.

At last, it's all prepped, front and back, and lightly sprayed with Krylon Matte Finish. I've transferred the design with a very old piece of dark graphite paper so that I don't have problems with show-through.

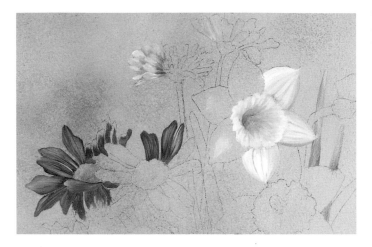

When beginning a large or complex painting, paint here and there, using bits and pieces of the various color combinations to get a feel for how they are going to work. I've worked out the purples for the asters, making sure they are only a step brighter in intensity than the background. You can see the repeat of the violet plus Raw Sienna mix in the dark area of the yellow mums and the jonquil's corona and sepals. Repetition of color mixes is a must for good color unity. You should begin carrying the most important mixes to other areas of the design almost immediately.

The violets on the side of the design away from the light source should be dulled. Here you can see the yellows have browned the violet aster even more than in the previous example. The first colors have been placed on the container. It should just barely show so the floral areas remain important. The same violet mix, the violet mix plus White, and Raw Sienna are used.

The various elements are gradually coming together. Most of the basecoat is on the crock, and the values are being kept very close to the background. The outer leaves and flowers on the shadow side away from the light source also carry less emphasis. I've used the violet mix in the leaves in order to de-intensify and unify. There are a lot of leaves, so it's an opportunity to move the soft violets into many small areas.

All the elements have at least some paint on them, and you can begin to see how the color relationships are coming along. The light yellows and whites are coming forward and helping the less important areas of the design recede. Raw Sienna has been used throughout to control purples and to mute yellow areas. A violet mix, close in intensity and value to the background, has been used for shading on all white and pale yellow areas.

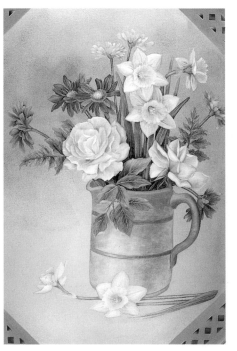

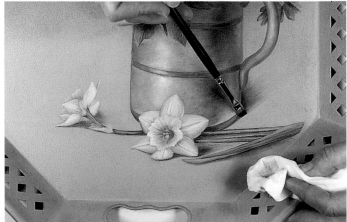

Shadows make the painting, giving it the depth it must have to look real. Good photographic references can help you with placement of the shadow shapes. Place them firmly, then buff off the outer edges with a soft paper towel to get a nice gradation of values.

It's easiest to place the shadows that fall onto the painted areas after they have dried completely. A cast shadow is almost always darker next to the object that is casting it, and contains several values. If the color won't hold on the first try, wait and reglaze on dry paint.

As we found in the flower lessons, strong lights added on a dry surface will give spark and excitement to a painting. The addition of light values in the jonquils have made a real difference.

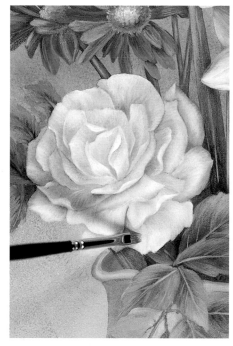

The final highlights on the roses have given them wonderful depth. The flips and rolls on the petals add yet another dimension. It's always a good feeling to reach a finishing point and to enjoy the sense of accomplishment that comes with creating a pleasing design.

The Finished Painting

This pattern may be hand-traced or photocopied for personal use only.
Enlarge at 140% to bring it up to full size.